EGON SCHIELE

Art, Sexuality, and
Viennese Modernism

EGON SCHIELE

Art, Sexuality, and
Viennese Modernism

EDITED BY

Patrick Werkner

The Society for the Promotion of
Science and Scholarship

Palo Alto, California

The Society for the Promotion of Science and Scholarship, Inc. Palo Alto, California

© 1994 The Society for the Promotion of Science and Scholarship

The Society for the Promotion of Science and Scholarship is a nonprofit corporation established for the purposes of scholarly publishing: it has special interests in British and European studies.

Library of Congress Cataloging-in-Publication Data

Egon Schiele : art, sexuality, and Viennese modernism / edited by Patrick Werkner.
 p. cm.
 "Lectures given at the symposium 'Egon Schiele and His Time: Vienna 1890–1918,' which was held at the Art Department of Stanford University in May 1990"—CIP pref.
 Includes bibliographical references and index.
 ISBN 0-930664-12-4
 1. Schiele, Egon, 1890–1918—Congresses.
 2. Nude in art—Congresses. 3. Expressionism (Art)—Austria—Vienna—Congresses. 4. Art and morals—Austria—Vienna—Congresses. I. Schiele, Egon, 1890–1918. II. Werkner, Patrick. III. Stanford University, Dept. of Art.
N6811.5.S34E34 1994
700'.92—dc20
 93–44467
 CIP

Distributed by the University of Washington Press,
P.O. Box 50096, Seattle, Washington 98145-5096, USA.

Preface

This book assembles the lectures given at the symposium "Egon Schiele and His Time: Vienna 1890–1918," which was held at the Art Department of Stanford University in May 1990. The event was prompted by the centenary of the artist's birth and by the rapidly growing interest in Schiele's art in the United States.

The symposium was held at a time when the controversy in the United States about art censorship, obscenity, and freedom of expression, which had been triggered by the Mapplethorpe-Serrano case, reached its first peak. A rare political activism emerged in the art world, which was fearful of new retrogressive legislation and of possible implications for the funding policy of the National Endowment of the Arts (these fears all too soon turned out to be justified). As that year's visiting professor in Austrian Studies at Stanford, I found myself in a situation that, as far as the question of obscenity was concerned, obviously bore some analogies to the period of Viennese modernism, with its explosive mixture of antagonistic forces both in art and in politics. The symposium thus implicitly commented also on current affairs, with the majority of the speakers focusing on questions of art and sexuality—which are highly relevant to the case of Schiele.

Three speakers from the United States and four from Austria presented an array of papers dealing with different aspects of Schiele's

art and its context. (The fifth Austrian speaker, Manfred Wagner, was prevented from coming to Stanford, but his paper is included here.) The interdisciplinary character of the symposium, with music, literature, architecture, and cultural history included in its spectrum, was productive of lively discussions. In addition, the diverging and often opposing evaluations of Schiele's art that are evident in the following articles stimulated the interest of the audience, which, indeed, was big enough to fill the large Annenberg auditorium at the Art Department. I hope that by now presenting the symposium's papers in print, an impetus will be given to further discussion on the art of Schiele, on Viennese modernism, and on the issue of sexuality and art.

At this point, I would like to thank those individuals, colleagues and friends at Stanford University who made it possible for the symposium to take place and for this book to be published: Kurt Steiner and Peter Frank, the chairmen of the Selection Committee for the Austrian Chair—it was Peter Frank who first suggested the possibility of a symposium; Lorenz Eitner, the former chair of the Department of Art; Wanda Corn, the chair of the Department of Art in 1990, for devoting a great deal of her time to the project; Betsy Fryberger at the Stanford University Museum of Art, who improvised a small exhibition on Schiele and Viennese art; Walter Lohnes and Russell Berman, professors in the Department of German Studies; Marilyn Benefiel from the Institute for International Studies; the staff of the Art Department, in particular Mona Duggan for her unstinting assistance in the realization of the project; Nancy McCauley and Kate Nilsson from the Department's slide collection; Timothy Donahue-Bombosch and "Haus Mitteleuropa," where documentary films on Schiele and his time were screened; Alessandro Nova and Dwight Miller, for their friendship and encouragement; and finally, I would like to thank Albert Elsen for his continuous help and his support of the project.

To the students at the Department of Art at Stanford, I am grateful for their motivating curiosity and interest in Vienna 1900 and in Schiele.

In New York, the Austrian Cultural Institute under its director, Wolfgang Waldner, and with the assistance of Ernst Aichinger, generously supported the project. Without the help of the Austrian Foreign Ministry, the symposium would not have been possible.

Further support, which is gratefully acknowledged, came from the Austrian Consulate in Los Angeles and from the following institutions

at Stanford University: The Center for European Studies; the Institute for International Studies; the Humanities Center; the Department of German Studies; the Department of History.

Peter Stansky, president of the board of trustees of the Society for the Promotion of Science and Scholarship (SPOSS), generously supported the inclusion of the book into the publishing program of SPOSS. Janet Gardiner, executive officer of SPOSS, was most helpful in directing the publication of the book. The Österreichische Forschungsgemeinschaft (Austrian Research Foundation) in Vienna also supported the publication with a grant.

The largest share in the realization of the project is of course that of the speakers/authors. I am grateful to them for their efforts at Stanford, and for preparing their papers for print. In Vienna, I am also grateful to Manfred Wagner for his support of the project.

Finally, I would like to acknowledge the good humor and patience of Beatrix, without which our American adventure would not have been possible.

Patrick Werkner
Vienna, October 1993

Contents

Preface v

Introduction 1
LORENZ EITNER

Drawing and a New Sexual Intimacy: Rodin and Schiele 5
ALBERT ELSEN

The Response of Early Viennese Expressionism to
Vincent van Gogh 31
ALMUT KRAPF-WEILER

The Child-Woman and Hysteria: Images of the
Female Body in the Art of Schiele, in Viennese
Modernism, and Today 51
PATRICK WERKNER

Egon Schiele as Representative of an Alternative
Aestheticism 79
MANFRED WAGNER

The "Obscene" in Viennese Architecture of the
Early Twentieth Century 89
 PETER HAIKO

Egon Schiele and Arnold Schönberg: The Cultural
Politics of Aesthetic Innovation in Vienna, 1890–1918 101
 LEON BOTSTEIN

Body as Metaphor: Aspects of the Critique and Crisis
of Language at the Turn of the Century with Reference
to Egon Schiele 119
 MICHAEL HUTER

 Notes 131
 Egon Schiele: Short Biography 149
 Select Bibliography 151
 List of Illustrations 155
 Copyright and Photographic Acknowledgments 157
 Index 159

EGON SCHIELE

Art, Sexuality, and
Viennese Modernism

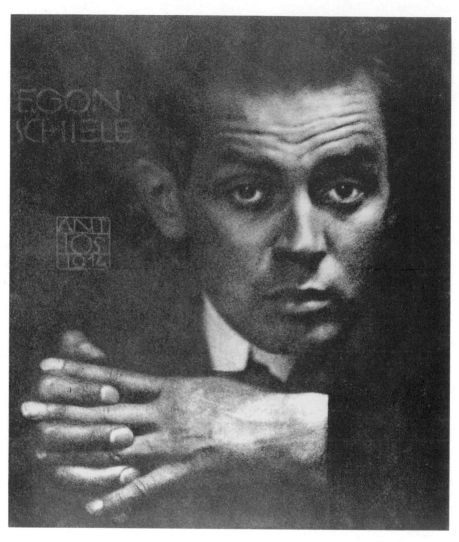

FIGURE 1. Anton Joseph Trcka, portrait photograph of Egon Schiele, 1914. Vienna, Graphische Sammlung Albertina.

Introduction

Asked to speak a few words of introduction and welcome to Stanford's symposium, "Egon Schiele and His Time: Vienna 1890–1918," I thought that I might be forgiven if, in the spirit of Schiele, I gave my remarks a personal and even somewhat confessional note.

In 1967, a Viennese art dealer, well known for his advocacy of modern Austrian art, somewhat furtively showed me a large watercolor by Egon Schiele. We were at that time in the early stages of building the collection of the Stanford University Museum. The watercolor that was brought up from a dark recess beneath the desk was important and impressive, but clearly an object that, as the dealer admitted, he found difficult to sell. He was therefore willing to part with it for about $5,000, a distinctly low price even then for what seemed to me a powerful work by Schiele.

The watercolor, a self-portrait, showed the artist nude, confronting the viewer in a crouching position, his hand clasped round the base of his colossal, fiery red phallus.

It was apparent to me that this was a work of high quality. The price was one that the Stanford Museum could just afford in 1967. But it was also obvious that autoeroticism on this monumental scale was unlikely to be widely and warmly appreciated at Stanford as it was then. It may

be well to remember that though Schiele by 1967 had gained a high reputation among the cognoscenti and been given several exhibitions in this country—in Boston and Minneapolis (1960), in Berkeley (1963), and at the Guggenheim (1965)—he was still an unfamiliar figure to the wider American audience. This particular watercolor, I concluded hesitantly, was perhaps not the best introduction of Schiele's work to our part of that audience. I did not buy the watercolor.

Twenty-three years later, in the wake of the Mapplethorpe controversy, this abstention—which, in hindsight, I believe to have been a mistake—will make me seem a prude or coward. But there were perhaps other reasons as well.

Since I had been brought up in an Austrian family in which Schiele and the art of his time were still a vivid parental memory, it was certainly not the shock of the unfamiliar that held me back. Nor do I think that it was my personal squeamishness or worry about the public's feeling, though God knows both of these may have played a part. My discomfort, I believe, stemmed mainly from a conflict about emotional self-revelation in art and, beyond art, about untrammeled self-expression in everyday life, a conflict that I had intimately experienced during childhood in my own family.

There is a tradition in Austrian art of vehement expression and ecstatic hyperbole. It forms a persistent strain that has periodically surfaced in the course of the centuries and is traceable as far back, at least, as the mannerist late Gothic of the Pachers. In the great Baroque altarpieces of Kremser Schmidt and Maulbertsch it rose again; it continued to the end of the eighteenth century in the grimacing heads of Messerschmidt, and haunted the portraits of Romako at the close of the nineteenth. Schiele's work, in its stressful exaltation, its emotional magniloquence and hectic exhibitionism, seems to me an extreme instance of this recurrent tendency in Austrian art.

But there exists another, quite different strain in Austrian art and culture that counters this hyperexpressive tendency—a strain of refined materialism, of orderly, sometimes pedantic rationality, skeptical rather than enthusiastic, humorous or melancholic rather than tragic, timid about the display of emotion, a little philistine, perhaps—in short, the Biedermeier spirit in the Austrian tradition.

Growing up in my Austrian family in the 1920's and 1930's, a family in which art and literature were a presence and a topic of discussion,

I was at an early age confronted with a compelling demonstration of this duality because my parents embodied these opposites, the enthusiastic and the skeptical, in a way that was bound to make an impression on me. My father, descended from a family of civil servants and academics, was a person of intense intellectual curiosity and wide-ranging interests, a rationalist and realist who hid his emotions, with a kind of modesty, under a well-developed sense of humor. He read history and biography, but so far as I know very little poetry, with the exception of the verses of Christian Morgenstern. In earlier days, he had been a very regular reader of Karl Kraus's *Fackel* and of *Simplicissimus*. My mother, from a family of industrialists, had rebelled against the conventionality of her parents, to whom she was at the same time deeply attached, and had sought freedom in the life of an unmatriculated music student, living on her own in Vienna in the years before the First World War. Open to all the modernisms of the time, she was a fervent idealist, emotionally attracted to emotional display, unafraid of ridicule, though sensitive to my father's habit of poking fun at things that she held sacred. She was an enthusiastic admirer of Gustav Mahler, read lyrical poetry, *Ver Sacrum*, the plays of Strindberg, and the sketches of Peter Altenberg, which she covered with exclamatory notations in indelible pencil.

Both parents took an interest in modern art. My father was professionally involved with architects and designers, and in the 1920's had close business dealings with the artists of the Bauhaus. My mother's interests ran to music and painting. I cannot remember whether Schiele came up for any discussion at home, but Klimt, Kokoschka, Joseph Hoffmann, and other Viennese moderns of the preceding decades often did.

I do not know whether my mother was familiar with Schiele's more stridently sexual compositions. I suspect that she would have been taken aback, but would have approached them with seriousness and sympathy, responding to their emotional intensity and sincerity. My father, tolerant, but embarrassed by aggressive self-exhibition, would—I am afraid—have reacted with deconstructive humor, something to which serious erotic art is rather vulnerable.

When I made my mistake in 1967, I was perhaps acting out my past and, unconsciously, taking sides. It is unlikely that I shall ever be given the chance to make this kind of decision again. The public mood

has changed, the taboos have fallen, and the rise of the art market has meanwhile barred Schiele's work from entry into our museum more effectively than any opposition to "obscene" art. But were the opportunity to arise again, I am not sure which way I should decide when, confronted by the provocation of Schiele's image, I were to listen, in memory, to my mother's voice or my father's laughter.

ALBERT ELSEN

Drawing and a New Sexual Intimacy: Rodin and Schiele

In 1909 the young Egon Schiele abruptly left the Vienna Academy of Fine Arts where he had been a student. Some time later he published a statement that partly explained his action. What Schiele sought was freedom from academic recipes and the opportunity to work alone and to be himself in order to become, in his own words, a creator who would image or portray all that he wanted. Only in this way did Schiele believe that he and others who shared his views could call themselves New Artists.[1]

The few drawings from his academic period that have been available to me in reproduction show that he was an undistinguished but conscientious and skilled student who had mastered the "recipes" for rendering the face and body. He had worked from models posed in academically acceptable positions, whether standing, sitting, or reclining. The figures are seen either frontally or in profile, and full-length. The drawings are done in outline, and some show the young artist's assimilation of the currently fashionable style of imposing straight or slightly inflected lines on the human form (Figure 2). According to academic tradition, the model loses her natural identity as she is made the subject of a poesie—meaning that the artist visualizes her as a goddess, or literary heroine, for example. The goal of academic teaching in

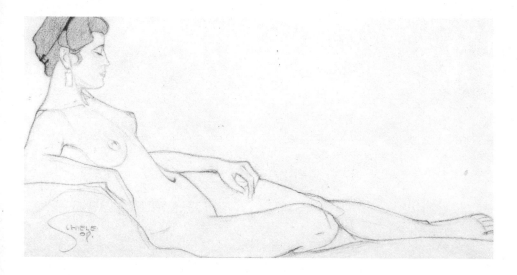

FIGURE 2. Egon Schiele, *Reclining Nude Leaning on Right Elbow*, 1908. Charcoal. Private collection.

Vienna, like that in Germany and Paris, was to develop a style predicated on certain norms of correct drawing, beauty, and perfection that would enable the artist to undertake edifying paintings of history and mythology.

When we compare some of these academic efforts with drawings of a crouching model leaning on her elbows and Schiele's self-portrait made some years later, it is apparent that there has been a radical transformation of the person as well as the artist (Figure 3; compare Figure 8).[2] In these tough, vivid drawings, Schiele's early, impersonal style is gone. A new precision, based on actual observation of the model, replaces the old, founded on adherence to externally imposed stylistic ideals. Rather than outlines, the lines are now more emphatic contours. The drawing instrument is now a probe pressing for bone, muscle, and tissue. The conventional poses are gone, and there is a total change in the models and what they do. Building upon the discipline but not the formulas of his academic training, Schiele has transformed himself into not just a New Artist, but a modern artist whose drawing, in its venturesomeness, is comparable to that of De-

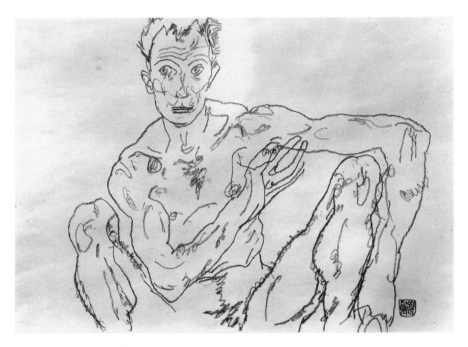

FIGURE 3. Egon Schiele, *Crouching Male Nude*
(*Self-Portrait*), 1918. Black crayon. Vienna,
Graphische Sammlung Albertina.

gas, Lautrec, Matisse, Rouault, and other Fauves in Paris, and Klimt
and Kokoschka in Vienna.

My subject is the answer to the question: Was there a crucial in-
fluence on Schiele's drawing after 1909? The answer is yes, and that
influence was the art of Auguste Rodin.

The year 1990 is the centenary of Egon Schiele's birth. It is also the
150th anniversary of Rodin's birth in Paris in 1840. There are many rea-
sons to celebrate this occasion in terms of what Rodin accomplished
in art, but it seems appropriate here to single out his contribution to
modern drawing. Without that contribution, Schiele would have been
a different artist.

Rodin's Invention of Continuous Drawing

Between about 1895 and 1897 Rodin actually invented a new way of drawing. By 1900 it was known to the world through his great one-man retrospective of that year and reproductions in art magazines such as *La Revue Blanche* and *La Plume*. This new method of drawing involved the artist in making contour drawings of a live and often moving model without taking his eyes off of his subject while he drew. Before Rodin's invention of what came to be called instantaneous drawing, artists working from the model would move their eyes from the subject to the paper as they drew, thereby in effect drawing from memory (Figure 4).

In 1903 a writer named Clement Janin wrote about his experience of observing Rodin make his instantaneous drawings:

In his recent drawings, Rodin uses nothing more than a contour heightened with a wash. Here is how he goes about it. Equipped with a sheet of ordinary paper posed on a board, and with a lead pencil—sometimes a pen— he has his model take an essentially unstable pose, then he draws spiritedly, without taking his eyes off of the model. The hand goes where it will: often the pencil falls off the page; the drawing is thus decapitated or loses a limb by amputation. . . . The master has not looked at it once. In less than a minute, this snapshot of movement is caught. It contains, naturally, some excessive deformations, unforeseen swellings, but, if the relation of proportions is destroyed, on the other hand, each section has its contours and the cursive, schematic indication of its modeling. The correction lines are numerous. Often the pencil, in the swiftness of its progress, misses the contour of a breast, the flex of a thigh; Rodin then goes back over this part with hasty strokes which mix together, but in which the just line is found.[3]

From the artist himself we have an explanation of why he invented this form of drawing:

Don't you see that, for my work of modeling, I have not only to possess a complex knowledge of the human form, but also a deep feeling for every aspect of it? I have, as it were, to incorporate the lines of the human body, and they must become part of myself, deeply seated in all my instincts. I must feel them at the end of my fingers. All this must flow naturally from my eye to my hand. Only then can I be certain that I understand. Now look! What is this drawing? Not once in describing the shape of that mass did I shift my eyes from the model. Why? Because I wanted to be sure that nothing evaded my grasp of it. Not a thought about the technical problem of representing it on paper could be allowed to arrest the flow of my feelings about it, from my eye to my hand. The moment I drop my eyes, that flow stops. That is why my drawings are only my way of testing myself. They are my way of proving to myself how

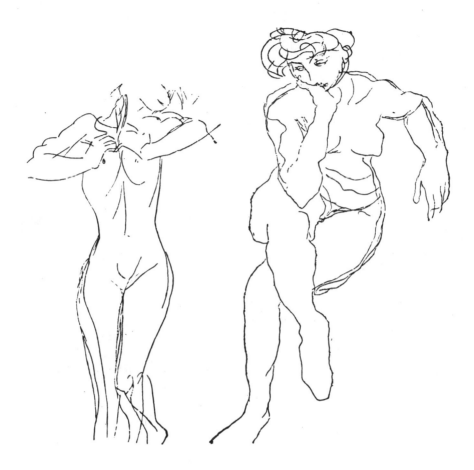

FIGURE 4. Auguste Rodin, *Two Nudes*,
ca. 1898. Pencil. Whereabouts unknown. From
Otto Grautoff, *Auguste Rodin* (Bielefeld, 1908).

far this incorporation of the subtle secrets of the human form has taken place within me. I try to see the figure as a mass, as volume. . . . Occasionally I get effects that are quite interesting, positions that are suggestive and stimulating; but that is by the way. My object is to test to what extent my hands already feel what my eyes see.[4]

Rodin's invention of what I choose to call continuous drawing grew partly out of his vocation as a sculptor who studied and made the human figure in the round, and who brought sculpture closer to life than at any previous time in history. He was testing and training his coordination of eye and hand without regard to style or technique. He sought to be totally self-effacing and unselfconscious before the living model, and to draw as if to possess that living form. Far from being detached, continuous drawing became the means by which he could sustain in his work the feelings induced by the sight of the model.

After Rodin there was no such thing as correct figure drawing—correct poses, correct proportions, correct finish—and beauty was open-ended. Rodin was a Fauve before the Fauves, and elsewhere I have shown how his continuous drawing was a liberating influence on Matisse at the most crucial time in that artist's career.[5] When Paul Klee first saw these drawings, in 1902 in a Munich exhibition, he thought they were astonishing: "The only good things were the drawings. . . . Especially Rodin, with caricatures of nudes—caricatures!—a species previously unknown in this case. And he's the best I've ever seen at it. . . . Contours drawn with a few scant strokes of the pencil, flesh tones added with a full brush in watercolor. . . . That's all, and the effect is simply monumental."[6]

A decisive source of Rodin's influence on Matisse, and other artists, possibly including Egon Schiele, was the 1902 publication by Ambroise Vollard of his drawings that accompanied (but did not literally illustrate) Octave Mirbeau's erotic novel, *Le Jardin des supplices*. (It would be interesting to know if any copies were owned by Viennese collectors and artists.) The drawings were also exhibited separately by Rodin, starting in 1900, and probably date from the last two or three years of the nineteenth century. Then and now, these drawings, transferred to lithographs, contain a wealth of information and inspiration for any artist concerned with drawing.

Rodin had the foresight to understand how basic his invention was—going to the very heart of making art—and what its implications would be for other artists such as the young Egon Schiele. In 1905

he told his friend and sometime assistant, the sculptor Bourdelle: "As my drawings are more free, they will give more liberty to artists who study them, not in telling them to do likewise, but in showing them their own genius and giving wings to their own impulse, in showing them the enormous space in which they can develop."[7]

It was Rodin's new drawings that both encouraged and showed the way by which Egon Schiele could express his sexuality in a personal style. No such credit is given in the literature on Schiele, and those who have written on his drawings seem totally unaware of Rodin's art in drawing. These commentators are too removed from the period, unlike Amadée Ozenfant who wrote in 1931:

It is somewhat surprising that Rodin the revolutionary should almost systematically be ignored in works dealing with modern art. Yet his liberating influence was tremendous. His fame was universal just when the fauves of the new painting were banding together. Indubitably he was the first of them all. He was the model revolutionary. The drawing I give next [he reproduces two line drawings from around 1900] deserve careful attention. His influence was far earlier than Cezanne on the Young. . . . The freedom with which Rodin treated nature and the human form was added to that of Cezanne liberating himself from the subject. Fauves, cubists, and all succeeding schools are indebted to these two masters.[8]

Rodin's European Drawing Exhibitions

In the first decade of our century Rodin's universal fame was abetted by a number of exhibitions of his sculpture and drawings throughout Europe. In 1900 he showed more than 120 drawings in the Paris pavilion where he held the first one-sculptor retrospective. In 1901 he showed 14 drawings in London. In 1902 he exhibited around 70 drawings in Prague; nearly 300 drawings were shown at the Berlin Secession in 1903–4 and 33 at Weimar; between 350 and 360 were displayed for sale in 1907 at the Gallery Bernheim Jeune in Paris; in 1907 and 1908 many more drawings were exhibited in Budapest (73). Fifty-three drawings were shown in Brussels, 70 in Prague, 103 in Leipzig, 148 in Paris, and 58 were shown in New York at Steiglitz's Gallery 291.[9] Most important for our purposes was Rodin's showing in 1908 of 120 drawings and prints at the Salon d'Art Hugo Heller and Company in Vienna.[10] During the 1908 Heller exhibition a talk was given by Rainer Maria Rilke, who had been Rodin's secretary and was close to the art-

ist.[11] As a result of this show, a Rodin drawing of a Cambodian dancer entered the collection of the Albertina Gallery in that city.

Rodin was well known and appreciated in Vienna long before 1908. He had participated in the first Viennese Secession exhibition of 1898 as a corresponding member, being represented among the group of foreign artists by fifteen sculptures. Rodin's gifts as a portraitist, notably the bust of Dalou, along with his worthiness of comparison to Michelangelo were recounted in an article by the critic Ludwig Hevesi. Also in 1898, Rodin showed five sculptures in an exhibition organized by the Kunstler Haus in honor of the 50th anniversary of the reign of Franz Josef, and for which he received a gold medal. (Klimt may have had something to do with all this because he knew and admired Rodin.) "Hodler was considered second only to Rodin by the Klimt generation in Vienna."[12] In 1899 Rodin contributed two works that included his portrait of Henri Rochefort to the fourth Secession exhibition. It was purchased for the future Austrian gallery of modern art. In 1900 Rodin showed the bust of Falguiere in Vienna, but in 1901 came the occasion for his most important sculpture exhibition. In a show dedicated to Segantini, Klinger, and Rodin, the artist contributed fourteen sculptures that included such major works as *The Burghers of Calais*, the monumental head of Balzac (both shown outside of France for the first time), the *Age of Bronze*, *She Who Was the Helmet Maker's Old Wife*, and the lesbian motif of *The Metamorphosis of Ovid* (then titled *The Friends*). Two of Rodin's most important partial figures, *The Walking Man* and *The Earth*, were exhibited.[13] Eight drawings were also included in the show, but unfortunately they were not listed in the catalogue, nor are they visible in the published photographs of the installation.[14]

A year later, in 1902, Rodin visited Vienna for several days, and with Gustav Klimt he viewed Max Klinger's Beethoven monument, of which he did not approve as a work of sculpture. "That is contrary to the true sense of sculpture. It is a formidable work of which will be made a million copies. But that has nothing to do with the work of a sculptor. One must reconstruct the human form, layer after layer, in order to recreate it."[15] Klinger was to later agree with Rodin, and by comparison with *The Thinker* he found his own monument "purile."[16]

Thanks to the research of Claudie Judrin, curator of drawings at the Musée Rodin, we have a very good idea of which drawings by Rodin were shown at Heller and Company. For a young, rebellious academic art student in 1908, the Rodin Vienna exhibition would have been a

must. There is no question of Schiele's awareness of Rodin's art. In 1910 he wrote a letter calling for a new international art exhibit "where each artist has his own hall . . . Rodin, Van Gogh."[17] It is not a matter of looking for matchups between specific Rodin drawings, cases in which, to use Rodin's words, Schiele literally did "likewise," but rather what ideas the artist, younger by fifty years, could have learned from Rodin.

Despite the fact that Viennese art in the early twentieth century is not my area of special competence, I have agreed to write on Schiele's drawings because much of what they tell us can be shown to transcend any verbal language and culture. I leave it to others to overlay these drawings with *Geistesgeschichte*, but for now, let us look at what is unquestioningly demonstrable in the works on paper, but which has been almost entirely ignored in the literature, including the big 1972 book by Rudolf Leopold, *Egon Schiele: Paintings, Watercolours, Drawings*.[18]

Drawing as if to Possess

Rodin's great gift to Schiele was not a style, but the way to achieve his own style. This began by Rodin's showing him how to replace academic formulas by using his own eyes and directly confronting nature, or persons, places, and things: to look at buildings the way he looked at each model, in terms of their uniquely shaped mass and volume as a reflection of their individuality, if not their character. He did this by inspiring the younger artist, as he may have done earlier with Klimt and Kokoschka, to work from direct observation of the model and to shift to a more incisive contour drawing that evoked volume with little or no shading. (As once pointed out by Matisse somewhere, modern drawing is characterized in part by its omissions.)[19]

By 1912, it appears from evidence in the works themselves, Schiele developed his own version of continuous drawing, all of which meant a change from applying an impersonal style to letting the body speak for itself. In Rodin's new form of modern drawing as absorbed by the Viennese artists, the model is rendered naked rather than nude, a particular person rather than the idealized offspring of culture. By "naked" is meant that the absence of clothes is not her natural state, as would be the case of an academic nude.[20] Schiele was made to see the body more intimately and intensively than ever before. His mode of drawing became figuratively invasive, cutting close to the bone. (Per-

haps this was a reaction against the flowing, flat, boneless style of Jugendstil, or the decorative but sometimes fussy scribblings of Klimt's silhouettes.) It was this mode of rendering the model as if the point of the drawing instrument was actually passing over the contours— like a finger probing the flesh—that helped free Schiele at various times, but particularly in the last years of his short career, from self-consciousness about style and technique, and opened his art to his own eroticism. By drawing, Rodin showed Schiele not only how to arouse, sustain, and convey his feelings for a woman, or himself, but how to possess the model in an intimate, artistic way.[21]

Continuous drawing also allowed Schiele to capture quickly the basic and often fugitive impulsive gestures of not just a single figure but also a couple (that might include himself) in movement. (For such works a mirror was undoubtedly used.) The model's "line of action" (or her general movement), as academicians referred to it, was now totally conveyed by contours and not by light and shadow. In several drawings, that seem to increase in number between 1916 and 1918, especially in the artist's self-portrait (Figure 3), the year before his death, we can see the evidences of continuous drawing, at times by the great pressure his hand exerted on the drawing instrument, but especially in crude, synoptic figural extremities, overlapping lines, and bizarre proportions. Experiencing these "distortions" and seeing their expressive effect may have helped rid Schiele of academic indoctrination into perfection and the need to submit every drawing to a labor of refinement. (Like Rodin, Schiele may have gone over a figural drawing to include passages such as facial features that he might have missed.) In sum, by showing Schiele how to find his own style by a method that was without style, in which its subjects and technique stressed the natural, Rodin contributed to the younger artist's view that "Art cannot be modern. Art is eternal."

The Model Comes to Life

Schiele's postacademic drawings show the model self-aware and responsive to the artist in an entirely new way (Figure 5). Rather than posing for posterity on a modeling stand with various supports and props, surrounded by strangers at their easels but having to appear oblivious to any audience, she is now self-consciously in the private presence of a man who is deeply interested in her, not as a poesie,

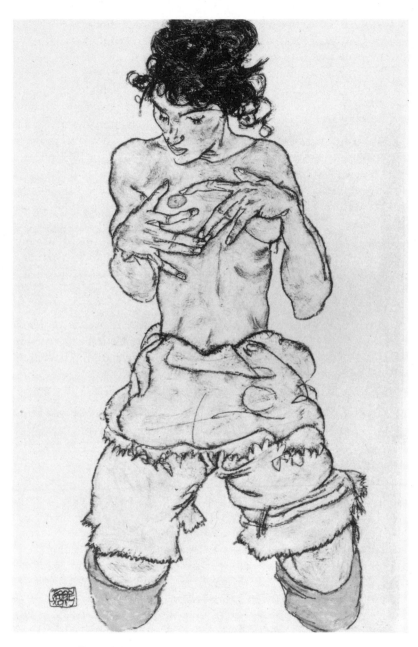

FIGURE 5. Egon Schiele, *Kneeling Semi-Nude*,
1917. Gouache and pencil. Private collection.

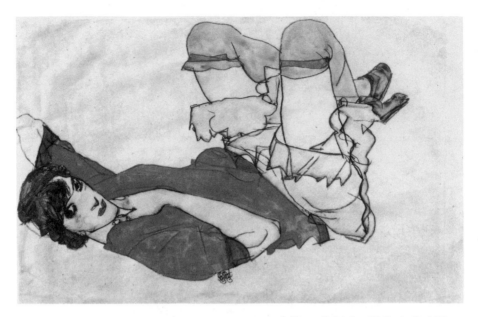

FIGURE 6. Egon Schiele, *Wally in Red Blouse with Raised Knees*, 1913. Gouache, watercolor, and pencil. New York, private collection.

but as a woman. Rodin did not like to use professional models, but sought out women with expressive if not beautiful bodies who could move spontaneously in the studio, and he took them off of what academicians called "the model's throne."[22] Like Rodin's subjects, Schiele's women, most of whom were close to him in his personal life, are aware of the artist and act or perform only for him right on the same floor where he sits (or kneels) to draw them. Whether or not Schiele gave his models total freedom to move as they liked until he found a movement that he sought to fix in drawing I do not know, but it is probable.

Schiele's subjects not only move by walking or dancing but assume positions that were not part of the art-inspired repertory of academic models. Academic artists were always concerned with making the upright figure plumb, showing the head on a vertical line above the supporting foot. Liberated from this requirement, Schiele explored new means of achieving a figure's balance in a drawing such as emphasizing how well the figure holds its place within the field of the drawing

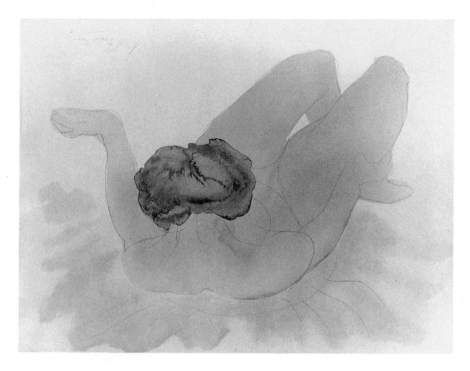

FIGURE 7. Auguste Rodin, *Reclining (or Kneeling) Nude*, ca. 1898. Pencil and watercolor in a transfer lithograph. From Octave Mirbeau, *Le Jardin des supplices* (Paris, 1902). Stanford University Museum of Art 83.156. Gift of B. Gerald Cantor.

rather than responding to the laws of gravity. The motif in isolation (meaning the figure sketched without groundline or furniture) helped Schiele draw the model in one orientation, say on her back, but then frequently change that orientation when he signed the work, so that she would be upright[23] (Figures 6 and 7). Rodin often did this, using his signature or the word "bas" to indicate what was now the bottom of the drawing. These new positions, which the model presumably assumed freely, reflect Schiele's Rodin-inspired focus on the instinctual life of the women who came to his studio. As with Rodin's models, the poses range from maximal compactness to maximal extension.[24]

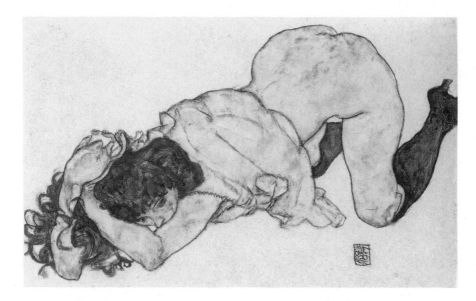

FIGURE 8. Egon Schiele, *Semi-Nude Girl with
Red Hair*, 1917. Gouache and black crayon.
Vienna, Rudolf Leopold Collection.

Despite the new freedoms for the artist and model, and the num-
ber of drawn poses without historical precedent, Schiele scholars still
reflexively look for postural precedents in other artists.[25]

The Possibilities of Proximity

For Rodin and then for Schiele, the blank sheet of paper was to be
visualized as a cube of space that began or extended into depth from
where the artist was, and into which the figure and its volume would
be located without even a groundline. (Klimt's drawn figures adhere
more consistently to the surface of the paper because his lines do not
appear to wrap around the body.) Although Schiele was not a sculptor,
from Rodin he learned to look at the body in the round, from every
perspective, and to make use of that implied space (Figures 8 and 9).
This democratic attitude toward the human form meant for both art-
ists that a woman's back could be made as expressive as her front.
Any and all foreshortenings were allowed, thereby producing for the

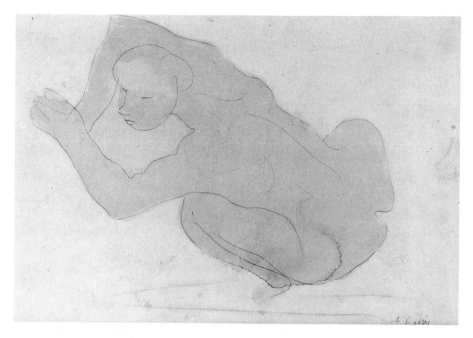

FIGURE 9. Auguste Rodin, *Crouching Woman*,
ca. 1900. Watercolor and pencil with gray
wash. Stanford University Museum of Art
69.155. Gift of B. Gerald Cantor.

artists ever-new discoveries of the body's capacity to take surprising
and artistically unprecedented form. There are drawings by both men
in which the human body is not readily or immediately identifiable
but appears as an abstract form.

All of the foregoing went with Rodin's teaching Schiele to work
close to the model in several respects. Physical proximity, for example,
that trespassed the zone of discrete distance between artist and model
so valued by academicians, meant that the body might be seen in new
ways, but ways that sabotaged classical notions of figural beauty. In
many Schiele drawings we are aware that the model is literally at his
feet, or that he is sitting or standing over or looking up at her. In the
history of Western drawing it is not until Degas and Rodin that we see
artists frequently drawing the human form from above. (Probably be-
fore Rodin, Degas did such drawings, notably of bathers in apartments

rather than nature.) From an academic viewpoint, a closeup and over-head view of a model makes the body seem contracted and produces unpleasant distortions—wreaking havoc with preferred proportions because the legs are foreshortened, the torso is enlarged, and the face is often not seen. For Rodin there was no such thing as ugliness in nature, only bad art. He undoubtedly changed Schiele's thinking about what constituted the beautiful and the ugly in drawing as opposed to academic views and contemporary cosmetic standards in life. Both artists found character in what the public may have considered ugly, and their genius was to articulate that character.[26]

Let us assume that in the Vienna Academy of Fine Arts as in the Ecole des Beaux-Arts in Paris, beauty depended upon the harmonious relations of the parts of the body to each other and to the whole. As with Rodin's drawings, where the pencil ran off the sheet, several of Schiele's drawings, such as the front and dorsal views of a woman walking, show the subject cut by the edge of the paper so that limbs are missing, or a head. This fragmentation, along with untraditional positionings of the body, opened for Schiele new possibilities of the figure's design (Figure 10). Even when the figure was not cut by the edge of the field, as in the series of drawings of a naked, pregnant woman, Schiele might omit extremities, either by not drawing them, or by working with a subject in which the arms or lower legs, say, were concealed by the model or her view in foreshortening.[27] Schiele might have seen Rodin's *Walking Man* when shown at the Secession, but he could also have known through reproduction Rodin's other partial fig-ures in sculpture as well as drawing. Whether from Rodin's sculptures or drawings, Schiele would have learned that there are parts of the human body that are dispensable for art, and that well-made parts can stand for the whole, having a beauty and expressiveness of their own. (In his paintings, however, Schiele would restore limbs missing in the drawing of the same subject, as in his self-portraits.)

Blue Like a Man's Legs

With his absorption and commitment to contour drawing, and follow-ing Rodin's example of not using color for purposes of modeling (but to augment the sense of a figure's volume), Schiele was free to use color for purely expressive rather than descriptive purposes. In some drawings, vivid and surprising colors, like blue for a man's legs, are

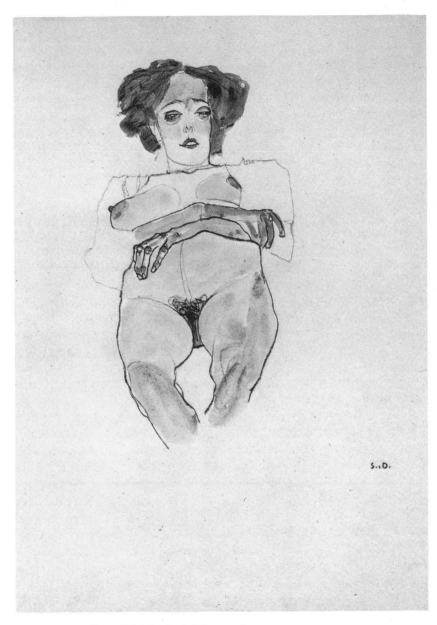

FIGURE 10. Egon Schiele, *Seated Pregnant Nude*, 1910. Gouache, watercolor, and black crayon. Private collection.

applied in solid areas. When the wet color is allowed to clot in certain areas like the neck, elbows, and wrists, as in the drawing of Gerti Schiele of 1910, there are affinities with Rodin's use of watercolor that produced Rorschach-like blots in surprising places.[28] Schiele's introduction of reds and blues into the flesh area invite comparison with Fauve figure painting just a few years earlier.[29] This practice is also indicative of Schiele's growing awareness of the modern self-sufficiency of a drawing with color: the work has its own indigenous harmony of contour, color, and texture. There are also drawings in which Schiele, like Lautrec, tinted the contours with arbitrary colors or stroked nondescriptive hues across the body.[30]

Sexually, the French and Viennese models were without inhibitions in the presence of both men. As if sisters to Rodin's models, Schiele's subjects are seen in foreshortening as they lie on their sides, exposing and presenting their buttocks, or sit or recline with legs spread, exhibiting their genitals by sometimes lifting their garments[31] (Figures 11 and 12). For every such Schiele drawing Rodin may have made a dozen in the last twenty years of his life.[32] What the older artist showed the younger is that there were no taboos to be observed about the subjects of drawing. It was Rodin who introduced the motif of the model enjoying her own sex. Depicting a woman's erotic self-gratification was perhaps for Schiele, as it certainly was for Rodin, an analogy to a man's making art from a woman. (Rodin did equate the making of art with the sexual act.)

Both artists' frequent focus on the models' genitals was consistent with their openness to the entire body in all its configurations, as well as with their fascination with sexuality and the origins of life.[33] Seeing these erotic drawings in the context of the large body of each artist's work gives them a greater sense of normalcy and puts the sexuality of both artists into perspective. Where the body forks is the sexual center, but also the rotational pivot of a woman's bodily movement, and for Rodin, more than for Schiele, these movements could sometimes take on gymnastic qualities (Figure 13). The erotic in Rodin also led him to astonishing new discoveries of form for the body in art. For example, he was fascinated by the pelvis when elevated and the bridge-like positions the model could assume. There are analogous drawings by Schiele in which the focus on genitals and pelvis creates an unprecedented design for the body (see Figure 10). What separates

these drawings of the genitals from pornography is the high artistic self-consciousness both artists displayed with regard to not only the drawing itself, but the strong composition or design that makes the body seem abstract, which is crucial to overcoming a viewer's unease with the subject. Neither artist changed his style or intensity of observation when drawing the woman's sex.

According to *Webster's Ninth New Collegiate Dictionary*, a voyeur is someone who obtains "sexual gratification from seeing sex organs and sexual acts," or "someone who habitually seeks sexual stimulation by visual means." Even though they seem not to have been frustrated in obtaining sexual gratification by other means, by this definition and their numerous drawings showing sexual organs, both artists were voyeurs. Their voyeurism does not extend to making viewers feel that they are hidden and watching unobserved the subjects of the drawing, as in the pastels of bathers by Degas, who do not look at the viewer. Even in the most erotic drawings involving a single woman, both artists frequently render the facial features of their subjects.[34] The models for the two artists at times return their gaze, thereby acknowledging their presence, which arguably alters, even if it does not diminish, the voyeuristic aspect, and helps preserve the women's individuality.[35] Schiele's women show a range of expression from open-eyed staring to half closed eyes, as if lost in sexual revery. Both men's drawings are revelations of their own sexual emotions and their own personal discoveries about the actual form of the human body, not deliberate appeals to others' prurient tastes. (In Schiele's case, however, this may be problematic as will be pointed out in what follows.) I like Kirk Varnedoe's summation of his reactions to studying hundreds of Rodin's erotic drawings: "These are not documents of idle self-indulgence, but of heated, driving fascination, the displaced locus of the same intense seriousness that motivated Rodin's draughtsmanship from the beginning."[36]

In all probability it was Rodin who, through his sculpture and drawings, encouraged Schiele to take up the motif of lesbians making love (Figures 14 and 15). In her book *Egon Schiele's Portraits*, Alessandra Comini writes,

Voyeurism, rather than compulsion or guilt, is the context of Schiele's many studies of female nudes masturbating, either singly or in pairs. Consciously following in the tradition of Rodin and Klimt, whose drawings of lesbians and single female nudes masturbating were much sought, Schiele exploited

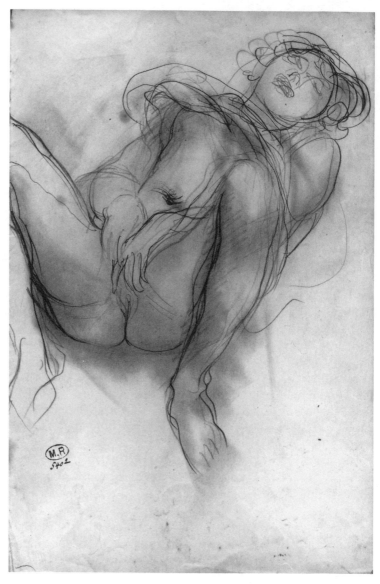

FIGURE 11. Auguste Rodin, *Naked Woman Reclining with Legs Apart, Hands on Her Sex*, ca. 1900. Pencil and stumping on papier crème. Paris, Musée Rodin, Inv. D. 5402. Copyright photo Bruno JARRET/ADGAP and copyright Musée Rodin.

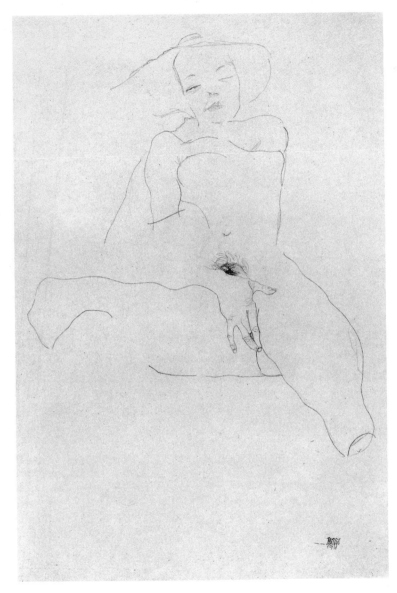

FIGURE 12. Egon Schiele, *Seated Female Nude*,
1911. Pencil. Private collection.

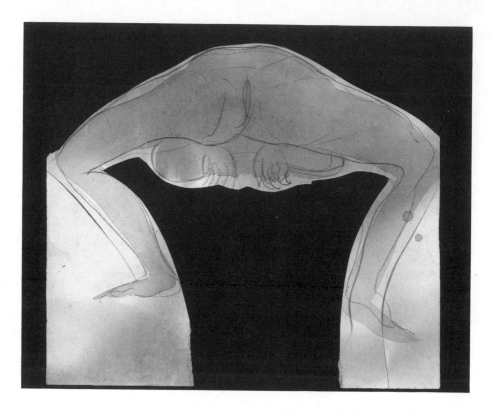

FIGURE 13. Auguste Rodin, *Naked Woman with Her Legs Apart*, ca. 1900. Pencil and watercolor on papier crème, incompletely cut out. Musée Rodin, Inv. D. 5225. Copyright photo Bruno JARRET/ADGAP and copyright Musée Rodin.

only the erotic aspect of this type of scenario, for which he found occasional female models to pose, omitting the psychological dimensions. Possibly the reason for this lack of interest in his professional models' psyches was that these pictures were his main means of support: there was always a market for his handsome, titillating, and daringly specific drawings and watercolors of erotica.[37]

While Comini's observations may be true with regard to professional models, they do not explain the erotic drawings made from Wally, Schiele's mistress of several years, and perhaps from his wife Edith, in which what has been termed "the psychological dimensions" are arguably present. (Rodin never drew heterosexual coupling, as Schiele did.) Rodin's lesbians are more energetic, even athletic in their intertwining. Continuous drawing allowed Rodin to capture the lines of action in the impulsive and strenuous embraces of his performing models, and this served as a strong paradigm for Schiele's treatment of the same subject.

When challenged by the argument that his art was obscene, Rodin initiated the defense used by modern artists ever since in similar situations: he argued that he was after truth and that his work came from sincere observation of life. It is hard to imagine Schiele not agreeing with Rodin's statement: "In art," he once said, "immorality cannot exist. Art is always sacred, even when it takes for a subject the worst excesses of desire. Since it has in view only the sincerity of observation, it cannot debase itself."[38]

Fighting Finesse

A final observation about Schiele as a draftsman: the commitment to work from the living model by close observation and continuous drawing in his last years helped Schiele fight off an acquired if not natural inclination to stylize, or to become a prisoner of style. In this regard, Schiele added his own invention to drawing (see Figure 2). As if to fight his own finesse, at times he mounted his paper on a rough board so that the line would be less fluid and the textures of his drawn line would be somewhat less descriptive by being deliberately thickened and coarsened. (This amounted to a change in voice and the way he pronounced the contours.)[39] To that end he would turn his chalk on its side, drag or pull it across the roughly backed sheet, thereby thickening or corrugating the lines inside the contours as well as the contours themselves. This sometimes produced a rippling effect, fine for fabric,

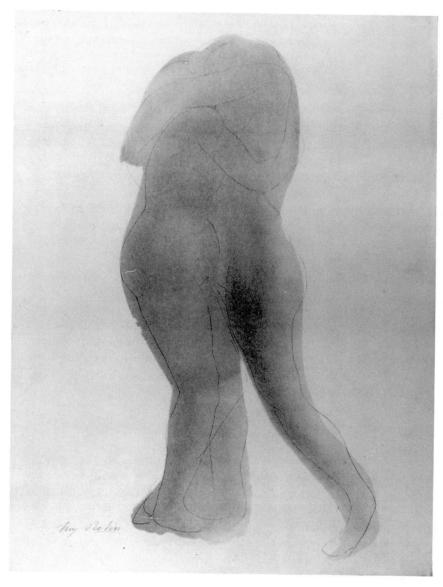

FIGURE 14. Auguste Rodin, *Sapphic Couple*,
1898. Pencil and watercolor in a transfer
lithograph. From Octave Mirbeau, *Le Jardin des
supplices* (Paris, 1902). Stanford University
Museum of Art 83.156. Gift of B. Gerald Cantor.

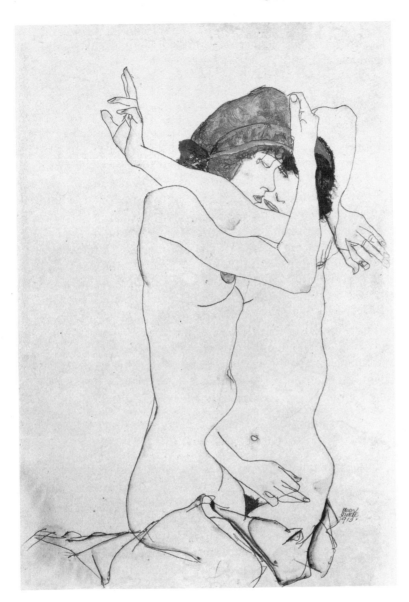

FIGURE 15. Egon Schiele, *Girlfriends*, 1913.
Gouache, watercolor, and pencil. Private
collection.

startling for flesh. Having established the basic configuration and pattern of a clothed subject, Schiele would then use the chalk point to fill in the facial features with finer lines.[40]

Last Thoughts

Schiele broke with his formal education in drawing because he wanted to find himself and be a creator. It is a mark of strong young artists that they choose powerful models by which to confront nature and art itself in order to establish their identity. I have chosen to focus on Schiele's drawings and Rodin's influence in this medium, rather than his paintings, because I think this short-lived artist's place in history will be greater because of his work on paper. Although impressive, almost to the end of his life the figure paintings are often burdened with a contrived symbolism, stilted figural composition, and a heavy-handed stylization, all of which are lacking in the works on paper. Their having been made directly from life may explain why Schiele's drawings lack the morbidity found in so many of his paintings. It was through figure drawing that Schiele found himself, and Rodin's example gave him the courage to be daring. Each drawing after 1909 was Schiele's defiant gesture of freedom. It takes nothing from this Viennese artist and Austrian pride in him that the mentor he never met, and who gave him wings to liberate his impulses, was French.

Second Thoughts or What Might Have Been

Let me share my own reservations about what has been presented. It would have been of great help to see more of Schiele's academic drawings, and to know more about the instruction he received while a student: the rules he had to break in order to show his art's power. A chronological catalogue raisonné of all Schiele's drawings will give us a better idea of his month-by-month development. It would be helpful to know if Schiele saw Rodin's drawings for *Le Jardin des supplices*, and what he knew of the drawings of Degas and prints by Lautrec. In my focus on Rodin's influence, I may have been guilty of not taking into account other sources for Schiele's development. It would certainly be helpful to know more about Schiele's own views of what constituted obscenity or pornography in art. I hope we will have all of this information before the centennial anniversary of the artist's death.

The Response of Early Viennese Expressionism to Vincent van Gogh

By comparison with the influence of other artists of the late nineteenth century—Edvard Munch, Ferdinand Hodler, Toulouse-Lautrec, Paul Cézanne, George Minne, or Auguste Rodin—the direct impact of Vincent van Gogh is surprisingly muted and ambivalent. Indeed, as such this influence may be seen far more as an ethical attitude—as an example of humanity and moral heroism, rather than of technique and style. What he communicated to the Austrian artists was his sense of the essential oneness of life and art, the same fundamental perception that is mirrored in his letters. It is likely that young artists in Vienna with an interest in Expressionism would have read the letters, and that they came to know the pictures of van Gogh through various widely distributed publications before they had a chance to see the originals. As we will see, the poet Hugo von Hofmannsthal, who first saw van Gogh's paintings when he knew nothing of the artist himself, reacted strongly to his remarkable use of color, which seemed to him to be of a different order from what he had hitherto experienced. Van Gogh's work went on exhibit in Vienna for the first time at the Secession's great show of Impressionists in 1903.[1]

Erwin Mitsch quotes in his monograph on Schiele the critic Hermann Bahr's striking description of that phase of early Expressionism: "Never was there a time shaken by so much terror, such a fear

of death. Never was the world so deathly silent. Never was man so small. Never had he been so alarmed. Never was joy so far away and liberty so dead. Now necessity cries out: man cries after his soul, and the whole age becomes a single cry of need. Art, too, cries with it, into the depth of darkness; it cries for help, it cries after the spiritual: that is Expressionism."[2] It is in this sense that van Gogh, whom Bahr mentions several times in his diaries, was a trailblazer—the supplier of comfort and consolation.

Around 1898, Bahr was really overwhelmed by the thought of creating a new and fresh art. In his first programatic introduction in *Ver Sacrum*, the famous Vienna Secession's periodical of the exciting first five years of this movement, he enthusiastically espoused the cause of foreign art, which he saw as injecting vitality into the Viennese scene: "What we want is an art that is not enslaved by the foreign, but is also without fear of the foreign or hate of the foreign." (By "foreign" Bahr means, ironically, anything beyond the Kahlenberg, the mountain on Vienna's western periphery.) "Art from abroad shall bring us to recollect ourselves, we will accept it and admire it . . . but we shall never copy it."[3] With the publication of such sentiments Bahr tried vigorously to promote the Secession until the movement began to decline into fashionable affectation. At this point Bahr turned against it, writing sarcastically in *Ver Sacrum* that if one were to send a dog with green and white spots out into the street, some lady would be bound to exclaim contentedly, "Oh, that is Secessionism." In reaction, Bahr began searching for a more profound and genuine approach to art, and thus became one of the most committed forerunners of Expressionism in Vienna. By this time, most of the leading intellectuals like Karl Kraus or Hans Tietze used the comparison with van Gogh to legitimize the nonconformist existence of the genius. Sometimes Hermann Bahr mentions van Gogh even in connection with Goethe's drawings, which in their intensity of drawing reminded him of the powerful drawings of van Gogh.[4] Or again, in the context of the painter Kolo Moser, he brings in references to the importance of the Dutch artist.

Vincent van Gogh had a considerable and early influence on some German art critics and painters. Julius Meier-Graefe, who was his most important promoter in Germany, and who from time to time lived and worked in Paris, also helped to plan the Impressionist show of the Viennese Secession in 1903. It is for this reason that van Gogh's paint-

ings appeared so early in Vienna. This show, and the speeches given during the exhibition by Meier-Graefe and the other German art critic, Richard Muther, proved to be an eye-opener for some Viennese artists and segments of the Viennese public; however, most of them were not aware of the exhibition. Impressionism itself was shown in the main section and made a strong impact. What was really significant for the early development of Expressionism in Vienna was the defining of such antecedents of Impressionism as Tintoretto and El Greco, and its further transmutation into the Post-Impressionism of van Gogh, Gauguin, and Cézanne.

That Klimt and the avant-garde Secessionists were aware of the greatness of van Gogh as early as 1903 is demonstrated by the fact that they purchased one of his late masterpieces; this picture, *The Plain of Auvers sur Oise*, was put to the vote of the Secessionists, selected, and acquired as a donation to the new Modern Gallery in the Lower Belvedere. This conformed to the Secession's stated intention of acquiring works for the Modern Gallery; however, one should not overlook the fact that there were a number of extremely conservative painters in the movement, and the purchase of the van Gogh was thus in this respect rather remarkable. The prime movers—apart from the president, the painter Wilhelm Bernatzik—would seem to have been Gustav Klimt and Carl Moll. The latter subsequently went on to purchase three van Goghs. (He was sometimes involved in art dealing.) In fact, one of his self-portraits shows van Gogh's *Portrait of His Mother* hanging on the wall in the left upper foreground (Figure 16). However—and this is interesting and typical of the relationship between works of art— by no means is there any visible influence in brushwork or style, in composition, or color. Although the coloring of van Gogh's work may well have attracted Klimt, at this time he was more interested in Toorop, Khnopff, or Minne and other symbolist Impressionists, and the response to the Dutch artist appears later.

The enigma of van Gogh's influence has been well analyzed by the distinguished Viennese art historian Fritz Novotny in his paper "The Popularity of Vincent van Gogh" (1953). He points out that the great impact of van Gogh's painting is caused by the possibility of its bringing a deeper empathy with nature into people's experience. According to Novotny, many, whether simple or sophisticated, were able to respond to this—an observation suggested by the wide sale of prints and colored postcards of the artist's work. Van Gogh once printed a

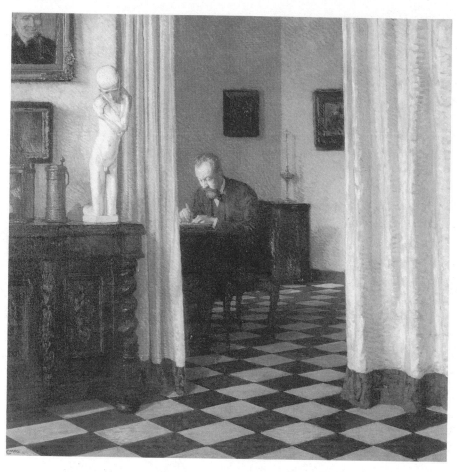

FIGURE 16. Carl Moll, *Self-Portrait in the Studio*, ca. 1906. Oil. Galerie Würthle, Vienna.

series of lithographs on popular themes so that the distribution could be wider and reach everybody, priced within range of the average pocket and with contents for average minds, and he was delighted when the printers themselves asked him for a copy to hang on the wall of the factory. Indeed, this was the profound intention of his art and mission. Novotny identified this special quality in van Gogh's oeuvre, the ability to strike a chord among a diverse public, and he correctly prophesied that the artist would become one of the best-loved masters of all time.[5]

An interesting example of the reception of van Gogh in Austria at the turn of the century confirms Novotny's general thesis. The Austrian poet Hugo von Hofmannsthal, in a fictional letter dated May 26, 1901 (published in 1907), dramatically describes the impact upon first encountering the pictures. He went to an unknown art gallery and had the overwhelming experience of seeing. At first the pictures seemed strange and alienating; he had to struggle to see any of them as an integral whole: Then, in a flash, he saw nature and the power of the human soul within the work. And beyond nature, he saw the proper, the indescribable power of fate. He became aware of the colors: "There is an unbelievably strongest blue that comes again and again, a green like melted emeralds, a yellow blurring into orange." Within the colors he sensed the innermost life of things: "An unknown soul of unbeliev- able strength did answer me, with a whole world he answered me."[6] Under the direct influence of the pictures Hofmannsthal falls naturally into an Expressionist mode of writing. The Austrian poet Rainer Maria Rilke, who was an art critic as well as more generally an art commen- tator (as Auguste Rodin's secretary he published a monograph on the great sculptor and various papers on French and German art), also encountered van Gogh at an early stage of his career, when he was living in Paris, and was deeply impressed, as is indicated in his letters to his wife, the sculptor Clara Westhoff. He was familiar with both van Gogh's pictures and letters, and he marveled at the artist's power of communication. Van Gogh's procedure of writing letters to his brother and friends was nearly parallel to the creative process; therefore we can follow the progress of work directly. Other Viennese writers who appreciated van Gogh early on include Robert Musil, who compared him to Nietzsche and Flaubert; as an example of genius he was also mentioned by Karl Kraus and Egon Friedell.[7]

After 1903, the next major van Gogh events in Vienna were the

exhibition in the Miethke Gallery in 1906 and the appearance of his work at the International Art Exhibition of 1909. Forty-five van Goghs were displayed at the Miethke Gallery. Carl Moll was its artistic leader and was responsible for the whole exhibition program of these years, during which he showed nearly all of the important painters. Arthur Roessler, who was to become the "strong champion of Schiele's art, to which he dedicated himself with both word and deed throughout his life,"[8] was the author of the catalogue. The important periodical *Kunst und Künstler*, featuring a selection of van Gogh's main letters in German translation and illustrations of drawings, was also available at the exhibition.

Apparent in Klimt's landscapes after this show is a greater depth of feeling for nature, an energizing of the forms; they become more vivid than in the Impressionist lake surfaces with twinkling reflections on the smooth structure. In *The Farmer's Gardens*, the new element of broad and dynamic brushwork recalls the Dutch artist and the exuberant beauty of his flowers and trees. The motif of the sunflower, as it recurs in the work of both Klimt and Schiele, may be an allusion to the numerous sunflowers of van Gogh. However, there are great differences in content. While van Gogh painted flowers in vases, and Schiele shows them mostly wilting and dying, Klimt displays them in gardens, in natural context with other flowers. In one such garden, two sunflowers stand out as individuals, while in another, a single monumental sunflower stands in the middle of the composition like one of the melancholy beauties in his female portraits. Perhaps too, van Gogh encouraged him in landscape painting to a more liberal brushwork and coloring, producing an idiosyncratic mix of Impressionist and Expressionist tendencies that influenced Austrian art for a considerable length of time. Again, there are marked differences between the painters: van Gogh liked to paint trees in their springtime garb of blossoms, while Klimt loved to depict the ripe fulfillment of autumn. He even featured a *Golden Apple Tree* among his orchards of apples and pears laden with fruit. Schiele, on the other hand, preferred the dark melancholy and dreariness of late autumn and the leafless winter trees: "All is living dead," as he expressed it in a poem from 1910.[9] Sometimes, too, formal aspects of van Gogh's work can be observed in Klimt's paintings, as for example the encirclement of colored fields with dark, powerful lines.

There is one recurring factor in the whole van Gogh reception: it

seems that the black-and-white reproductions of the paintings and drawings were sometimes as or even more influential than their originals. Klimt's *Avenue in the Park, Schloss Kammer* (Figure 17) bears a new element of earnestness and menace. Also, there is a depth of perspective that occurs only in this picture. There are several paintings by van Gogh that might have been examples for details: *The Hospital in Arles*, *The Corridor of the Hospital*, *The Streetworkers in Arles*. The black-and-white illustrations in the early Meier-Graefe books are particularly striking in the way in which forms are surrounded by dark brushstrokes. These surroundings may be seen in the treatment of the trees in Klimt's alley. This particular picture is generally considered to be the Klimt work that is closest to van Gogh.[10] In his portraits, Klimt, like van Gogh, sometimes used Eastern and Asiatic motifs from woodcuts or vases (for example, in the portrait of Friederike Beer-Monti in the Metropolitan Museum, New York).

The painter closest to Klimt among the younger generation was Egon Schiele. He first came to know the older artist in 1907 and deeply admired him throughout his life. Two years later he met his patron, Arthur Roessler, who, like Kokoschka's patron, Adolf Loos, introduced him to collectors and publishers. Of the collectors, the most important were Carl Reininghaus and Oskar Reichel, both of whom also acquired works by van Gogh. Roessler, the art critic of the *Arbeiter Zeitung*, was genuinely fond of Schiele, doing all he could to help him. He gave him the run of his library and presented him with an edition of Meier-Graefe's monograph on van Gogh. Schiele obviously was impressed by van Gogh in several aspects.[11]

In contrast to Klimt, from whom we have no personal opinions about van Gogh, we have references in Schiele's letters, as well as the assertions of others that Schiele admired him very greatly. He was born in the year van Gogh died (1890), and was always aware of this fact. Although he may have been too young to see the Miethke show of 1906, he must have seen the van Goghs in the International Art Exhibition of 1909, where he also exhibited.[12]

Schiele's portraits of 1910 are like silhouettes against the void of a monochrome, abstract background. Of course he could have seen similar shapes in Klimt's portraits, but the way the compact forms are cut out of the background is more reminiscent of van Gogh portraits such as *L'Arlésienne* (Figure 18), which was published various times. One of the versions had been bought by Carl Reininghaus in 1909. One

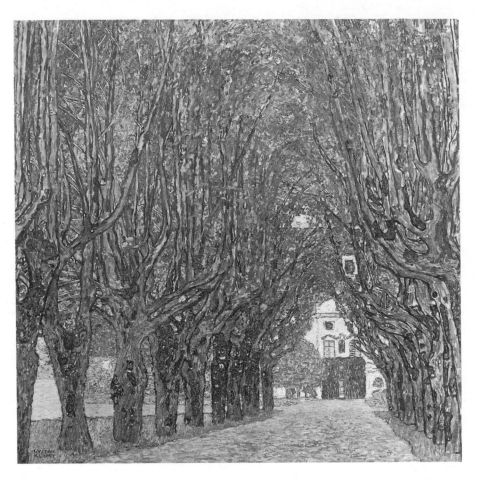

FIGURE 17. Gustav Klimt, *Avenue in the Park,
Schloss Kammer*, 1912. Oil. Vienna,
Österreichische Galerie.

notes the curves and sharp angles in the silhouettes of the portraits of Gerti Schiele (1909, Figure 19), Eduard Kosmack, Arthur Roessler, or Herbert Rainer.

In the portrait of Roessler and in that of his brother-in-law, the painter Anton Peschka, van Gogh's *Zouave* is brought to mind, while the portrait of the painter Zakovsek recalls that of *Dr. Gachet*, especially in the diagonal disposition and in the hand at the cheek.[13] Other examples of the response to van Gogh would appear to be Schiele's *Bedroom at Neulengbach*, which recalls *The Bedroom at Arles*, which was one of the eleven van Goghs at the Kunstschau of 1909 and came to the Reininghaus collection afterwards, and the *Landscape with Fields* (Albertina), which recalls *The Plain of Auvers sur Oise*, which the Secession had bought for the Modern Gallery in 1903.[14] However, it is again black-and-white illustration that seems to have been most impressive. Van Gogh's *Landscape at Arles* appeared in Meier-Graefe's *Development* as early as 1904—and Schiele may have seen this, since in the black-and-white version the little trees surrounding some fields, with dark clouds overhead, are more striking, just as they are in Schiele's work. In addition, wide and deep spaces are seldom a feature of Schiele's landscapes, which consist mostly of dark and dreary little towns and houses.[15]

One of van Gogh's motifs had considerable significance for Schiele, as previously mentioned: the sunflower. He often painted it withering and fading, seemingly a symbol of the artist himself. At the same time, Schiele knew the work of other precursors of Expressionism such as Munch, and Hodler, whose *Evening in Autumn* (1893, Neuenburg Museum) he transformed into his subsequently famous *Four Trees*. Giovanni Segantini's tree in his picture entitled *The Evil Mothers* (1894, Österreichische Galerie, Vienna, Figure 20) was transmuted by Schiele into the tragic, lonely vision of the *Autumn Tree in Turbulent Air* or *Winter Tree* of 1912 (Vienna, Rudolf Leopold Collection, Figure 21). George Minne and Rodin already had great importance for Klimt, and afterwards for Schiele, as so-called "neo-Gothic artists." Together with Toulouse-Lautrec, Minne inspired Schiele's long, thin, mannerist nudes, with their shining white halos, delineated on dark paper. Van Gogh seemed to have inspired Schiele by his intensity. At the astonishingly young age of nineteen he discovered his own artistic personality and began, like Kokoschka and Gerstl, to work with the same obsessiveness that he admired in van Gogh.

FIGURE 18. Vincent van Gogh, *L'Arlésienne* (*Madame Ginoux*), 1888. Oil. Paris, Musée d'Orsay. Reproduced from Julius Meier-Graefe, *Impressionisten* (Munich, 1907).

FIGURE 19. Schiele, Egon. *Portrait of Gertrude Schiele*. 1909. Oil, silver, gold-bronze paint, and pencil on canvas, 55″ × 55¼″ (139.5 × 140.5 cm). The Museum of Modern Art, New York. Purchase and partial gift of The Lauder Family.

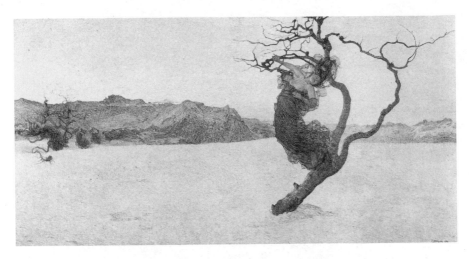

FIGURE 20. Giovanni Segantini, *The Evil Mothers*, 1894. Oil. Vienna, Österreichische Galerie.

Oskar Kokoschka, who had been linked with van Gogh by the critics as early as 1908, was unfairly treated by Meier-Graefe in his *History of the Development of Modern Art*, where he speaks of the fatal sweetness of the Viennese Orient that was like a kind of infection.[16] According to Meier-Graefe, it was difficult for the young artist to escape from this, and the inspiration of van Gogh had been indispensable. Meier-Graefe said Kokoschka in his early paintings should have been called an imitator of the Dutch painter, who played the role of a brutal field surgeon, curing Kokoschka of the decadent aestheticism of Vienna. In Germany, the Viennese scene has always been misrepresented by Expressionist critics because of what they considered to be the sweetness and decadence of Austrian painting. Their judgment of Oskar Kokoschka was particularly harsh, since he had been an outstanding early Expressionist in the German context as early as 1910, when he was part of the circle around Herwarth Walden and *Der Sturm* in Berlin. Gustav Klimt was of course widely misunderstood by the German Expressionists.

Kokoschka, when young, disliked being compared to other artists and saw himself as an original genius who later stood in the broad Western artistic tradition originating with the Greeks, and in the tradition of the Austrian and Bohemian Baroque.[17] But a few of his pictures

FIGURE 21. Egon Schiele, *Autumn Tree in
Turbulent Air* or *Winter Tree*, 1912. Oil. Vienna,
Rudolf Leopold Collection.

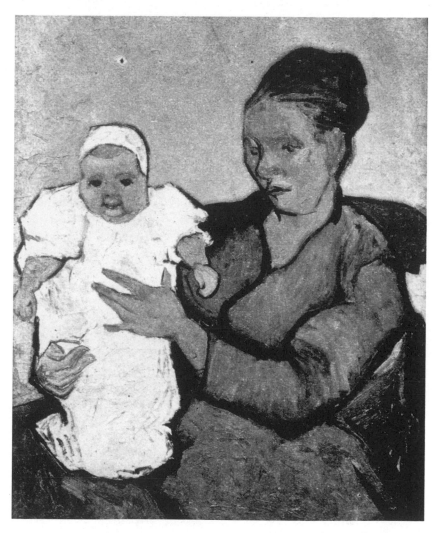

FIGURE 23. Vincent van Gogh, *Madame Roulin with Her Daughter Marcelle*, 1888. Oil. Philadelphia, Philadelphia Museum of Art. Reproduced from *Internationale Kunstschau*, exhibition catalogue, Vienna, 1909.

Facing page: FIGURE 22. Oskar Kokoschka, *Child with the Hands of Its Parents*, 1909. Oil. Vienna, Österreichische Galerie. Copyright ARS, New York/Pro Litteris, Zurich.

betray the direct impact of van Gogh—the *Portrait of Father Hirsch* is traditionally compared to van Gogh, as well as the *Still Life with Pineapple and Bananas*, both probably painted after Kokoschka had seen the show at the Miethke Gallery in 1906. The brushwork and limpid coloring are quite unlike other pictures he did at this time, most of which may recall the work of Anton Romako, whose paintings he saw in the Reichel collection. A more personal assimilation of an impression of van Gogh is revealed in his *Child with the Hands of Its Parents* (1909, Österreichische Galerie, Vienna, Figure 22). When he grappled with the problem of how to paint a portrait of a baby, he apparently remembered van Gogh's portrait of the daughter of Madame Roulin, Marcelle—not lying or sitting but standing, and held by the hands of her mother. It was one of the van Goghs at the Kunstschau of 1909, and appeared also in the catalogue, there entitled *Die Amme*. Using the palette of Romako, he transforms the image of van Gogh's healthy, happy baby into a pale, elderly specterlike child emerging from roseate clouds. The hands of the mother and father at the sides of the standing baby, symbols of protectiveness, bear a striking resemblance to the hands of Madame Roulin as they appear in the catalogue's black-and-white picture (Figure 23); however the colors are very different.

Much freer is his reference to van Gogh's *The Potato Eaters* (Figure 24). This dark and heavy painting full of love for the poor peasants seems to stand behind one of Kokoschka's rare group portraits, *The Friends* (Figure 25). Again, the influence is not at all in the coloring, which one would have expected to be the most interesting thing a painter could learn from van Gogh. Indeed, only the poet Hofmannsthal mentioned color as important, while painters seem to have looked at black-and-white reproductions, for example in Meier-Graefe's book on Impressionists of 1907 (see Figure 18). Thus, Kokoschka painted his friends in a *Freundschaftsbild* inspired by van Gogh's humanity and love of men, a type of painting well known since the Romantic age. *The Emigrants*, too, was painted in this manner. If we continue comparing black-and-white reproductions, we find the same similarities, for example in portraits such as *Portrait of Adolf Loos* and *Portrait of Carl Moll*.

In its background, *The Tempest* brings to mind the flow of van Gogh's *Starry Night* and the composition of *Rest at Noon, After Millet*, with the straw around the two peasants lying together as in a boat. Kokoschka transformed the simple farm scene into a very personal statement

showing himself and Alma Mahler at the end of their violent love affair, floating through the air.[18] Likewise, the great landscape of the Thames in London of 1954 seems to echo nostalgically van Gogh's riverbank scenes. A year before he had drawn attention to the importance of van Gogh in an essay where he had pointed out affectingly the necessity of figurative painting as he and van Gogh practiced it, stressing the existential necessity for the painter of a harmony between mankind and nature, affirmed against the inhumanity of the world. He saw the inhumanity expressed in abstract and nonfigurative art.

The painter in Vienna who was said to have been most moved by van Gogh was Richard Gerstl. He had been forgotten following his suicide in 1908, but was rediscovered through the efforts of his brother and Otto Kallir-Nirenstein in 1931. After this, he was described by the art critic Wolfgang Born as an "Austrian van Gogh"—a characterization subsequently adopted by many other critics. Arthur Roessler, writing in 1931, used markedly Expressionist phraseology in describing Gerstl's work and explicitly compared him to van Gogh, writing that nothing else was as important as van Gogh in Gerstl's time for a painter in Vienna. Gerstl's only painter friend, Victor Hammer, remembered that indeed Gerstl spoke often of van Gogh with admiration and said that the thing he most wanted to achieve was the communication of "expression."[19]

The van Gogh landscape that had been bought by the Secession for the Modern Gallery in 1903, *The Plain at Auvers sur Oise*, was crucial to Gerstl's landscape painting, as can be seen from his *Cogwheel Railway on the Kahlenberg* and other works such as *Grizning, Nussdorf, Tree at Traunsee*, and *The Fruit Garden*. Besides Max Liebermann's painting, which Arnold Schönberg recalled he admired, it was van Gogh's landscape painting that helped Gerstl to develop his personal style and palette. As a member of Schönberg's circle, which consisted of avantgarde musicians and intellectuals, Gerstl may well have come into contact with the painter's work, and—especially, early on—with the fascinating letters to van Gogh's brother Theo, the letters containing the theoretical considerations of his work. These he could have known in French, since they had been published in the *Mercure de France* before 1900, and then in *Kunst und Künstler* in 1904–5 in German. His *Self-Portrait Semi-Nude, Against a Blue Background* (Figure 26) may derive much of its inspiration from the van Gogh letters. Van Gogh writes to his brother from Arles in 1888:

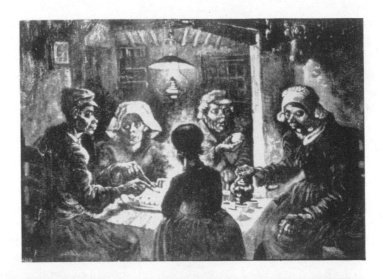

Top: FIGURE 24. Vincent van Gogh, *The Potato Eaters*, 1885. Oil. Amsterdam, Rijksmuseum Vincent van Gogh. Reproduced from Julius Meier-Graefe, *Impressionisten* (Munich, 1907).

Bottom: FIGURE 25. Oskar Kokoschka, *The Friends*, 1917–18. Linz, Neue Galerie der Stadt Linz, Wolfgang Gurlitt Museum. Copyright ARS, New York/Pro Litteris, Zurich.

Facing page: FIGURE 26. Richard Gerstl, *Self-Portrait Semi-Nude, Against a Blue Background*, undated. Oil. Vienna, Rudolf Leopold Collection.

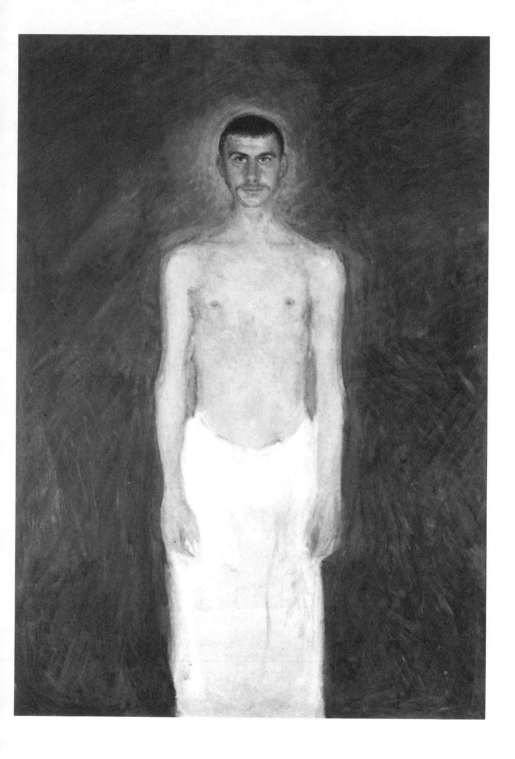

Above all, I want to achieve a strong expression. Leaving theory aside . . .
imagine, I paint an artist-friend, an artist, who dreams great dreams . . . this
man should be blonde. All the love I feel for him, I want to paint into the
picture. First I paint him as he is, as truly as possible, but this is only the be-
ginning. That is not the end of the picture. Now I begin to add color freely . . .
behind the head—instead of the banal wall of the room—I paint e t e r n i t y.
I make a simple background out of the richest blue, in full strength of the
palette. Then, by this simple composition, the blonde, lightened head on
the blue, rich background produces an effect as mysterious as a star in the
dark ether.[20]

Like painters in the whole of Europe, the early Austrian Expressionists
felt van Gogh's impact and responded to it in a very personal way.

The Child-Woman and Hysteria: Images of the Female Body in the Art of Schiele, in Viennese Modernism, and Today

Schiele's Early Figurative Work

"I always think that the greatest painters were those who painted figures," Egon Schiele wrote in 1911.[1] Figures: nudes or portraits as the representations of a state of mind—this was a nineteenth-century idea that came to Schiele from the art of the fin-de-siècle. The way in Vienna had already been paved by Gustav Klimt, but a radical shift took place in the generation of Oskar Kokoschka and Egon Schiele. In their art, the body became a medium for representing inner experiences in a most dramatic way. Schiele in particular explored all the possibilities of bodily expression.

To this end, Schiele focused almost exclusively on young models (Figures 27–31). They were his own age or younger, often even children. This applies in particular to his first, eruptive phase of Expressionism after 1909, and with special emphasis to 1910–11. For Schiele, the immature and attenuated body revealed an intensity of life that had little to do with the refined elegance of the Viennese Secessionists and their ethereal bodily ideals. Nonetheless, his concern with the adolescent body evolved from the Secessionist background.

In a series of drawings and paintings from 1909 on, Schiele subjected his models to a ruthless process of deconstruction. Every area of

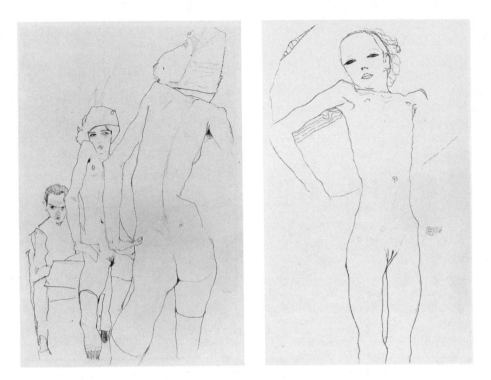

Left: **FIGURE** 27. Egon Schiele, *Schiele, Drawing a Nude Model Before a Mirror*, 1910. Pencil. Vienna, Graphische Sammlung Albertina.

Right: **FIGURE** 28. Egon Schiele, *Nude Girl*, 1911. Pencil. Private collection.

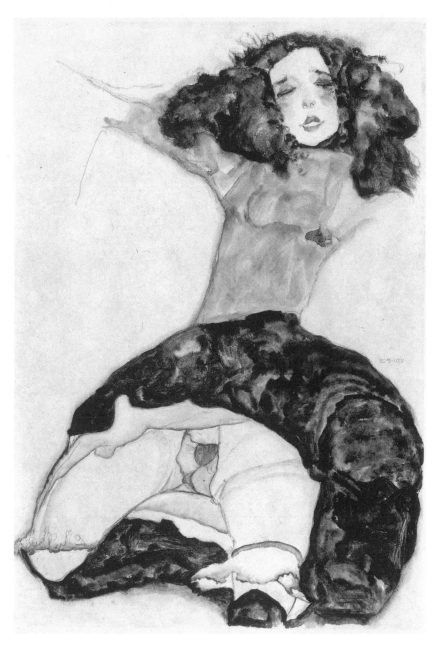

FIGURE 29. Egon Schiele, *Black-Haired Girl with Raised Skirt*, 1911. Gouache, watercolor, and pencil. Vienna, Rudolf Leopold Collection.

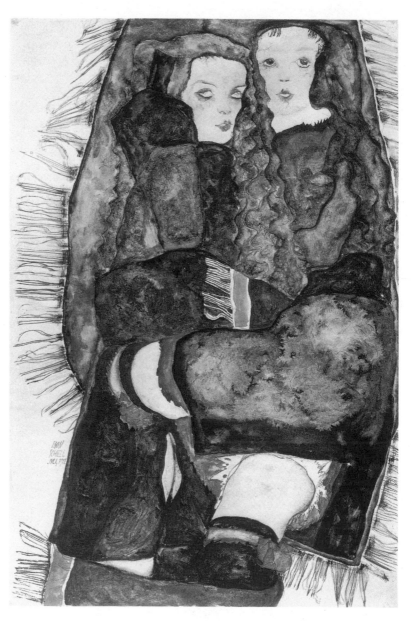

FIGURE 30. Egon Schiele, *Two Girls on a Fringed Blanket*, 1911. Gouache, watercolor, ink, and pencil. Private collection.

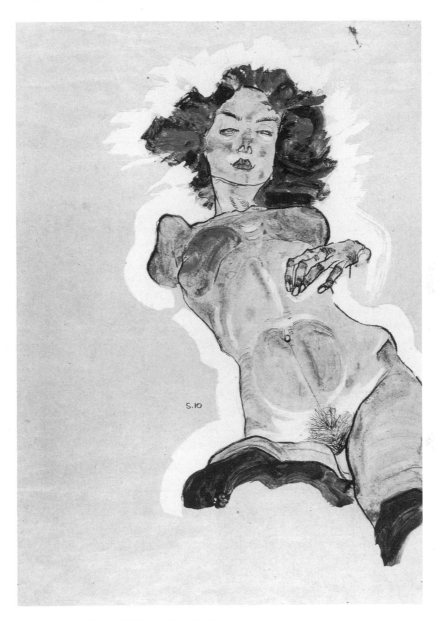

FIGURE 31. Egon Schiele, *Female Nude*, 1910.
Gouache, watercolor, and black crayon with
white heightening. Vienna, Graphische
Sammlung Albertina.

apparent ugliness and morbidity was highlighted. The artist confessed
that he had "a craving to experience everything,"[2] and his self-portraits
are a visual record of this process (Figures 32 and 33). There is no basic
distinction in them between the treatment of his own head and that
of a seminude or nude figure. The grimace, the scream, the contorted
face, are the exact counterparts of the crouching, tense, springing pose,
and of the body seen in the form of a cross, a phallus, or a geometrical
figure. In the outline of a nude, Schiele delineated the drama of human
life. In a watercolor, the surface of a naked body appears as a psychic
landscape.

Through his use of color, Schiele opened up additional expressive
possibilities. In some watercolors, a head is colored red and lilac, as if
on the point of bursting, or frozen in a corpselike pallor. Knees and
ankles sometimes take on a life of their own in harsh blue. Genitals,
nipples, and lips can be emphasized in crimson. The same profusion
of colors may be applied to a single hand or face. This expressive
exaggeration of color has its formal counterpart in the stretching or
cramping of a body and in the paroxysms that shake a whole figure
or are revealed in a look. It is in the self-portraits of 1910 and 1911
that Schiele carried all this to extremes. Self-caricature alternates with
self-contortion, tragic gesture with narcissistic pose.

Schiele's early figurative works live by gesture. The whole body and
its clothes become a means of formal creation. The face and hands,
in particular, are elements of a stylized body language that involves
a large number of recurrent formal devices (see Figure 33). This does
not mean that it is possible to extract an unambiguous sign language
for the interpretation of any given painting by Schiele. In his oeuvre
we are confronted with a highly private mythology. Similarly, Schiele's
own letters that provide explanations of his paintings or information
on their content give little more than generalized points of reference
and reflect a highly emotive approach to self-interpretation.

It is perhaps no accident that an artist friend, Erwin Osen, who
shared Schiele's fascination with the expressive potential of the body,
was a mime/actor. He appeared in cabarets with a female partner
called Moa. Like Schiele, he was interested in the body language of
the mentally ill. Osen did a number of drawings at the Steinhof mental
hospital to illustrate a lecture on "Pathological Expression in the Por-
trait."[3] Schiele for some time was obviously under the spell of Osen
and Moa, whom he drew repeatedly in a series of ecstatic, mimetic

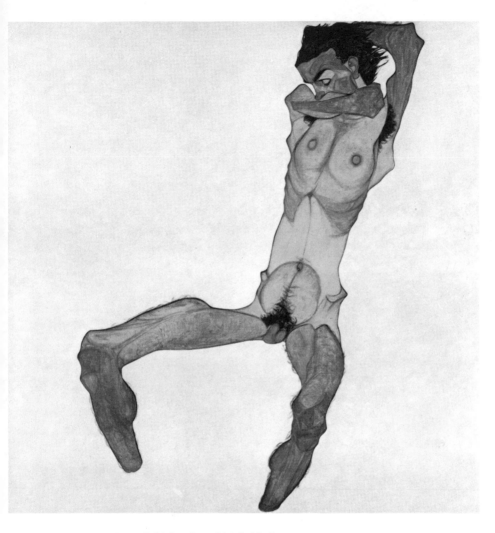

FIGURE 32. Egon Schiele, *Seated Male Nude*
(*Self-Portrait*), 1910. Oil and gouache. Vienna,
Rudolf Leopold Collection.

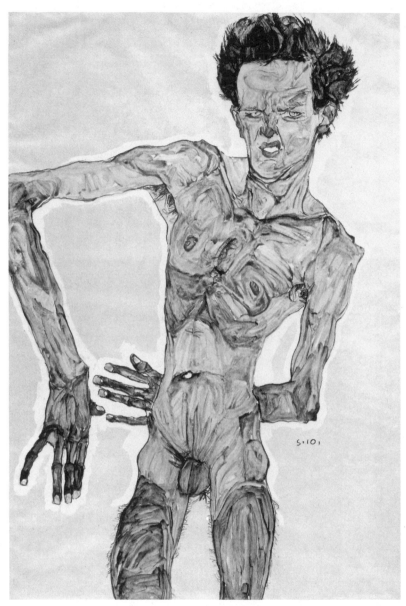

FIGURE 33. Egon Schiele, *Nude Self-Portrait,
Grimacing*, 1910. Gouache, watercolor, and
pencil with white heightening. Vienna,
Graphische Sammlung Albertina.

poses. A number of Schiele's portraits and nude drawings of Osen are closely analogous to his self-portraits. They share an eerie, disquieting exaggeration in the representation of the body.

Many of Schiele's representations of children are not, in fact, sexually accentuated, but are characterized by sympathy and empathy (Figure 34). As his friend Arthur Roessler noted, Schiele spent months "drawing and painting proletarian children. He was fascinated by the ravages of the grim sufferings to which these innocents were exposed."[4] Through his acquaintance with a gynecologist, Erwin von Graff, Schiele was able to do drawings in a women's hospital in Vienna. His depictions of pregnant and sick women and girls (see Figure 10) amount to a countermanifesto to the refined female portraiture of the Viennese Secessionists. Surprisingly, there are scarcely any old people among Schiele's models. Instead, young women are represented in terms of decay, illness, and death.

In his portraits, his self-portraits, and his ecstatic nudes, Schiele was constantly searching for the hidden, demonic, and unwholesome aspects of his subjects. There is no difference in principle between the treatment of these and that of the "pathological" subjects. The handling of the images blurs the distinction between sickness and health, between the normal and the abnormal. Everything is subjected to the skeptical vision that reveals the scars, the vulnerability, the dark sides that are concealed behind sleek personal facades. Schiele saw the abyss that lies beneath seemingly innocuous appearances.

"The erotic work of art is also sacred!"[5] This pronouncement of Schiele's is at once a recognition of the existential profundity of eros and a defense of his own work. His fascination with death constantly interacted with his urgent concern with sex. Schiele's early Expressionist work can be seen as the field of tension between these two realms. It was logical that his "craving to experience everything" should lead him into taboo areas. Sexuality was seen by Schiele as a metaphor of creativity and transcendence.

Drawings and watercolors of the female nude constitute the largest single section of Schiele's oeuvre. The central importance of this topic in his work is matched by its analogous position in that of Klimt. However, the gaunt girls of Schiele's nude studies, the contortions of their bodies and the often demonic treatment of their personas, form a marked contrast with the mostly soft, rapt, and self-absorbed nudity that Klimt depicts.

FIGURE 34. Egon Schiele, *Two Little Girls*,
1911. Gouache, watercolor, and pencil. Vienna,
Graphische Sammlung Albertina.

It is a striking fact that Schiele created a series of highly expressive portraits of men and comparatively few portraits of women. In view of the harshness of his style, however, it is hardly surprising that he received few commissions for female portraits. The clear division between a man's world, which might be intellectual enough to tolerate experiments in expressiveness, and a woman's world, whose function was to present an image of refined sensuality, reflects the prevailing tension between the sexes in Vienna around 1900. The resultant atmosphere of compulsion and obsession strongly affected Schiele.

It is in the early phase of his career that Schiele makes his most original and also most disquieting contribution to modern Austrian art. In the drawings and watercolors of this early period, Schiele gives of his best. Their spontaneity, liveliness, and directness seem more authentic and genuine than the atmosphere of his paintings done at the same time. These, by contrast, show a somewhat forced symbolism and a tendency to heavy pathos. Although pathos can be found in his graphic art as well, it never becomes sentimental or artificial. The dramatic intensity with which these first Expressionist works investigate his own body and the bodies of his models and sitters is unparalleled in his later oeuvre.

The young model plays a central role in Schiele's work, and thus the meaning of youth and the significance of the young and adolescent body in Viennese modernism become key questions in the interpretation of his art. A study of iconography and context is particularly rewarding in the case of Schiele, since scholarship in these fields has left many questions open. Gustav Klimt, by contrast, has received considerable attention—and is receiving ever more—from scholars who focus on philosophical, symbolic, psychological, or other topics related to his work. This is due to the fact that Klimt's work is rooted in symbolism and historicism, and provides rich mythological and allegorical material. For Schiele, one has to adopt a different procedure in order to gain access to the subtext of his work.

The Image of the Child-Woman and Viennese Modernism

Schiele's fascination with the figures of pubescent girls and boys can be traced back to a common concern with the adolescent body in Europe around 1900. It is anticipated in the sculptures of George Minne[6] and in several works by Ferdinand Hodler—to name but two artists

whose works had considerable impact on their contemporaneous Viennese colleagues. At that time, adolescence was seen as a synonym for change, for newness, for openness and creativity. The German term for Art Nouveau, Jugendstil, took youth—*Jugend*—as the equivalent of the renewal of art. The Viennese Secession called its magazine *Ver Sacrum*—holy spring. Spring, not summer, is the symbolic program of the new art movement.

In Gustav Klimt's monumental Beethoven frieze of 1902, the figure symbolizing poetry is a young woman. Clearly inspired by Greek vase painting, she is meant to depict poetry in its broadest sense, as art in general. Here, too, art is young. Oskar Kokoschka's little book *The Dreaming Youths* tells the story of the sexual awakening of a boy and of his first passion, for a girl called Li. The two figures appear in the last of Kokoschka's lithographs for the book, which was published by the Wiener Werkstätte in 1908. They are shown naked, in a paradiselike environment, surrounded by exotic vegetation and by animals. The scene may also be interpreted as a modern paraphrase of Adam and Eve. However, never before had Adam and Eve been represented so youthfully in iconography.

Kokoschka's art at that time, in the other lithographs for *The Dreaming Youths* and in his graphic work in general (Figure 35), prefigures Schiele in the sense that it shares the same concern with poses and gestures of pubescent models. It is revealing to see in which circles of Viennese modernism Kokoschka's art was first absorbed.

In 1909, the 23-year-old artist was more or less adopted by Adolf Loos, who introduced him to his own clients and had them portrayed by Kokoschka. Because Loos guaranteed that he would acquire the painting if it did not please, he soon ended up with the largest portrait collection of Kokoschka's work that ever existed. In Loos's circle, the artist met the poet Peter Altenberg, who had a weakness for young girls. Loos and Altenberg shared the same passion for dancers and actresses, who were usually much younger than they were; the two men frequently fell in love with the same girl. Loos was regularly more successful, while Altenberg frequently had to content himself with a photograph of his adored one. The room in the cheap pension in which the poet lived was plastered with pictures of his idols.[7] Altenberg's *Fabricated Photographs*, in which the female images form only a part of the topics represented, have recently been given new attention by Leo A. Lensing. He has argued—convincingly—that these pictures were just

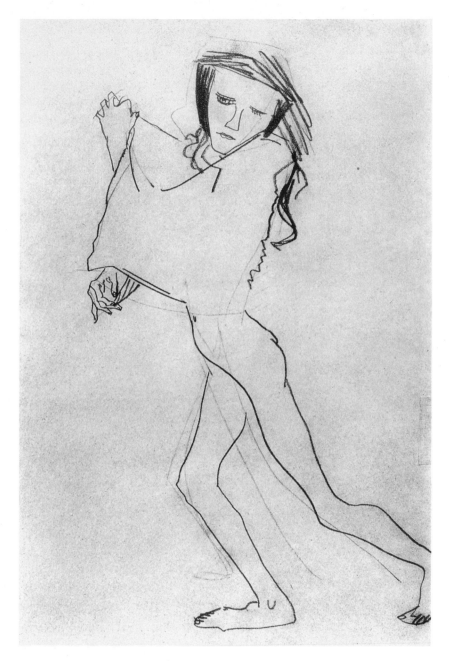

FIGURE 35. Oskar Kokoschka, *Study in Movement*, ca. 1908. Pencil. Private collection. Copyright ARS, New York/Pro Litteris, Zurich.

as important as his literary production and were an innovative blend
of photography and poetry.[8]

Altenberg usually covered the images of his adored ones with ec-
static epigrams. On his photo of Bessie Bruce, an English dancer and
for a long time the lover of Loos, Altenberg wrote in 1905: "Child-girl,
I loved you *immensely* and I suffered for you, most loved one, in pain
and in misery. God save and bless you!"[9] The *Kind-Mädchen*, the "child-
girl," was the object of Altenberg's erotic fantasies. One photograph in
his collection is a fetishlike close-up of the legs of a thirteen-year-old,
Evelyne H. She stands beside the edge of a sofa in underskirts and glit-
tering lacquer boots, and is seen from behind. On the picture, which
was probably taken by Altenberg himself, he wrote the exclamation:
"The absolutely ideal legs!" (Figure 36).

Another photo shows the dancer Elsie Altmann posing in a senti-
mental, girlish attitude. Altenberg's epigram addresses her as a "Can-
didate for suicide!" and covers the image with the expression of his
passion—just a few months before she became Loos's second wife.[10] A
photograph of Evelyn Landing bears Altenberg's inscription: "My *ideal*
from head to toe! Your *boyish* build enraptures me!"[11] Lilith Lang, who
had studied with Kokoschka at the Viennese School of Applied Art,
and who appears as the girl Li in his *Dreaming Youths*, was also repre-
sented in the collection—characteristically, in a photograph showing
her as a child.[12] Even the Empress Elisabeth, who had been assassi-
nated in 1898, was in the poet's compilation, pictured as an eighteen-
year-old. Beside her image, Altenberg scribbled pathetically: "You
knew nothing and hoped for everything. Later, you knew every-
thing—and hoped for nothing." The innocence of childhood is idolized
here, while mature age becomes equated with resignation.

Haiko and Reissberger have pointed out that Loos's condemnation
of ornament stemmed from his fear of the mature woman's sexuality.[13]
As Loos saw it in 1898, enlightened men had already dispensed with
ornament, which was of no use in the modern age, but rather a waste
of energy and material. Still, he conceded its temporary value for
woman: she still has to attract man, due to differences in labor distri-
bution. Loos, however, prophesied a time of equality in which woman
will no longer be in need of ornaments:

We are approaching a new and greater time. No longer by an appeal to sen-
suality, but rather by economic independence earned through work will the
woman bring about her equal status with the man. The woman's value or lack

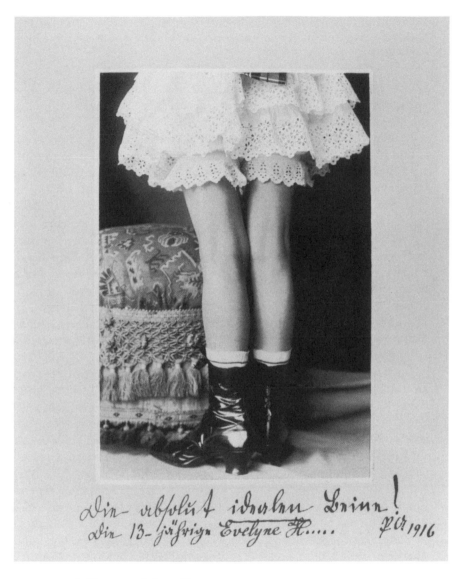

FIGURE 36. Photograph from Peter
Altenberg's collection, with epigram by the
poet. Vienna, Historisches Museum der
Stadt Wien.

of value will no longer fall or rise according to the fluctuation of sensuality. Then velvet and silk, flowers and ribbons, feathers and paints will fail to have their effect. They will disappear.[14]

Loos's later condemnation of ornament, its equation with crime—as in his famous essay "Ornament und Verbrechen" (1910)—amounts to the criminalization of woman.

In view of Loos's gender-oriented theories, it is intriguing to examine his house on the Michaelerplatz, built in 1910–11. In its renunciation of ornament it is, as Haiko and Reissberger argue, a denial of sensuality, and in consequence the realization of the "utopia of the disavowal of mature female sexuality." [15] In fact, the building was associated by contemporary critics with the naked body of a woman, and was called "indecent" and "provocative." But it was also called "sleek" and "clean-shaven"—thus, implicitly, the symbolism of the house, which may have existed only in Loos's subconscious, was understood by the critics. The architect's aesthetic ideal was an "innocent, preadolescent nakedness." [16] As he put it: "One yearned for unripeness. . . . The child-woman came into vogue." [17] The house on the Michaelerplatz in its anti-ornamentalism and "nakedness" thus corresponded— among other things—to the ideal of the child-woman.[18]

Loos was married three times. Lina Obertimpfler, his first wife, was an actress, Elsie Altmann, his second wife, a dancer. As Loos grew older, he chose progressively younger partners. Elsie had studied with Grete Wiesenthal, the Austrian pioneer of expressive free dance. Artists, writers, and intellectuals in Vienna around 1900 easily fell under the spell of dancers and actresses. Karl Kraus, the hated and feared satirist and close friend of Loos, had been the lover of the actress Annie Kalmar (who had also been admired by Altenberg). As with Loos and Bessie Bruce, Kraus's love affair ended tragically; both women suffered from tuberculosis, and Annie Kalmar died young (aged 23), in 1901, in Hamburg.[19] The clichéd story of the adored young woman who dies prematurely of tuberculosis, as exemplified in nineteenth-century opera—for example, Violetta in Verdi's *La Traviata*, or Mimi in Puccini's *La Bohème*—was here imitated by life. Bessie Bruce's treatments in a hospital in Switzerland, where she was portrayed by Kokoschka in 1909, were for many years paid for by Loos.

Another actress, Irma Karczewska, was fifteen years old when Kraus first met her in 1905. She played a small part in that year's pio-

neering performance of Wedekind's *Pandora's Box*, which Kraus had organized, and then embarked on a career in cabaret with his help. For some time, Irma Karczewska played a considerable role in Kraus's life and in his circle. It seems that she had a certain resemblance to Annie Kalmar, but was more petite. In 1907, Kraus's magazine, *Die Fackel*, contained an article that had been inspired directly by a love affair with Irma. The author was the psychoanalyst Fritz Wittels, who later became Sigmund Freud's first biographer. Under the title "The Child-Woman," Wittels analyzed her nature, "her precocious beauty, her complete freedom from sexual inhibition, her ability to gain sensuous pleasure from any lover, whether male or female." [20] Wittels took up Freud's concept of infantile autoeroticism in order to explain the sexuality of the "child-woman." Literary scholars have recently reconstructed the case of Irma Karczewska in Viennese modernism, and have been able to show that unconscious homosexual undertones played a pivotal role in the intellectual interactions between Wittels, Kraus, and Freud at that time. [21]

Around 1900, the dancer and the actress who break established rules, in the realm of art and in the realm of morals and society, became a metaphor for the break with the "old order" in art and life. This is particularly a feature of Viennese modernism, as has been shown elsewhere. [22]

The breaking of rules is, by definition, an attribute of vanguardism. However, when one considers its role in fin-de-siècle Vienna, one has to be aware of the moral code of the time, however hypocritical, which was also buttressed by the law. Paragraph 127 of the Austrian Criminal Code made it a crime to have sexual relations with anyone under the age of fourteen, and sexual contact with minors could thus have fatal consequences. The first major architectural commission that Loos received came from a man who had fallen afoul of the public standard of morality on the grounds of an alleged private vice. Theodor Beer, a professor of physiology at the University of Vienna, was Loos's customer. He commissioned the Villa Karma on the shores of Lake Geneva in 1904, but was unable to carry through the project. After a trial that was heavily criticized by Karl Kraus as being unfair, [23] Beer was sentenced to three months of imprisonment. He had been accused of having enlightened two boys on sexual matters, having encouraged them to masturbate, and having "touched them in an indecent way." [24] Beer lost his academic position and emigrated, and his wife committed

suicide in 1906. Beer then killed himself thirteen years later.[25] Loos himself was sentenced in 1928 for a sex offense with minors.[26]

As for Schiele, the uncompromising nature of his erotic images, and in particular his frequent consorting with minors who served as his models, led in 1912 to the notorious episode of his imprisonment. The artist was initially charged with abduction and forceful rape of a minor. As far as one can reconstruct the case today from some still-existing sources, these accusations were groundless. After the girl, the main witness in the trial, had retracted her statement, all the accusations against Schiele were dropped—with the exception of "offenses against morality," by which was meant the circulation of indecent drawings. On this charge he was convicted, and had to spend 24 days in prison.[27] During the trial, one of his erotic drawings was ceremonially burned.

With Schiele, Kokoschka, and generally in Loos's circle, one notes a shift from fascination with the *femme fatale* of the mature woman to the *femme fragile* of the child-woman.[28] Klimt anticipates the shift in some of his paintings. This does not mean that the *femme fatale* was no longer an object of desire—but simply that her younger sisters, who were already present in fin-de-siècle art and literature, grew in importance. The fragile woman, although sometimes the prey of illness, was nonetheless seen as a powerful personality.

For the vanguard artist, writer, and intellectual, the concepts of *femme fatale*, *femme fragile*, and child-woman were amalgamated. The attraction of this fusion lay in a mixture of attributes or projections. Youth itself, as we have already seen, was an important characteristic. Creativity and change were associated with it. In the case of the child-woman, the old myth of androgyny probably served as inspiration: the yearning for "oneness" on the basis of a speculative philosophical monism was a widespread characteristic of the contemporary weltanschauung around the turn of the century.[29] Furthermore, the innocence of childhood was transfigured thereby. Latent homosexual tendencies also found their way into the idolization of the child-woman as an alternative to the mature woman.

Men's fear of women was particularly manifest in Vienna around 1900. It resulted in the "struggle of the sexes," a frequent topic for painters and writers at the time. It was also a consequence of the changing attitudes toward patriarchalism and women's rights. At the same time, the adherents of a rationalist weltanschauung perceived women as both fascinating and frightening: womanhood was tradi-

tionally associated with nature, and nature with irrationalism. All this led to a preference for the child-woman, since the preadolescent female body, being closer to its male counterpart, was less fear-inspiring than the body of a mature woman.[30]

Finally, the symptoms of hysteria that fascinated Viennese psycho-analysts (and not only them) were associated with young women rather than with a ripe personality.

The Aesthetics of Hysteria

When the prominent critic Hermann Bahr wrote to Hugo von Hof-mannsthal about the latter's play *Elektra* of 1903, he suggested that "more use should be made of" the Berlin actress Gertrud Eysoldt. For Bahr (who later married the opera singer Anna Mildenburg), Eysoldt had correctly interpreted Elektra in "the one mode" that he saw as characteristic of the play, "that of the hysteric."[31] Eysoldt, who was portrayed in Berlin by Lovis Corinth and other artists, appeared in 1904 in a photograph in the magazine *Das Theater*. She was captured there in her role as Elektra, with a fragile body, long, bony arms, cramped fists, and an expression on her face probably indicating the hallucina-tions she had to suffer in the play.[32] Eysoldt thus personified for early modernism the "ideal" of hysteric symptoms stylized on stage.

The expressiveness of Eysoldt's figure corresponds to the drawings and watercolors that Schiele and Kokoschka produced around 1909, and to the photographs of Grete Wiesenthal that appeared in the Vien-nese magazine *Erdgeist* in the same year.[33] One is tempted to see this interest in hysteria as an important source of Viennese Expressionism.

Several studies in the history of psychoanalysis have shown that therapists around 1900 were aesthetically fascinated by hysteric symp-toms.[34] The *Iconographie photographique de la Salpêtrière*, which was pub-lished in three volumes between 1876 and 1880,[35] and the journal *Nou-velle Iconographie de la Salpêtrière*, edited by Jean Martin Charcot and Paul Richer, which appeared between 1888 and 1918, provided doc-tors (and others) with a documentation of hysteric symptoms. Richer, Charcot's loyal disciple, published a book on the "grand hysteria" in 1881 that illustrated the different phases of hysteric attacks in 105 plates.[36] But these publications may also be seen as catalogues of the (female) body's expressive qualities (Figure 37). Indeed, they could in this respect serve as early documents of performance and body art.

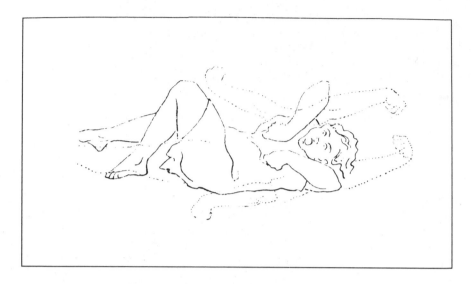

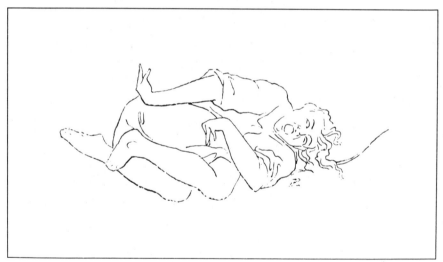

FIGURE 37. Phases in an attack of hysteria,
from Jean-Martin Charcot and Paul Richer, *Les
démoniaques dans l'art* (Paris, 1887).

It is no coincidence that Charcot—with whom Freud had studied in Paris in 1885–86—also coedited two books that clearly mark the connection between therapeutic and aesthetic interests. *Les démoniaques dans l'art* was published in 1887 by Charcot and Richer.[37] Two years later, their book *Les difformes et les malades dans l'art* treated the subject of illness in art through the centuries.[38]

In Vienna, Freud was ecstatic about "the most beautiful examples of symbolizations" in the case of Cäcilie M., "my most difficult and most instructive case of hysteria." His colleague Josef Breuer saw the hallucinations of his patient Anna O. as the outcome of a "fantastic-poetic vein." C. G. Jung wrote to Freud about a patient with a "very beautiful" case of hysteria; during her states of somnambulism, both doctors and nurses gathered around her, "full of admiration."[39]

The impact of Freud's and Breuer's *Studies on Hysteria*, published in 1895, was considerable.[40] Among the numerous writers and theorists who were influenced by this book was Hermann Bahr, as has been shown. His essay "Dialogue of the Tragic" (1904) explicitly based its concept of cultural theory on *Studies on Hysteria*. For Bahr, the key word was "*abreagieren*," to abreact. The Greeks, he stated, had invented tragedy to cure themselves of collective hysteria. Bahr linked the Aristotelian concept of catharsis with the doctors' new investigations. He argued that the ancient Greeks had dealt with suppressed emotions by "abreaction" through the catharsis of theatrical performance. The tragedies supplied them with hysteric figures to identify with. Bahr, in his essay, implicitly justified the subjectivism of self-expression. It is not surprising that he was later to become a proponent of Expressionism.[41]

The form of Bahr's essay is a dialogue. We may imagine its setting in one of the bourgeois apartments in Vienna around 1900, probably after a dinner party. It is striking how Bahr characterizes the genders. While the men decide to go on talking about the theater, hysteria, and medical treatment, we are told that the women leave the scene: "The lady said: 'Come, we will not let our enjoyment be spoilt by that!' And she pulled away her friend. They left for the theater."[42] While the men are shown discussing a future art that will overcome the present state of (hysteric) culture—they anticipate a "mythic art" without defining what is meant by the term—the women represent the status quo. They are victims of the theater, and thereby affirm the distribution of gender roles; for as far as Bahr is concerned, they have not yet overcome the state of hysteria.

Hysteria, however, was a form of creativity. Historians and phi-
lologists at the turn of the century associated Greek religious cults
with ancient descriptions of women whom psychoanalysts undoubt-
edly would have called hysteric. In 1894, the German philologist Erwin
Rohde published *The Cult of Souls and Belief in Immortality Among the
Greeks*.[43] In respect of the widespread cult of the god Dionysos, he
wrote:

Even Art . . . drew much of its inspiration . . . from the worship of Dionysos;
and the drama, that supreme achievement of Greek poetry, arose out of the
choruses of the Dionysiac festival. Now the art of the actor consists in enter-
ing into a strange personality, and in speaking and acting out of a character
not his own. At bottom it retains a profound and ultimate connection with its
most primitive source—that strange power of transfusing the self into another
being that the really inspired participator in the Dionysiac revels achieved in
his ekstasis.[44]

The power of ecstasy that philologists imposed on their view of
Dionysian cults—clearly in the tradition of Nietzschean thought—cor-
responded to the "beauty" of hysteric convulsions or hallucinations
that psychoanalysts admired in their patients. Both concepts found
their way onto the stage through Hofmannsthal and into art through
Klimt—and later, implicitly, through the painters of Viennese Expres-
sionism.[45] Their mediator in Vienna was expressive free dance, which
was supplied with its theoretic foundation by enthusiastic (male) crit-
ics.[46] Some of them even saw a new religion arising from the new forms
of dance.[47]

The physical ideal that seemed appropriate for expressing the emo-
tions of the new art's supporters were the slim, elastic, young bodies
of the dancers who were admired in their performances in the Seces-
sion building and in Viennese theaters: Mata Hari, Ruth St. Denis,
the Wiesenthal sisters, Gertrude Barrison, and others. In 1910, Erwin
Lang—the brother of Lilith Lang, who had been the model for the girl
Li in Kokoschka's *Dreaming Youths*—produced a series of woodcuts
showing Grete Wiesenthal in several dance poses. Altenberg remarked
on the occasion of their exhibition: "We behold the noble, *unfat*, flex-
ible body in its holy nakedness, we behold in the solemn face the soul,
without which there is no significant dance."[48]

The male Viennese voyeur sympathizing with vanguard art around
1910 found his ideal in the construction of the *femme fatale/femme fragile/
child-woman*. This construct was made up of a web of connotations:

youth as a specific quality, innocence, androgyny, creativity, the break-
ing of rules in art and morals, "beautiful" hysteric symptoms, and all
kinds of sexual undertones. It is this very physical ideal that supplies
the context for Egon Schiele's drawings and watercolors of that period.

But what differentiates Schiele in 1910–11 from the voyeuristic ten-
dency in much of contemporary Viennese culture is the fact that
he goes beyond the sultry, languorous atmosphere that characterizes
works of both art and literature at this time. His nudes are not the
result of a constrained sexuality trying to free itself through fantasies
of superiority or romantic escapism. They are intensely real. They do,
however, convey the overheated atmosphere of sexual awareness of
their time. Schiele's tabooless and sometimes merciless exploration of
eros is often represented with a distinct theatricality (see Figure 32).
It has its roots in a fascination with the dramatic qualities of ecstasy,
hysteria, and dance.

Schiele also takes up the topic of the child-woman, but treats it
differently. His young nudes convey the opposite of a transfigured
innocence or a mythologized preadolescent sexuality. They reveal a
corporeality viewed without illusions. Often they seem to represent
the demonic aspects of eros in youth (see Figures 28 and 30). They
are founded on a new intensity of experience that encompasses the
totality of life's qualities. It must also be kept in mind that at this time
Schiele himself was only a few years older than many of his models. In
his series of nude self-portraits he became, as it were, their partner in
investigating the body. With the nudes of his first Expressionist phase,
particularly in 1910–11, Schiele thus emerges as a radical explorer of
the issue of sexuality in art. He makes the leap from fin-de-siècle and
Jugendstil to an erotic art without pretense, from aestheticism to exis-
tentialism.

Jugendstil and Schiele: Eighty Years On

There is a certain analogy between the vanguard physical imagery of
Viennese modernism and the image of the female of today. It is no co-
incidence that the depictions of slim young nudes in the paintings and
drawings by Klimt (and to some extent by Schiele) are being sold today
by the thousand as posters. They adorn the apartments and studios
of an audience that obviously sees in these reproductions something
with which they can identify. The popular and international success of

this imagery is a phenomenon of the 1980's.[49] The roots of this success, however, are to be found in the 1960's, when the art of Vienna around 1900 began to be reevaluated in the context of a general rediscovery of Art Nouveau and Jugendstil.[50] The paintings of this era suddenly achieved new significance for a variety of reasons. One of them that is relevant to our theme is rooted in the counterculture movement of the 1960's. It was a feature of this culture that youth again became a synonym for a new and better world. It symbolized the alternative to what was seen as a corrupt social and political "establishment," and was given a voice and status by the student movement.

In the course of the next two decades, however, the messages of the revolt of youth were gradually transformed. Its symbols, having been stripped of their revolutionary impact, were adopted by a mainstream life-style. The burgeoning consumer culture readily absorbed and exploited images of a free sexuality that before had been at the core of political rebellion. This process resulted in a transformation but not in a substitution of the patriarchally oriented imagery of the body. The dominant ideal of the female body in the industrialized world since the 1960's has four main attributes: it is young, thin, and fit, and it is sexually attractive.

The female imagery of Viennese Jugendstil corresponds perfectly to this ideal (with fitness probably being less emphasized) and adds another factor to it: the girls and women in the graphic art and in the paintings of this era are very often embellished with luxurious jewelry and clothing; they exhibit sophisticated hairstyles and are often shown in extravagant settings. Present-day consumer culture thus not only identifies its physical ideal in these artworks, but is presented with it combined with the luxury products of a modern lifestyle. The explosion of the furnishings and design markets and the enormous expansion of the fashion industry turned the refined arts-and-crafts products of the Wiener Werkstätte into the putative ancestors of present "designer objects."

The consequence of all this is that a painting like Klimt's *Judith (I)* from 1901 (Figure 38), which shows a seductive, slim, and exquisitely decorated young lady (casually caressing the head of the decapitated Holofernes), often finds its way into jewelers' windows. The female body and the elements of decoration on and around it present potential purchasers with objects of desire. The most recent invention on

FIGURE 38. Gustav Klimt, *Judith (I)*, 1901. Oil. Vienna, Österreichische Galerie.

FIGURE 39. Window decoration of a perfume
shop, Vienna, 1991.

the Austrian perfume market is called Gustav Klimt—Vienne 1901; it
shows *Judith* in a miniature reproduction on the *eau de parfum* bottles
(Figure 39)! As the author was told in a scent shop, "It sells very well,
especially to tourists." A brochure, which again makes use of *Judith*,
tries to attract the potential customer by characterizing Vienne 1901 as
"the fragrance for the lady with stylish and erotic radiance who entices
with intelligence."

To a consumer-oriented, hedonist way of life, the imagery of Vien-
nese Jugendstil definitely offers more to associate with than any other
art movement of European modernism. Within nineteenth-century
painting, the adorned women in the works of the Pre-Raphaelites are
probably comparable as far as the aesthetization of the female image is
concerned, but they are too chaste and virtuous to compete with the
sensual subtlety of their later Viennese peers.[51]

In her study "Virility and Domination in Early Twentieth-Century
Vanguard Painting," Carol Duncan stressed the male voyeuristic ten-

dencies in early modern painting.[52] In particular, Duncan argued, the nudes in the art of the Fauves and of the German Expressionists affirmed male domination over the objectified, naked women, who are shown as powerless, often faceless, and passive, available flesh. Paintings of this kind, as Duncan reasoned, are based on a "sexist antihumanism" and "speak not of universal aspirations but of the fantasies and fears of middle-class men living in a changing world."[53]

Duncan did not include any Austrian artists in her article, although she would have found rich evidence for her arguments. (In 1973, when her study was first published, "Vienna 1900" had not yet been internationally recognized as a focal point of modernism.) The drawings of Alfred Kubin, for example, which stand between Symbolism and Expressionism, exhibit some of the most aggressive images of misogyny. In this respect, they correspond to Otto Weininger's philosophical bestseller among the intellectuals of his day, Sex and Character, first published in 1903. But also in the art of Gustav Klimt, "women are denied a basic power which is not associated with the use of their sexuality. . . . [They] are often devised to appeal to the male sexual appetite."[54] Kokoschka's horrifying pictures of the gender struggle in his early Expressionist work and his other images of women are more ambiguous.[55] In general, male voyeurism in imperial Vienna was at the core of its fin-de-siècle culture.

However, a study of the art of Schiele makes it clear that it cannot be seen in terms of male domination over objectified women. This is not to say that he was a fighter for women's rights, but his nudes are neither faceless nor are they presented as solely passive. His early work in particular shows his sitters and models—and especially his nudes—as inscrutable beings, ecstatic, tragic, and passionate. Although voyeurism is also at the core of Schiele's art, there is a strong subversive element in the way he presents his nudes. His art breaks through the ornamentalism of Jugendstil, and autonomy is restored to his models. Even more striking, however, is the fact that Schiele included his own body and other male nudes in his panorama of figures.[56] By comparison, there are no self-portraits by Klimt at all (except rare caricatures). Schiele unmasked not only his sitters but also himself. He subjected himself as well to the gaze of the viewer. This seems only partly to have been motivated by narcissism, because his self-portraits do not interpret his own body any differently from those of his models.

Schiele's voyeurism thus was of a different order. In place of the need to uphold male supremacy, its erotic motives were instead in-

spired by an insistent curiosity about life in all its aspects. This quality of his art is confirmed by the fact that his early portraits and nudes are able to cause uneasiness even today.

The industrialized nations' consumer culture of the 1980's has adopted the imagery of Klimt for its own purposes. In his portraits of elegant ladies, the sitters are often swamped in a mass of ornament and presented as a piece of stage decor. Paintings of this kind, Klimt's pretentious allegories and his aesthetically refined nudes, have become the popular icons of a "postmodern" decorative life-style. They reveal a lot about contemporary cultural and social attitudes. Schiele's art, although second only to Klimt's in popularity, has escaped this decorative function, at least in his early Expressionist work. His images of the body were, in their time, opposed to the ornamentalism of the Viennese Secession, just as today they do not conform to the synthetic physical ideal of the mass media. Today's idolization of youth cannot exploit the lean, attenuated, eerie figures of Schiele's early art. Such images do not exude the self-righteousness of a physical ideal bursting with health and fitness as the prerogative for social success. On the contrary, they are characterized by a heedless attitude that, then as now, refuses to be subject to a functionalist view of the body.

Egon Schiele as Representative
of an Alternative Aestheticism

Any dispute about art in Vienna, or elsewhere in Central Europe, tends to boil down in the end to the demarcation of differing aesthetic objectives that have developed in the period since 1820.[1] The opposing concepts, which continue to be irreconcilable, have remained essentially the same: abstraction versus realism, truth versus beauty, substance versus mood. This sort of dualism in cultural attitudes began to take shape in the context of the increasingly sensitive nationality question after 1820, following the Congress of Vienna—and did so quite independently of the putative claims of aesthetic theory itself; it was most markedly apparent in the realm of music. The issue then was the (from today's standpoint understandable) rebellion of German musical expression against the centuries-old tradition of forms. On the one hand, there was the phenomenon of the music consumer being offered the possibility of sinking into an intoxicated trance, thus enjoying an elevation of his mood from the mundane preoccupations of everyday life, together with an aestheticization of feeling; on the other, there was the intellectualization of the aesthetic as a constructivist measure, even in those cases where the given content appeared to call for a pathetic mode of expression.

This duality is evident in Eduard Hanslick's distinction between "pathological hearing" (that of mood) and "musical hearing" (gov-

erned by sound), a distinction that underlines that with the passage of time there were no bridges being built between the two attitudes in nineteenth-century Vienna. This process of division was given further impetus by the fact that political forces fastened onto them, and thus perpetuated their own interests through the medium of aesthetics.[2]

Thus it was that the Wagner party represented German nationalist forces: translated into the realm of aesthetics, this meant tonality, easy comprehensibility, a veneer of moral uplift, the boastful self-display of the *Ringstrasse*, the illusionary pose of the man of the world, and the nationalist sense of history; correspondingly unattractive to them was any form of cosmopolitanism, the influence of whose cross-border chameleonism was considered to be malign. The opposing tendency, operating under the aegis of the sinking star of Liberalism and impregnated with the open-mindedness of the Jewish intellectuals that had become indispensable to cultural development in Austria, clung to materiality and tried to avoid being exploited for any nonaesthetic aims. Their dogged engagement with materiality may be seen from numerous examples—Schönberg, Berg, Webern, and Mahler in the field of music; Kokoschka, Schiele, Schönberg, and Kubin in painting; Wittgenstein in philosophy; and Karl Kraus in literature. These all had one thing in common: namely, that their works were, at the time of their inception, appreciated by intellectuals only. Their success with the public, if success it can be called, began only in the late 1960's, reaching a high point in the 1980's. It is still not clear whether our appreciation of these works today reflects the original intention of the artists, or whether received interpretations of them continue to separate us from the true nature of their art. These doubts are lent particular force in the case of the music of Gustav Mahler, which achieved its huge popularity in part through its exploitation as film music, while its status as standard-bearer of various differing aesthetic viewpoints reflected an interpretative manipulation of the composer by vested interests.

With Egon Schiele, everything is much clearer. In the context of a fin de siècle still regulated by such values as reason, order, progress, and perseverance, and disciplined by conformity to the norms of good taste (practically all of which the artists of the Secession and Jugendstil never challenged), he was the artist who concentrated on reality, on the passions, on the disorder of chaos, and on sexuality.[3] Outward appearance, the aesthetic value placed on embellished facades, which

may be said to have reached its apotheosis in the architecture of the *Ringstrasse*, interested Schiele not at all.

If the spectrum of social values at the turn of the century is eclectically reflected in the individual stances of contemporary artists, the taxonomy of fin-de-siècle art that we now apply[4] may be thought of as owing much to Schiele in its individual categories. Art is never for him a sedative or a drug, and probably also never ornamentation (a point that merits further discussion); instead it is an epistemological instrument, an attitude of protest, a vehicle for innovation, a form of social argumentation. The profile of the artist may be seen as infinitely flexible, to a greater or lesser extent reflecting the requirements of any given individual; that is, neither denying such requirements nor being identified with them.

On the other hand, Schiele's works are identified with those factors that have been singled out in the literature dealing with this period as a representative of it, and that, so to speak, are felt to encapsulate the artistic impulse of the fin de siècle. These factors may be summed up in five concepts: crisis, longing, progress, potentiality, and deliverance.[5]

The crisis was certainly economically determined, but also, in the main, made manifest in the reorientation of social and political objectives: the latter now included republicanism (expressed through parliament), equality before the law (in particular, the struggle for women's suffrage), social justice, the enforced assimilation of members of the multifarious nationalities of the Habsburg empire that poured into Vienna, the decline of federalism after 1860, the urgency of the language issue, the increasing tendency to see everything in ethnocentric terms, and in particular, the precipitate growth of German nationalism.[6]

The entire Austrian intelligentsia and the art world were thrown into crisis by these phenomena, a crisis that was given contemporary expression in Schönberg's essay on Liszt of 1911.[7] Kokoschka, Kubin, and Schiele were expressing their ideas in writing; Anton Wildgans, later a well-known poet, gave up his "bourgeois" studies in jurisprudence, Robert Musil formulated a new artistic perspective (discovering, in the punning words of the critic Blass, "a new land of the soul"— "*Neuseel-Land*"); suicide was fashionable, and utopian visions supplied the ideology of an alternative world, or at least an escape from reality. But what of Schiele?

He, as it happened, had anticipated this crisis by leaving the Academy in 1909 and founding the New Artists group. Dissatisfaction with his teacher in the Academy, the history painter and portraitist Christian Griepenkerl, was no doubt a prime motivation; much more important, however, was certainly his aesthetic decision in favor of the new European avant-garde, with which he had come into contact at the Kunstschau of 1909, and whose influence may be seen in his pictures exhibited at the show of the New Artists in Gustav Pisko's gallery in December 1909. With this step, Egon Schiele committed himself to the representation of truth rather than beauty, a personal decision that was perhaps more impulsive than the ordered perspective of art history allows. Insofar as Schiele's painting is now perceived as documentary "ugliness" (although I prefer to think of his work as tending toward caricature[8]), from the moment that this characteristic became predominant, "physis" and "psyche" became inseparable in his work, as Patrick Werkner has shrewdly observed.[9] From that time on, the body was never again to be presented simply in terms of its external appearance; the contour line ceased merely to trace the surface boundaries; the pose was no longer static and stiffly academic. That he absorbed enough of the general mood in 1911 may be seen from the self-portraits, which, whether they depicted him "grimacing" or with "sunken head," go to the limits of what is possible in figurative portraiture.

This merciless treatment of himself and the transposition of the same approach to the social environment, whether he is dealing with nature, the city, women, mankind collectively, or imaginary themes, had indeed no parallel in Vienna, not in Kokoschka's work, not even in that of Schönberg.[10]

The fin de siècle's feeling of longing was deeply embedded in the recesses of the individual psyche. Naturally, there also existed collective desires, with which, however, it was not always easy for the individual to come to terms.

Prominent among such yearnings were a desire to be freed from the dead hand of convention, an increasing enthusiasm for German nationalism, and the insane belief in war as a purgative for a hopelessly decayed political structure.[11]

Schiele's particular brand of longing is expressed in terms of eros, a specific apprehension, perhaps, of nature itself. This conception was not confined to his writings—"The erotic work of art is also sacred"[12]

was his verbal formulation of it—but is even more evident in his brush-work, where eros is defined in terms of what lies beyond what is actually depicted. Thus, his work is informed by certain basic requisites—the tension between male and female, for example, and the attempt to achieve the most intimate of approaches through an insistence on the role of the ego. Just as Klimt's pictures of women have now been unmasked as objects of male fantasy,[13] or at least as projections of contemporary society's view of women, and just as German Expressionism is impregnated with atavistic sexuality, so Schiele, too, aims at the projection of something elemental, which, however, is never frozen in the momentary reality of naturalistic depiction, and never simply shows the nude as a nude; instead, it always hints at some more fundamental notion (which is usually only later made manifest). The female nude of his works speaks not only for herself, but for her social class, her societal role, her character, her femininity, and the subtle ways in which she is able to use it. One would indeed have had to have the blindness of the Austrian judiciary to censor such work as pornographic.

This yearning for something that remains to be attained is evident in Schiele's treatment of landscape and nature, as Patrick Werkner has shown. The objects depicted do not stand for themselves alone, are not simply representations of what is seen, but are rather a commentary on themselves; or even more, a commentary on their surroundings, on their relationship to what is represented, on the world itself. These forms of discourse, which reveal themselves in a multilayered composite way of seeing (and which I take to be a specific attribute of the painter's method), continually make a statement and tell a story, and are thus in no way merely the silent witnesses of what is transferred to canvas. The above-mentioned aspects of the dominant bonding forces of the day reflect the cultural constant of "gesture," which is without doubt fundamental to the history of Viennese art, but which also informed its music and literature from the Middle Ages onward.[14]

Schiele's use of gesture, however, departs radically from tradition; so much so, indeed, that one can speak of an exponential leap forward in artistic expression when one considers the artist's achievement in making gesture the expression of something deeply private, while at the same time it remains inextricably bound to the object depicted.

Progress was also an essential element of the zeitgeist, and often implied diverse forms of experimentation. At the turn of the century

it was manifest not only in the opening up of hitherto hermetically sealed circles of influence and power in favor of a mass society, and in the rage for modernization, whose effects even began to permeate the rigid bureaucracy and to make the imperial metropolis of Vienna more responsive to the needs of its citizens; but also in a deliberate breaking of ancient taboos, in the emergence of new scientific and artistic disciplines, in the expansion and liberation of scientific research, and in the access afforded to all such developments for the great mass of society.

From a superficial point of view (far too readily adopted by art historians), the breaking down of taboos might be deemed to represent the most important yardstick of progress, an interpretation that is unsupported by any statement by the artist himself or his contemporaries. The remark attributed to Schiele or Roessler[15] as a reply to the Neulengbach magistrate's outrage at his nude drawings—"Have adults all forgotten how much they themselves were corrupted, aroused, and fascinated by sex when they themselves were children?"—shows that the point of depicting sexuality was not simply to offend against accepted standards of taste, but unrepentantly to demonstrate a determination (which is to be understood as entirely natural for the artist) to concentrate on representing unvarnished reality in all genres, or at least to strive for a mercilessly truthful mode of seeing.[15] Progress, in the context of Schiele's work, is more appropriately seen as the way in which the artist removes from gesture its general application, its narrative role in the group or in the treatment of a theme, and makes it instead the motor of intimacy, of singularity, of individuality; in this way he transforms character study from something as it were imbued with tradition into a living human and psychic phenomenon.

If, as he was accused, Schiele disobeyed the classical canon of art,[16] that was not because of his treatment of the nude (which, incidentally, is perennially the most sensitive barometer of taste in art history), but because his nudes were not just naked figures; they were the proponents of a reality, conductors of impressions extending beyond the confines of the picture, the medium for a concrete idea, the conveyors of a vitality that was not fictive, but instead actualized and made manifest. It is nevertheless frustrating to have to admit that, despite various premature attempts to ascribe a worked-out symbolism to Schiele's private world of gesture, the full extent of its sphere of operation remains unfathomable. Unlike with Kubin, and perhaps also with Kokoschka,

with Schiele the gesture remains private, bound to the autonomy of the depiction, and thus, of course, a suitable vehicle for multiplicity of meaning and feeling. And of course it is always possible that in the very sympathy of feeling evoked in the viewer there is also a hidden element of resistance that inevitably pursues the course of an independent imaginative response, all the more so when and if Schiele's figures seem intransigent in their refusal to appeal for empathy. This language of gesture in Schiele is carried to such lengths that it sometimes eludes any form of concrete representation and confines itself to aesthetically formal dimensions. For example, Schiele's *Hermits* of 1912 were explicated by the painter in a letter to the collector Carl Reininghaus in the following terms: "I freely admit that for the time being you are quite right: in the big picture one does not see, at first glance, how the two are standing." Figures "are conceived of as slumped and self-absorbed . . . bodies of people weary of life, suicides, but nonetheless bodies of people with feelings. You should see the two figures as a dust cloud similar to the earth that tries to build itself up but ends by impotently falling apart." [17] What further interpretation could possibly be needed?

Potentiality was the seductive element in the world of 1900 that lent the period an air of pre-Fascist assertiveness. [18] The physical and psychological rigor in the treatment of material, whether such material happened to be physical matter or mankind itself, brought the two phenomena into the same domain. It is no accident that the investigative theories of psychoanalysis groped into the furthest corners of human existence, and that the euphoria aroused by technological conquest of the world in microcosm approached, at that time, a confidence in the imminent subjection of the entire world to the power of technology. This partially realized myth enables Vienna to be seen as "the archetype of the modern Western world," with its rationalism, scientific approach, secularism, and social mobility, and thus also as a bastion against the progressive dismantling of these enlightened values.

The opportunities for autonomous living (freedom of expression, art and science, an increase in leisure and personal decision-making, ownership of property, professional independence), and of course the disengagement from older Christian ethics and the ethic of natural law (particularly with regard to sex), together with the severing of connections with traditional ways of life (church, marriage, family), have a perceived value for the individual seeking

self-development in a strictly regulated industrial society; that value lies in the memory of the liberal atmosphere of the turn of the century, a nostalgia that supplies the missing elements of certainty and reassurance in his current existence. The Vienna of 1900 is experienced as a refined city not suffering from gigantomania; and at the same time as "our own little metropolis," the hub of Central Europe, with opportunities for material advancement, culture, tradition and innovation; and full of color, playfulness, and easy grace.[19]

Carl Schorske has already drawn attention to the depoliticization of life through aestheticism.[20] Schiele's answer to this process was the elevation of the "self." His credo written for the New Artists exhibition ("The new artist is and must unconditionally remain himself, he must be a creator, he must be able to build the foundations all by himself, without recourse to the past and tradition. . . . Every one of us must be himself"[21]) demonstrates the decisive importance of the new role of the self in the adoption of an aesthetic sharply differentiated from the norm. At the same time, there was the belief in the autonomous artist as the heroic spirit of the age, as the creative figure who is able to bring to birth a new world. Over and above this was the new dimension given by discovery of the self, the apprehension of oneself as one discrete form of prototype for humanity in general; also the radicalism of dealing with oneself in a manner applied to virtually no one else; and finally the boldness of acquiescing in the ravages of time, never softening the impact of the self. This perception of the self makes it clear that the artist is, on the one hand, master of the world that is uniquely seen by him, and on the other, a prisoner of his own way of seeing; if you will, he is the bearer of the neurosis of creativity, driven, persecuted even, by his own creative powers, at once object and subject, producer and consumer, the one who sees and at the same time is seen.

This self certainly also afforded a kind of protection to an artist who, if his own statements are to be believed, saw himself as the spiritual successor of Franz Schubert.[22] Protection was needed from the hypertrophy and failure to which the high claims of *Gesamtkunstwerk* made the artist peculiarly vulnerable; and protection, also, from the embrace of a society toward which his attitude was, at the very least, highly skeptical; and lastly, protection from arbitrary classification and categorization. This self, then, at one and the same time stood in judgment over, and was an initiate of, the privacy and legitimacy of the

psychotherapeutic claims to which artists often feel themselves to be exposed.

Schiele's self-awareness is the product of the reduction of potentiality entirely to the domain of the self, and his relatively detailed observations regarding the functioning of the art market should be understood in the light of this.[23]

The near-insatiable drive for deliverance, no doubt closely related to the mood of potentiality, grew out of the feeling current at the turn of the century that, with the conquest of the material world and the psyche apparently complete, the solution of all outstanding existential problems was in sight. Added to this was a growing recognition that the loss of religion, which had long since degenerated into a normative institution for sexual morality and into being the custodian of societal rituals such as baptism, weddings, or burials, was something with which one could relatively easily come to terms; thus, like the overweening aspirations of potentiality, the deliverance scenario also exhibits totalitarian claims of a pre-Fascist nature.

Schiele's idea of deliverance would appear to have been centered on death. "Everything is living dead" is indeed the lapidary final line of one of his poems.[24] Scholarship has unearthed the encounters with death that Schiele experienced within in his own family, and thus surmises that this experience was reflected in his art. Whatever the underlying reason, however, it is highly noticeable that from 1909 onward (or, in other words, only after he had made a clear commitment to his chosen side of the aesthetic debate), the treatment of death in his work increases and intensifies. Of course, he is not immediately entirely divorced from traditions; added to which, his discovery of the proletariat surely exercises a considerable influence. His experiences while drawing in Vienna's gynecological clinic could have been a stimulus for him to develop the death theme, and no doubt the Viennese penchant for suicide also had its effects. But it is equally imaginable that for Schiele, death appeared simply as the obverse of gesture, offering a kind of "alternative existence" in the sense of an unmapped terrain in theology; or then again (which would be more in tune with the times), perhaps he saw death in the same light as Gustav Mahler, who wrote his own apostrophization of it in the closing movement of the Second Symphony: "I shall die in order to live." This formulation could only have meant that—whatever the judgment of the world may be, how-

ever reality might appear—work and struggle are not transient; they receive their spiritual recompense, and in so doing are translated from the political reality of this world into a reality that is metaphysical.[25]

This sort of approach to Schiele's work seems the more plausible to me, at least in the case of the picture titled *Hermits* of 1912, the subjects of which have come down to us as enduring icons; but the same applies also to *Dead Mother I* and *II*, and perhaps, if in a slightly different way, to the *Self-Portrait in a Black Robe* of 1910: all of these works might reasonably be interpreted in terms of a documentation of the survival of their physical realities into future time.

At least since the Germanists' meeting at Düsseldorf in April 1976, it has been officially accepted in academic circles that creative literature is capable of illuminating social history. The elite of German studies were at that time agreed that literature itself can reflect historical reality, despite or because of its fictive character; and, indeed, that political, social, or ideological reality is not directly experiential, but is the product of a hermeneutically filtered reconstruction. At the time, the methodology of this discipline was outlined by the art historian Max Imdahl, using the example of Giotto. He pointed out how the details of a picture and the relationships between them produce a certain pattern of forces, which he characterized as analogous to the system of a "magnetic field."[26] In a similar way, I believe I have supplied one or two arguments to explain the manner in which Schiele's work adumbrates the central preoccupations of the world in 1900. At the same time, I have tried to show how his art intrinsically embodied a form of aesthetic duality that, as I see it, has dominated Central European cultural history from 1820 to the present day.

The "Obscene" in Viennese Architecture of the Early Twentieth Century

In August 1911, Egon Schiele left Vienna accompanied by his model Wally. He rented an isolated house with a garden in Neulengbach, a small village in the Vienna Woods, twenty miles west of the city. Schiele's intention, as is clear from a letter addressed to his uncle, was "to remain in Neulengbach forever." Here he intended "to bring great works to completion," but for this he needed "to work in peace," something that was "impossible in Vienna." Only here in Neulengbach did he feel himself so creatively fertile "that he must give freely of himself."[1]

Schiele's enthusiasm for Neulengbach was not reciprocated by the town's inhabitants. His reputation as a pornographer (in 1911 an exhibition of drawings by him in Prague had been closed by the police on the grounds of obscenity), the fact that he lived in sin with his model, and his invitation to the village children to come and pose for him—all these aroused the indignation and hostility of the mostly Catholic and largely peasant population of Neulengbach.

On April 13, 1912, Schiele was arrested by two village constables, who also confiscated 125 drawings. Schiele was charged with "immorality" and "seduction of a minor." During his imprisonment, which lasted nearly a month, Schiele always insisted that he was innocent

regarding the second charge, that of "seduction of a minor." At the trial, this charge was in fact dropped because the girl changed her testimony. The first charge, that of "immorality," alleged that by careless or wilful display of erotic drawings in his studio while entertaining and sketching child models, Schiele had contributed to their corruption.[2] It was indeed the case that Schiele had often been warned by his Viennese friends to be more careful about the sort of drawings he left lying around when children came to pose.

Schiele never denied having made erotic drawings and watercolors, but maintained, as one can read in an entry in his diary written during the time of his imprisonment, that "all these erotic drawings were still in every case works of art." In the end, the trial, by concentrating exclusively on the charge of producing erotic, therefore supposedly obscene drawings, became a trial of modern art in general. During it, one of Schiele's drawings was publicly burned by the judge as an act of symbolic condemnation of the artist's work as a whole. The destruction of Schiele's drawing signaled the abandonment of any rational legal process and the emergence of an irrational hatred of modern art in general.

In a period of intense sexual repression the charge of obscenity was an especially potent means of defaming works of art. Moreover, and this is the crucial fact, the accusation of obscenity was raised not only by self-appointed censors in the name of "true art," but also by the representatives of the modern movement itself, who accused the historicist art of the second half of the nineteenth century of the same excesses. Furthermore, the accusation of obscenity was used not only to defame paintings or drawings but also to defame modern architecture, as in the case of Otto Wagner and especially Adolf Loos. The charge of "obscenity" was used by Adolf Loos, for instance, to describe the architectural ornament he so hated.

As early as 1898, Loos was referred to as a "slayer of ornament,"[3] a new Saint George, as it were, out to rescue the virgin (architecture and handicrafts) from the evil dragon of ornament. He saw himself as a fearless warrior who by means of his untiring battle against ornament opens the way for mankind's cultural development. With missionary zeal he proclaims: "The path of culture leads from ornament to the abolition of ornament."[4] In his polemic, "Ornament and Crime," and elsewhere, he insists that ornament is the expression of an unbridled instinctual life. For him it is clear that "All art is erotic. The first orna-

ment ever created, the cross, was erotic in origin. . . . A horizontal line: the reclining woman. A vertical line: the man penetrating her."[5]

Loos speaks again and again of the libidinous sensuality inherent in, and proceeding from, ornament. Significantly, sensuality and libido are here spoken of as uncontrollable and therefore dangerous threats, not as liberating forces. For Loos, the content of ornament, which cannot be countered with reason, must be countered with the destruction of ornament.

Viewed superficially, Adolf Loos's theory is similar to that of Sigmund Freud. In "Ornament and Crime," Loos states that: "The evolution of culture is synonymous with the removal of ornament from everyday objects."[6] Almost at the same time Freud was writing: "Our culture is universally built upon the suppression of instincts. Sacrifice and renunciation have been progressive in the course of cultural development." And further: "Those whose unbending constitution will not allow them to go along with this suppression of instinct stand opposed to society as 'criminals,' as 'outlaws.'"[7] Compare this with Loos's verdict: "But those in our day who, from inner compulsion, smear the walls with erotic symbols (ornaments) are criminals or degenerates."[8]

The fundamental difference between the two positions lies in the fact that for Freud, instinct remains (despite the necessity for control) the essential driving force in the development of the ego, while Loos sees suppression or even absolute renunciation of instinct (which translated into the language of architecture means lack of ornament) as the one and only path to real humanity.

The vehemence with which Adolf Loos (compared with all the other artists of modernism) battles against ornament of any kind clearly betrays his acute anxiety in the face of the threat. Over and over, he makes the connection between ornament and femininity: "All objects that we call modern are unornamented . . . with the exception of the things that pertain to woman." Later on he explains: "Wherever we abuse everyday objects with ornament, we shorten their life-spans. . . . This murder of material can only be justified by the caprice and ambition of woman—for ornament in the service of woman will live forever. . . . But the ornament of woman corresponds in essence to that of savages, it has erotic significance."[9]

Femininity, sensuality, and instinct are seen by Loos as inhabiting a narrow context where ornament becomes the attribute of the mature woman and her fully developed genital sexuality. Loos confronts the

feminine (and thus ornament) with condemnation, even enmity. In his opinion, woman can develop only if she abjures ornament, and with it her own genital femininity, and renders herself equal to man through work.

As long as this is not the case, however, the "only weapon that woman presently possesses in the battle of the sexes is the ability to inspire love. Love, however, is the daughter of desire. To excite desire and yearning in man is woman's hope." This womanly appeal to the instinctive sensuality of man is projected, according to Loos, with the aid of dress and—in consequence—with the aid of ornament: "Woman is obliged to appeal to man's sensuality, and unconsciously to his morbid sensuality, by means of her dress." Hence, woman's dress differs from that of man in its "preference for ornamental and colorful effects." Only when woman achieves economic independence from man will her "worth or unworth" be independent of the sensuality projected by dress. "Then silk and satin, flowers and ribbons, feathers and colors will lose their effect. They will disappear." [10]

For Loos, lack of ornament becomes a symbol of intellectual power, and, moreover, of the victory of eros over "unnatural" sensuality. Only when sensuality ceases to abuse eros will humanity no longer be "denied its spring awakening." [11] Since for Loos the "unnatural" sensuality inherent in ornament is time and again linked with the sexuality of the mature woman, and since eros is abused by sensuality, this can only mean that the suppression of ornament is the result of suppressed sensuality and the latter's sublimation in eros. Or, to put it differently: lack of ornament is sublimated sensuality, the ascetic beauty of which can only be apprehended by those who live "at our level of culture."

Only to those who have not yet attained the height of culture, who still cannot go to hear "Beethoven or Tristan after the toil and trouble of the day," does Loos grant the right to ornament—that is, besides women, to Kaffirs, Persians, Slovakian peasants, and his shoemaker, "for all of them have no other means by which to scale the peaks of their existence." On the other hand, he declares that we, by dissociating ourselves from "those who require ornament . . . have acquired the arts that have gone beyond ornament." [12] Absence of ornament and an elitist sensibility are paired in this blueprint for an ornament-free world—which for Loos means a world without bestial sensuality.

Adolf Loos realized this utopian denial of mature female sexuality (which he propounded for the whole of society) for the first time in

his house on the Michaelerplatz—a building that provoked enraged protest (Figure 40). But this protest demonstrates only too plainly that the rationalization of the architect's unconscious intentions as expressed in this work of art was understood by others, at least subconsciously.

As in the case of Egon Schiele, the authorities intervened, stopping construction, and demanding a "real" (meaning an ornamented) facade to cover its "obscene nakedness," as the *Neue Freie Presse* reported.[13]

Contemporary criticism associated the facade of the Loos building with the naked body of a woman. Some contemporary critics even described the Loos house as the extreme expression of an intellectual perversion. In their opinion, the lack of ornament made the architecture obscenely naked, and its nakedness was particularly offensive "because even the disciples of nudism are aware of the difference between a bulky, buxom girl and an ideal, beautiful woman."[14]

Even Paul Engelmann, one of Loos's pupils, compared the facade to a naked body, although in a quite different way. In *Die Fackel*, the famous journal edited by Karl Kraus, he described the upper part of the facade as so soft and virginal that you want to kiss it, while the marble of the lower parts seemed to be naive and lustful, like a lascivious woman.[15]

For a small elite, for the "man with modern nerves" who detests ornament, the naked, smooth facade of this "house without eyebrows" —that is, without hair, and hence without secondary sex characteristics—may serve to sublimate sensuality in eros. Here, eros is defined as love of the female body in its early, childish, pubescent stage. The Loos house thus becomes the architectural incarnation of still-innocent, preadolescent nakedness, a stage of development that, as we know, fascinated not only Adolf Loos, but also Peter Altenberg and Egon Schiele—as it did, indeed, all of fin-de-siècle society. "The child-woman came into fashion," wrote Adolf Loos, who further confessed: "One yearned for immaturity."[16]

In view of the traditional nature of the surrounding noble and ecclesiastical architecture of the Michaelerplatz (the site where the house was to be built), so much nakedness, nakedness of a specific kind—in itself already "indecent, arousing, and horrifying"—was bound to be taken as especially provocative.[17] Moreover: "In his blueprints he had acted as if he would 'decorate,' but when carrying them out he was

FIGURE 40. Adolf Loos, house on the
Michaelerplatz, Vienna, 1909–11.

caught by the building authorities in flagrante delitcu, building un-
cannily smooth marble walls."[18] The display of what was supposedly
private was seen as a public insult. Loos: "My house provoked real out-
rage and the police promptly appeared at the scene. Such things might
be carried out behind closed doors, they said, but they do not belong
on the street!"—especially not in a locale seen as being "sanctified by
art, tradition, and history."[19]

Another approach to the intuitive, unconscious understanding of
an architectural symbolism that unleashes both desire and anxiety is
offered by contemporary caricatures of the building. For example, it is
represented as a sewer with its grate propped open, in front of which
stands a male figure, his back to the viewer, staring at the opening
(Figure 41). "The most Modern Man walked the streets, brooding on
Art," reads the caption; "suddenly he stopped in his tracks, having
at last found what he had long sought in vain." It was axiomatic that
pleasurable contact with immaculate purity, long a social taboo, must
be "channeled" aside as "dirt." The threat of punishment (that is, cas-
tration) via the snapping shut of the grate takes the form of a punitive
metaphor, that of prison bars. It is no accident that the Loos house was
variously called the "sewer grate" or the "prison house." In passing,
we should observe that by contrast, contemporary observers seem to
have found other modern buildings of the Viennese fin de siècle rather
more appetizing: one thinks, for example of the nickname "*Krauthappl*"
(cabbage crown) for the Secession building, or "*Lemoni-Berg*" (lemon
mountain) for the Steinhof complex, the lunatic asylum for which Otto
Wagner designed the famous Steinhof church.

The vehemence of the clash between attackers and defenders of the
Loos house, and above all the almost existential battle waged by Loos
himself, make it plain that the issue at stake was far more than an
exclusively academic discussion for and against ornament.

The Loos house is not the only example at the turn of the cen-
tury in which architecture is not only compared to a naked body
but also stigmatized as obscene. Ironically, this happened also in the
case of the architectural proposal for a new historical museum, the
so-called Kaiser-Franz-Josef-Stadtmuseum designed by Otto Wagner
(Figure 42). In no case did Otto Wagner intend, like Adolf Loos, to
create an architecture without ornament. This can be proven very
easily from his designs. What Wagner intended was to show how
the construction work was done. For this reason he did not hide the

„Los von der Architektur."
(Aus der Silvesterzeitschrift des Oesterreichischen Ingenieur- und
Architektenvereines.)

— Kunstbrütend ging der Moderaste durch die
Straßen. Plötzlich blieb er erstarrt stehen; er hatte ge-
funden, was er solange vergeblich gesucht:

(Bitte wenden!)

FIGURE 41. Caricature from *Illustriertes Wiener
Extrablatt*, January 1, 1911.

FIGURE 42. Otto Wagner, design for Kaiser-
Franz-Josef-Stadtmuseum, 1903. Vienna,
Historisches Museum der Stadt Wien.

construction behind ornament; instead, the construction became the
new ornament.

Time and again after 1900, Otto Wagner propagated his "modern
building style," namely, the encasement of the building with thin but
costly material. He argued that "the monumental effect is heightened
by the superior material, the pecuniary outlay is thus vastly reduced,
and the time needed for construction is shortened to a regular, normal,
and desirable span."[20] Accordingly, the architect encased the museum
with thin marble slabs, a technique he adopted at about the same time
for his Postsparkasse and Steinhof church, all quite conventional brick
buildings in themselves. This, he maintains, allows the achievement
of a higher degree of monumentality in only three years' construction

time, whereas some of the monumental buildings of the Ringstrasse took more than ten years to build. In an era in which the "time is money" principle, clearly recognized by Wagner, began to play an ever-increasing role in the construction business, this seemed in his eyes to be "advantage enough to . . . recommend the modern building style."

In order to place added emphasis on the encasement per se, as well as on the means of fastening, Wagner allowed the "anchoring" of the slabs—metal bolts with aluminium heads in the case of the Post-sparkasse and Steinhof church, gilded bolts in the museum plans—to remain visible. However, the slabs are glued to the wall, and thus need no further anchoring: the "nails" are purely decorative, and thus only ostensibly justified as functional ornaments. The goal is not actually the visualization of the structure per se, but of what reminds us of it. For all time to come, the economical, time-saving aspect of the chosen structure is meant to manifest itself. The task of the bolts is to point out to the viewer the novelty of the encasement (namely, the slabs), to make it prominent and "eternal."

For Wagner, the architecture fit for the new age arose exclusively out of the visualization of successful solutions to those problems that "necessity" seemed to pose. The elevation of necessity to the realm of symbol is made to guarantee the work's artistic value. In this respect, "the oft-repeated aesthetic law that true architecture can arise only from the essence of the object" is fulfilled.

The modern, economic, and utilitarian nature of the construction should be emphasized. Being aware (as he wrote) that most people do not admire iron as a visible construction material, especially for monumental public buildings, it was his aim to convince them with his artistic ideas how to use it in an aesthetic and monumental manner. All construction parts should be done by handicraft, then painted and overpainted, and finally small pieces of aluminum and gilded bronze should be added.

In Wagner's opinion, done in that way, the main staircase of the historical museum (Figure 43) would become very elegant and impressive. But the Viennese critics totally disagreed. They compared the iron construction to warehouses and department stores (especially those of Paris). The critics finally came to the conclusion that such an architecture is not of sufficient artistic worth to be adopted for a museum.[21]

FIGURE 43. Otto Wagner, design for Kaiser-
Franz-Josef-Stadtmuseum, 1902. From *Der
Architekt* 8 (1902), plate 65A.

Many articles in the press also made critical comments on the idea of using gold to emphasize the construction parts. Although gold had been used for centuries to ennoble architecture, its ennobling power was now vigorously denied. "Gilded parapets, gilded hand-rails, gilded balconies, gilded window frames, an Oriental superfluity of this material, which is usually so prized. All is sparkling, flaming, glittering, and gleaming, as if Vienna had suddenly become the town of multimillionaires." [22]

Going to the heart of the matter, one of the critics wrote: "Nobody should say that if there is too much gold you can reduce it, you can take all of it away," for "if you should try this, the result will be a rather poor skeleton without any monumental presence, a too-intimate, naked wall with many holes—and nakedness is the anti-aesthetic enemy of the whole world." [23] Here again you find the claim that nakedness is the enemy of the aesthetic.

Gold as used by Otto Wagner, as ennoblement of the construction material, takes the place of common ornament, which is always only a metaphor, something added to the construction to ennoble the result, and not the construction itself. Gold covers the construction, but does not hide it. Gold becomes the second skin. That is the reason why the critic quoted above could claim that if you took away the gold, only nakedness with many holes would remain as a meager skeleton, as an eyesore, as ugliness itself. Architecture without conventional decor was considered at the turn of the century to be a body without clothes, a nakedness that had to be hidden.

The obscenity of such an architectural concept in the eyes of contemporary critics is highlighted in the following characterization of Wagner's design: "For any other purpose this kind of architecture would be more appropriate, and most appropriate of all for an amusement palace, where there's non-stop entertainment, where musicians are always playing, and the music is seductive . . . a dance hall beside the church perhaps [the Karlskirche is next to the building plot]." And further: "Churches often had much worse neighbors in history, and the *'lustige Volk'* [merry-making populace] were only required to be silent when the bells of the church were ringing." [24] There can be no doubt about what this paraphrase of Wagner's architecture is really describing, namely, a brothel. Thus, the architecture of Otto Wagner was also proclaimed—like the architecture of Adolf Loos—to be an architecture of obscenity.

Egon Schiele and Arnold
Schönberg: The Cultural
Politics of Aesthetic
Innovation in Vienna,
1890–1918

This comparison of Arnold Schönberg and Egon Schiele is intended
as a modest provocation. It has four objectives: (1) to locate more
precisely parallels in the character and development of painting and
music in Vienna around the turn of the century; (2) to refine the
methodology by which one seeks to explain shifts in aesthetic practice
and values within biographical frameworks and within the develop-
ment of art and music in a particular historical environment; (3) to
sketch a differentiated interpretation of fin-de-siècle Vienna, particu-
larly with respect to the place, reception, and function of aesthetic
activity within society, culture, and politics; and (4) to suggest, from
the perspective of the late twentieth century—an era of so-called post-
modernism—what might have been (and perhaps remains) the sig-
nificance of the divergent elements in the Viennese fin de siècle for the
history of twentieth-century music and painting.[1]

There is little evidence that Schiele, in contrast to Gustav Klimt, Max
Oppenheimer, or (outside Vienna) painters such as Paul Klee, Vassily
Kandinsky, and Henri Matisse, had a profound interest in music as a
parallel aesthetic medium. Yet Schiele knew Schönberg. He produced
a poster for Schönberg's 1910 concert, and sketched (in watercolor) the
composer as well as his pupil Anton von Webern in 1917. In 1906, the
year Schiele entered the Academy of Fine Arts, Schönberg, who was

sixteen years older, was already established as a figure of the avant-garde. Eleven years later, when Schiele began work on his Schönberg portrait, he was as well known as his subject, if not more successful outside Vienna.

The biographical contrasts between the two are considerable. Schönberg was born in Vienna into a decidedly modest, middle-class Jewish home. Both his parents were born outside the Austro-German linguistic and cultural provinces (narrowly defined) of the Habsburg empire. Schönberg never attended secondary school and was self-taught as composer, painter, and writer. Only Richard Wagner's career can be compared to Schönberg's as an example of an outsider triumphing over the reigning networks of professional training and advancement. Neither Wagner nor Schönberg had parents who were professional musicians. Neither experienced formal training or recognition as talents at an early age by the central institutions or personalities of their communities. It may very well have been this unconventional path and the subjective (and perhaps defensive) sense of exclusion that fueled in both Wagner and Schönberg an obsessive ambition to achieve historical recognition as revolutionaries, as founders of new movements based on a more profound understanding of history and tradition than displayed by mainstream contemporaries. Johannes Brahms, Gustav Mahler, Alexander Zemlinsky, and Richard Strauss all demonstrate opposite and more common career patterns.

Although several composers, including Wagner, made reputations as writers (for example, Robert Schumann and Hector Berlioz), few were serious painters as well. Only Felix Mendelssohn possessed something comparable to Schönberg's talent in the visual arts. Despite Schönberg's dismissal of his own work as a painter as that of an "amateur," he produced an impressive output between the years 1908 and 1912. He exhibited publicly, sold his work, and attracted the praise and attention of important visual artists. Richard Gerstl was the major substantive and biographical influence on Schönberg's visual work. Gerstl committed suicide in 1908, before Schönberg began to paint in earnest. Although Schiele could have seen Schönberg's paintings, it is unlikely that he would have known Gerstl's. After Gerstl's death, when Schönberg started painting seriously, he was already infamous as a major local figure in "modern" music. When the Vereinigung schaffender Tonkünstler was founded in 1904, Schönberg was its leader. His reputation as a modern before 1910, unlike that of an older contemporary, Richard Strauss, was possessed of little that could be considered af-

fectionate. Schönberg was considered at best a talented extremist.[2] For most critics, his music was not merely ugly, but an arrogant affront to the cultivated musical sensibilities of the Viennese audience.[3]

Schiele, in contrast, was born not in but near Vienna, in Tulln, to an Austrian Catholic family of stolid, middle-class, upper-echelon railway employees. His talent was recognized early. Despite some family resistance, he attended the key professional art school of Vienna. He remained for three years. By the time he left in 1909, the nineteen-year-old had attracted the attention of both Klimt and Josef Hoffmann. In 1908 three Schiele paintings made it into the Kunstschau exhibition. Furthermore, Schiele benefited from a reasonably stable pattern of external support and patronage throughout his short career, despite public scandals and imprisonment. Schiele's notoriety stemmed less from the formal innovations of his art and more from its explicit imagery—its suspect moral character and susceptibility to being labeled as pornography. Unlike Schönberg, who left for Berlin twice before World War I, Schiele never felt compelled to leave Vienna or its immediate environs.

Whatever controversy attended Schiele's art circa 1914 differed from the public debate in Vienna associated with Klimt ten and fifteen years earlier. Klimt had sparked discussion about the public function of art as well as issues of style, iconography, and philosophy.[4] One result of those conflicts was that Klimt and his Secession associates managed to cultivate substantial critical and commercial success in Vienna, even by the time the Olbrich Secession building was dedicated in 1898. The attack by Klimt and his colleagues on an established art community had generated quickly its mirror image, an elite audience and adequate private patronage for new art and design. The objections in Schiele's case between 1910 and 1914 were less about novel aesthetic strategies than about the detailed illustration of sexuality (much of it directly imitative of Klimt); more about personality (e.g., coy self-depiction) and personal conduct than about any provocation tied particularly to the mediating power of painting. In fact, success and recognition within the new public for so-called modern art never entirely eluded Schiele. If Schönberg sought to chart a path different from Mahler's, Schiele followed—with precocious and virtuosic painterly brilliance—a successful formula that had developed out of the controversies Klimt engendered at the end of the century.

What makes the two careers so different, of course, is the brevity of Schiele's. He died in the postwar influenza epidemic in 1918. As

the shifts in Schönberg's career will make plain, it is interesting to speculate on the directions Schiele's work might have taken. At the stage of aesthetic development comparable to Schiele's when he died, Schönberg had made a shift to his "second" period. This second period (1907–1917), which coincided with the last years of Schiele's work, included Schönberg's brief turn to painting as well as his eventual return to an exclusive concentration on musical composition and his foray into so-called "atonality." By 1915 another transition was already under way, one that would lead to the method of composition with twelve tones, which was to dominate Schönberg's work in the 1920's and after.

Schönberg's second period, which began already with the Op. 9 Chamber Symphony and the Two Ballades Op. 12 and ended with the drama *Die Glückliche Hand*, Op. 18 from 1913, concluded with a decline in published or performed artistic productivity. Between 1917 and 1922 Schönberg was at work on *Jacob's Ladder*, which he never completed. *Jacob's Ladder* revealed the development of a compositional strategy that utilized pitch in a manner that focused on interrelationships from an exclusively contrapuntal perspective. In *Jacob's Ladder* Schönberg created a preliminary model for the later twelve-tone method. The design of that method completed Schönberg's self-conscious struggle to fashion a final break with the conventions associated with late nineteenth-century romanticism.

With the writing of the Five Piano Pieces Op. 23, the Serenade Op. 24, and the Suite for Piano Op. 25 during the early 1920's, Schönberg generated a truly contemporary, new, and original approach to musical form, one that he regarded as simultaneously contemporary and classical. Schönberg's modernist revolution was, so to speak, a jump over the clichés and habits of nineteenth-century composition and musical apperception that had evolved since the death of Beethoven. For Schönberg, a contemporary reassertion of compositional and musical values overtly evident in Bach and Mozart and buried in the interior of Brahms's music was at stake. Although the differences in strategy, technique, and vocabulary between Schönberg's third period and his earlier two were decisive, his very late works from the 1940's (and perhaps also the music of the 1920's and 1930's)—the Violin Piano Fantasy Op. 47, the Trio Op. 45, *The Survivor from Warsaw* Op. 46, and the *Ode to Napoleon* Op. 41—all share common rhetorical and expressive features with earlier compositions. Likewise the music of

the second period—although decidedly more radical and iconoclastic than that of his first period, which had derived from the music of Mahler and Strauss—can also be regarded as a continuous outgrowth of earlier developments.

For the purposes of the Schiele-Schönberg contrast, the first two phases of Schönberg's development are of greatest interest. During the first period, the late romantic phase inspired by what in the 1890's was the "modern" movement—the work of Strauss and Mahler—Schönberg sought to integrate classical techniques such as developing variation into the programmatic and gestural conventions associated with the lush and grand works of Mahler and Strauss. Schönberg mirrored the influence of his mentor Alexander von Zemlinsky. Schönberg's second period can be considered his "Expressionist" phase.

However, despite these characterizations, the division between stages is clearly never neat. Crucial underlying themes and strands remain evident throughout the career. In 1910 Schönberg referred to his *Gurrelieder*, written in 1900, as part of a "bygone aesthetic" (that of his first period), whose restrictions he had already broken in pursuit of an intentional path of progressive innovation.[5] Yet, as Jan Maegaard has noted, during those years Schönberg was planning a four-part oratorio (of which *Jacob's Ladder* was to be the last section) inspired by Mahler's Eighth Symphony and devoted to the struggle for religious faith in the modern age.[6]

This recapitulation of Schönberg's aesthetic evolution provides the frame of reference for the comparison with Schiele. Schiele's first decisive influence, apart from the academic work he produced as a student, was Gustav Klimt. Insofar as Klimt possessed an analogue within the musical world of Vienna, it was Mahler. Klimt and Mahler collaborated in 1902 on the opening of the famous Beethoven exhibit at the Secession, which featured Max Klinger's statue and Klimt's now-famous friezes. Conservative Viennese critics (for example, Robert Hirschfeld and the great theorist Heinrich Schenker) and sympathetic observers readily linked Mahler with Klimt and the Secession, as well as with the Wiener Werkstätte. This was apt enough, given the collaboration between Mahler and Alfred Roller at the Vienna Opera.

From a negative critical perspective, the music of Mahler, like the art of Klimt, was excessively cluttered and decorative—designed for sensual effect. It possessed a seductive linearity. It did not derive from rigorous formal integrity. The imagery (metaphorically speaking, in

Mahler's case) was deemed psychologically deviant or excessively erotic; the use of materials overly rich and indulgent. Logic in art was sacrificed to a seemingly formless embrace of the *Gesamtkunstwerk*, to a pathological focus on gesture, the psychic interior, the mystical and symbolic. Despite Mahler's disavowal of programmatic intentions (even in the use of cowbells in the Sixth Symphony), the critical community linked his music with the coloristic, grandiose, elaborate, and illustrative dreamlike post-Wagnerian narrative visible in new fin-de-siècle painting. The unique aesthetic properties of instrumental music were subordinated to complex attempts at extra-musical illustration and representation.

This criticism did not come exclusively from so-called conservatives who attacked Jugendstil and the Secession by using "modern" as a reflexive pejorative. Certainly many contemporary Viennese critics might be characterized as reactionary defenders of an historicist aesthetic canon; as fearful of any element of social and cultural criticism within contemporary aesthetic movements. But so-called radical conservatives such as Karl Kraus also had little use for the Secession and the writers of Jung-Wien. Kraus (and Adolf Loos and Otto Weininger) was as much in search of a new modern sea change in the aesthetics of literature, painting, and music as Klimt and his admirers and followers. Not surprisingly, Kraus's defense of Mahler was lukewarm, based less on aesthetic grounds than on cultural politics in Vienna. It rested on a choice among the lesser of evils. The reactionary elements of Vienna (including anti-Semites) and the hypocritical, self-important journalistic community who took it on themselves to pen overblown, critical prose against Mahler in Vienna's dailies were far worse than Mahler, whose aesthetic integrity and talent were beyond doubt. Kraus and his friend Loos defended Mahler not for his aesthetic achievement (about which they had doubts) but for his role as a symbol against mindless and stultifying reaction.[7]

However, as the controversies surrounding both Mahler and Klimt before 1906 demonstrate, two competing trends within fin-de-siècle Viennese modernism had become apparent by the time Schiele arrived in Vienna. The tension was not between reactionaries and progressives, but between two groups within modernism itself, competing over the direction a truly "modern" art should take. One group—including Kraus, Adolf Loos, and Heinrich Schenker—criticized the facile historicism and bourgeois tastes of the late nineteenth-century

urban audience for high culture as corrupt. Yet they also regarded much of Jugendstil, the Secession (including Klimt), and writers such as Hermann Bahr and Arthur Schnitzler (despite the latter's evidently superior talent) to be a false movement of opposition. These critics believed that the "new" generation of artists simply extended an empty and narcissistic aestheticism. As they saw it, the "opposition" merely celebrated decoration and ornament and threw themselves into a race for fame and material success that deprived art of its necessary function as an instrument of philosophical and cultural critique. Far from rebelling against the past or its premises and systems of patronage and fame—they charged—the "new" artists manipulated the status quo and displayed new "styles" much the way a fashion designer would. In the name of a "new" movement, they conspired with an extension of late nineteenth-century aesthetics masked by clever schemes of journalistic self-promotion, criticism, and the selling and buying of art. The "moderns" associated with Kraus and Loos continued a tradition of criticism against their contemporaries that Richard Wagner had cultivated. They attacked aestheticism and the reigning network of criticism and commerce in art.

Kraus, Otto Weininger, and Loos were certainly the key figures in this divergent direction in fin-de-siècle Viennese modernism. Their essential objective was to strip art of a philosophical narcissisim and to reaffirm art as a redemptive project. That project was ultimately ethical. Art needed to exert a purifying influence on a corrupt culture. Language—painting, literature with respect to journalism, and music—demanded rescue from abuse, hypocritical misuse, and the excessive concern for exterior appearances. Loos's 1908 argument in "Ornament and Crime" was perhaps the major statement of this position.[8] From a somewhat different but complementary direction, the socialist writer and Viennese critic David Josef Bach, a key contributor to the socialist daily the *Arbeiter Zeitung* (and an early influence on Schönberg), also argued on behalf of a socially redeeming agenda for modernist art.[9] In Arnold Schönberg's later terminology, the battle within the new movements of art was between "style" and "idea."

In this context, the aesthetics of *Ver Sacrum* and Klimt and his colleagues were suspect. The work of Kokoschka and other Austrian Expressionists after the 1908 Kunstschau exhibition went further toward the Kraus-Loos axis, as would the music of Arnold Schönberg's second and third periods. One can even integrate the early work of Ludwig

Wittgenstein into this grouping. It was no accident that Kraus, Wittgenstein, and Schönberg retained a deep admiration for two seemingly disparate figures—one contemporary, Otto Weininger, and one historical, Johann Nestroy—both of whose work argued for the radical ethical project within the arts. From the perspective of Kraus and Loos, the realization of that project demanded radical innovation not only in the ends but in the means of making art.

Schönberg was profoundly influenced by Kraus, Loos, and Weininger. By the early 1900's, at the end of his first period, he had become committed to a social and cultural project within his work as a composer. Aestheticism was replaced by a desire to purify not only art qua art, but also the all-too comfortable habits by which the audience listened and appropriated music. Schönberg sought to challenge the essential basis on which the much-expanded audience of the late nineteenth and early twentieth centuries approached, integrated, and judged music. For Schönberg, however, Mahler was squarely on the right side, even though his aesthetic strategies would eventually be considered by Schönberg as inadequate. It was Mahler's ethical character, the courage and honesty of his creative personality, that most appealed to Schönberg.[10]

As his 1911 *Harmonielehre* (dedicated to Mahler) revealed, Schönberg accepted the Wagnerian premise of a progressive historical development in the arts. A true art had to be new and different, and correspond to historical change and progress. Schönberg's oft-quoted phrase "the emancipation of the dissonance" reused the ethically loaded linguistic convention deriving from a theory in which political progress in history is measured by the category of freedom. As he noted when he discussed his 1906 Chamber Symphony Op. 9, what had been adequate for Bruckner and Mahler was no longer adequate for a new generation and new conditions. In the spirit of Otto Weininger, the criteria of adequacy were not purely aesthetic (e.g., formal and musical) but rather ethical and cultural as well.[11] Likewise, the "emancipation" from convention had to take place not merely within the text but in the hearts and minds of listeners.

Within this framework one can take a closer look at the evolution of Schönberg's and Schiele's work. After 1906, Schönberg began to write and reflect theoretically on his own compositional practice. He also turned to painting. In his painting, the starting point was a Viennese tradition of portraiture evident in Makart and Romako, as well as the

examples of self-portraiture from the French Impressionist movement. Schönberg sought to take the self-portrait a step further. He focused almost exclusively on an exploration of faces and figures, decontextual- ized from externally readable backgrounds. Within the many full-face Schönberg self-portraits, the key idea is that of vision. The process of seeing—with the eyes evoking not only the self and its interior struggle but the confrontation with the viewer (who becomes an analogue of the musical audience as well as the external reality absent from the image)—becomes, in a nearly ascetic manner, the all-encompassing focus of the canvas.

Despite similarities to Gerstl and Kokoschka, Schönberg's form of Expressionism centered on the transformation of interior vision. Schönberg dispensed with real space, movement, and moment. The single-minded focus on vision and sight led him eventually toward a more abstract and idealist tendency, away from a certain dynamic and extroverted trend in Expressionism followed particularly by Ko- koschka. Schönberg's affinity for the *Blaue Reiter* group and for Kan- dinsky in particular stemmed from Schönberg's formal interest in color and the spiritual aspect of painting, defined in terms of the employ- ment of the static elements of painting, not the depiction of movement. Unlike Schiele, Schönberg's painting owed little to Klimt.

Schönberg's interest in the so-called spiritual and in the symbolic meanings of color, as apparent in Kandinsky's work, was more than a distillation of the Expressionist impetus in Viennese portraiture. Schönberg's abstraction of painterly techniques associated with con- temporary Viennese Expressionism ran parallel with his musical inno- vations in the use of "tone colors" (*Klangfarben*) in the Five Pieces for Orchestra Op. 16 from 1909 and his extensions of timbre and pitch relations in *Pierrot Lunaire* (1912) Op. 21, including the introduction of *Sprechstimme*. Unlike Schiele, Schönberg, even in these works, was consciously obsessed with the interior logic of construction. In *Pier- rot*, Schönberg put into place his theory of the relationship between text and music, articulated in 1912, which deviated not only from the practice he had employed in the Expressionist *Erwartung* (1909), but which argued against an illustrative correspondence between words and music and for a rather more abstract and spiritual parallelism based on a shared formal gestalt.[12]

Erwartung and *Die Glückliche Hand* mark the apogee of Schönberg's musical Expressionist phase. Despite differences in structure, the use

of space, text, conceptions of reality, time and narrative content, and symbolism, these works both involved explicit content that deals with the subjective, the predicaments of sexuality and death. Despite the intensity of these two works and the close integration of music, text, and the visual, they stand in some contrast to the Klimt-Schiele tradition. They are not decorative, and they contain decisive aspects of formal and technical innovation more comparable to Loos's modernism in architecture and design.[13]

However, the most significant dimension of these works is that their completion coincided with Schönberg's explicit abandonment of Expressionism. Insofar as Schönberg's work could be linked to Viennese Jugendstil and Expressionism, his music and painting in the years 1907–1913 evolved gradually toward a rejection of Expressionism and toward finding a purely formalist musical means to redeem thought in art, and to apply that thought to the ethical-cultural project. In 1917 Schönberg began to search for a wholly novel mode of composition, not for purely aesthetic purposes but to fashion a language of art that would be adequate to the larger philosophical, political, and moral project. The innovative music of the 1920's employed a strategy of musical composition whose "truthfulness" could only be measured by its adequacy to aesthetic and ethical demands—as evident in *Moses und Aron* and subsequent works from the 1930's and 1940's.

Turning to Schiele, one immediately can see points of difference. After 1909, Schiele's works were characterized by a growing fascination with gesture and sexuality. Portrait and self-portrait dominate Schiele's work before 1914. The focus is less on the face and the eyes than on the vector of the body in space and the density and action of the figure. Movement and a defined moment, compositionally framed, emerge from the canvas. Specificity, not abstraction, is achieved. Characterization of the subject and the almost confrontational stylized relationship of narrative and imagery to viewer dominate over an exploration of interior sensibility and the nonobjective possibilities of color and line in space. The relationship of foreground to background still owes much to the Klimt model. The influence of Klimt with regard to color and pattern remains apparent in Schiele's integration of the canvas and frame into one compositional entity.

What contrasts most of Schiele's work from 1910 to 1914 with the parallel developments in Schönberg's is the absence of a radical critical engagement with issues concerning the function of art. Schiele reveled

in a scandalous use of sexuality. He toyed with, and manipulated, the well-known Viennese taste for pornography and eroticism. Depictions of genitalia, sexual poses, and masturbation are devoid of a critical dimension associated with the critique of Kraus and Loos. Schiele's pictures exploit the fact of mere shock. They play with and ultimately profit from the most superficial level of ambivalence and hypocrisy regarding sexuality and intimacy on the part of the audience. Narcissism and a coy attitude toward candor, rather than interior distress and angst (as in Kokoschka and Gerstl), emerge.

The difference between the public outcry and scandals created by Schönberg's music in 1908, 1909, and 1913 and those linked to Schiele's drawing and painting lies in the absence of an ethical or politically critical moment in Schiele's work. Schiele sought and gained a familiar sort of Viennese notoriety that translated rapidly into financial and critical success. The essential assumptions behind the patronage, viewing, and collecting of art—as well as the bourgeois public's obsession with sexuality—were never challenged. Schiele's stance toward sexuality before 1914 lacks the radical interpretive element evident in Weininger, Kraus, and certainly Freud. (Schiele, in terms of the local Viennese context, can be considered comparable to that Viennese fin-de-siècle figure Peter Altenberg with respect to Altenberg's self-indulgent sexual voyeurism. Kraus's, Alban Berg's, and Loos's admiration for Altenberg does not obscure the relative superficiality of Altenberg's eroticism when it is compared, for example, to Schnitzler's or Frank Wedekind's.) Schiele's route to success was to push forward the unmasking of bourgeois voyeurism by visually satisfying its fantasies.

By contrast, Schönberg, although as egotistical and vain a personality as Schiele, had begun, by the middle of his first period, to explicitly challenge the post-Wagnerian habits of hearing and listening by which even so-called "moderns" such as Strauss and Mahler had succeeded. In 1909 he took comfort in the idea that he outraged the audience by questioning their basic capacity for musical apperception. Schönberg sought to undermine the comfortable assumptions of competence and understanding on the part of the audience.[14] A Kraus-like challenge to the means, function, commerce, and purpose of art were lacking in the early Schiele. Despite its provocative surface, even a dialectically unstable attack on established psychic patterns and traditional criteria of judgement is hard to infer in his early work.

Yet similarities exist between Schiele's pre-war work and Schön-

berg's early compositions. Indeed, *Verklärte Nacht* (1899) and *Pelleas and Melisande* (1903) extended an inherited pattern much the way Schiele's early portraits did. In Schiele's early nonfigurative paintings, nascent aspects of innovation were visible, just as they were in Schönberg's early work. For example, *The Bridge* (1913) and *Autumn Tree* (1912), when considered alongside the 1914 *Facade with Windows*, point to formal explorations of space and texture that transcend the almost clichéd extension of figure and face in Schiele's portraiture. One can detect, further, a shift in Schiele's aesthetic agenda beginning in 1914, even in his portraits.

Both Schönberg and Schiele experienced crises in their personal and professional lives that intersected (not necessarily causally) with their work. The difficulties Schönberg experienced in his first marriage, the departure to America and death of Mahler (his key advocate), his perennial economic concerns, his acquisition of a coterie of brilliant and devoted pupils, and later, in the early 1920's, his explicit engagement with the Jewish question need to be taken into consideration when one seeks to illuminate the evolution of the work. In Schiele's case, the war and his marriage to Edith Harms were equally decisive. In the *Embrace* (1915), *Blind Mother* (1914), and the two 1915 canvases dealing with mothers and children, a new aesthetic ambition is perceptible. The focus shifts from autoerotic and narcissistic imagery— the single figure—to groups and narratives of interaction. Sexuality is supplanted by an exploration of intimacy. Even in the pictures of Russian soldiers from 1915 this change is visible in Schiele's concentration on painting the interior of facial expressivity.

This second phase of Schiele's work, which began after 1914, represented the introduction of a new level of complexity in the meaning of the subject matter that spurred painterly experimentation. The figures on the canvas assume a psychological subtlety in their relation to the viewer—the audience—and also to other figures on the canvas. Gone is the provocative directness of the earlier portraits. Loneliness, connection, abandonment, affection, and need—social dimensions of sexuality—are brought forward without cynicism, sentimentality, or facile polemic. The result is no longer, as in the early work, merely virtuosic, theatrical, or alluring. At stake is more than painterly facility and ornamental experimentation. The work is arresting in what it suggests about the human condition. The changes in Schiele's work from the years of the First World War can be compared to the transforma-

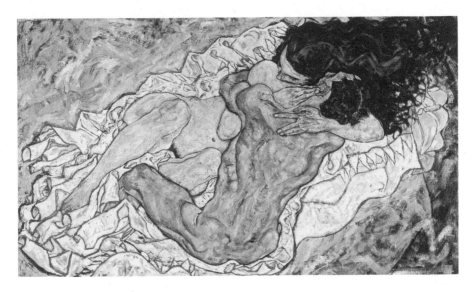

FIGURE 44. Egon Schiele, *Embrace (Lovers II)*,
1917. Oil. Vienna, Österreichische Galerie.

tion in the use of language and the concomitant deepening of the use
of satire and humor in the plays of Ödön von Horvath.

Not surprisingly, the works from 1914 to 1918, particularly those of
1917 and 1918, display key formal and technical innovations. Gone is
the facile, linear, decorative outline or the almost arbitrary schematic
integration of subject and background. Paint is applied in a dynamic
manner. There is a new, unstable intensity evident in application of
paint. The color use deviates from the palette of Klimt to a darker
and less conventional use of color contrast. The gestures of the figures
become intensely economical. A contemplative stress on the geomet-
rical logic of the frame of the canvas strikes the viewer. Composition
and structure transform and dominate mere narrative representation.
Death and the Maiden (1915) and *Embrace* (1917, Figure 44) are examples
of how a new project for the artist becomes manifest. Aesthetic de-
vices and imagery achieve a tense equilibrium. Within that equilib-
rium, however, a critical sensibility is transmitted. An ethical exchange
heretofore absent from Schiele emerges from the making of art.

The last phase of this development—one cut short by Schiele's

death—can be seen in the portraits of Hugo Koller, Paris von Güter-
sloh, Guido Arnot, Schiele's wife, and above all in the paintings *The
Family* and *Two Squatting Women*, all from 1918 (Figure 45). These are
perhaps Schiele's greatest works. An intense but calm concentration
is evident, a restraint in gesture and an economy of depicted move-
ment. To use Schönberg's terminology, the idea triumphs over the
self-conscious search for style. The decorative aestheticism and the
provocative surface evident before 1915 have disappeared. Schiele
does retain the Klimt-like sensibility of the integrated canvas in which
composition, use of color, and painterly surface create a unified, seam-
less work.

The paintings from 1918 transcended the distinction between the
means of depiction (style) and the meaning of the work (susceptible
to translation into words—the idea) by offering an entirely novel and
critical dimension of how art "represents" reality. Aesthetic transmu-
tation through painterly means and the integration of subjective per-
ceptions by the artist join, in Schiele's last works, with otherwise easily
"read" images to generate a critical discomfort. Unlike Schönberg,
Schiele used the readily recognizable surface of the canvas to under-
mine ease of apperception within the canvas itself. (In the music of
the second period, Schönberg sought to destroy the analogous dimen-
sions of pictorial realism, the immediate recognizability on the part of
the audience of melodic and harmonic grammar.) But a Schönberg-
like aspect of ethical and cultural critique entered the mature Schiele.
The poster for the 49th Secession exhibition—again a composition of a
group of figures—transmits, through formal artistic means, an insight
into the psychological and social dimensions of existence. Representa-
tion, through Expressionist abstraction of forms, transcends the purely
subjective and psychological drama in Schiele's early work. A recipro-
cal relationship emerges from tension between composition and sub-
ject matter. This dialectic represented a level of structural and coloristic
innovation that pointed toward a modernist emancipation from the
decorative and ornamental aspects of Jugendstil and Klimt's work.

Whether Schiele, like Schönberg, would have gone on beyond this
stage of mature Expressionism in the direction of a radical modern-
ist break (driven, as was Schönberg, by the lure of austere classicism
and also by a desire to break free decisively from representation and
abstraction to a decidedly modern idiom) is clearly speculative. What
might be argued, as a result of this Schönberg-Schiele comparison, is

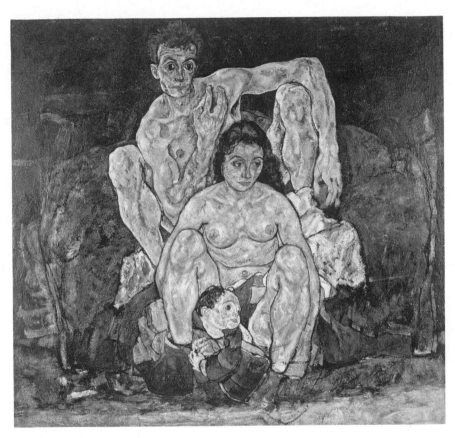

FIGURE 45. Egon Schiele, *The Family*
(*Squatting Couple*), 1918. Oil. Vienna,
Österreichische Galerie.

that Schiele's work never was significantly influenced by fin-de-siècle, pre-war, ethicist, modernist opposition. His work, until 1915, was instead more conciliatory, if not reactionary. It exploited and therefore accepted the terms inherited from the nineteenth century and the Secession regarding the function of art. Schiele masterfully used his notoriety as enfant terrible to achieve a reputation among collectors. Self and sexuality were absorbed uncritically as means to a successful career as craftsman—as producer of art works that could ensure him fame and a place "in the museums of the world." The reformist dimension of modernism within the later work—the critical aspect—developed out of the First World War, rather than from critical, modernist intellectual movements of fin-de-siècle Vienna.

Despite the ease with which we can associate Schiele with the Vienna of Freud and Wittgenstein, there was less radicalism or novelty in his work. The Viennese crucible in which aesthetic tradition, political and cultural change, and the dilemmas and unanswered questions of contemporary existence and meaning were thrown together did not, in Schiele's case, generate the sort of novel transformation we can legitimately associate with Schönberg. Unlike Freud, Wittgenstein, or Schönberg, Schiele never reached the stage of development that forced him to challenge fundamentally the materials, techniques, and consequences of inherited nineteenth-century traditions. Despite the undeniable greatness of his work, Schiele did not contribute fundamentally to the modernist discourse of the twentieth century. To some degree his achievement, except for the very last works, remained local, provincially Viennese. Unlike those figures whose names are frequently invoked alongside his, an intense engagement with the world of fin-de-siècle Vienna did not impel him to transcend its assumptions. Rather, the grim and profound pan-European consequences of World War I, as experienced within Vienna, inspired Schiele toward radical modernism.

In the arts, it was the Kraus-Loos-Schönberg Viennese axis, not the Klimt-Schiele and Jung Wien axis, that left the most revolutionary and critical legacy to the twentieth century. If Schönberg was decisive for the modernism of the mid-twentieth century—from the late 1940's to the early 1970's—Schiele's inherent conservatism and early aestheticism has led to an understandable revival of interest in him since the mid-1970's. If Schönberg was crucial for the work of Pierre Boulez, Elliot Carter, Roger Sessions, and John Cage (in clearly contrasting

ways), Schiele can be considered an important precursor, if not in-
fluence, for twentieth-century postmodernist artists such as Anselm
Kiefer, Robert Longo, David Salle, Eric Fischl, and even Jeff Koons
(in Koons's case, particularly the early Schiele). Despite this contrast, it
is clear that the developments and subsequent rediscovery and reinter-
pretation of fin-de-siècle Vienna have exercised a crucial influence on
the shifting aesthetics and function of art and music in the twentieth
century. Perhaps before the century draws to a close the critical pos-
sibilities inherent in the aesthetic modernism explored in fin-de-siècle
Vienna will find an echo once again.

MICHAEL HUTER

Body as Metaphor: Aspects of the Critique and Crisis of Language at the Turn of the Century with Reference to Egon Schiele

One of the earliest documents of the fin-de-siècle's so-called "language crisis" is Hugo von Hofmannsthal's review in 1895 of a book on a then-idolized actor called Friedrich Mitterwurzer. The review turns out to be merely an excuse for the diagnosis of a terrible affliction described as "disgust with words." Words have "put themselves before things," "hearsay has engulfed the world," and the "lies of the times" sit like swarms of flies "on our poor lives." According to Hofmannsthal, disgust with words is closely related to "disgust with opinions," which are but a "spectral connection of words detached from feelings." Words have become stronger than man and his original power of speech. People speak as if playing a part and even contrive "to be uninvolved with the formulation of their own experiences."[1] Life is like a bad play, and man's behavior resembles the gestures with which bad actors accompany their words.

The essay on Mitterwurzer intermittently highlights aspects of the theory and practice of the arts of the approaching two decades and of the culture of fin-de-siècle Vienna as a whole. Disgust with words, according to Hofmannsthal, leads to "a despairing love for all those arts" that are "executed in silence: music, dance, and all the skills of acrobats and jugglers."[2] Hofmannsthal's remark on the "silent" arts in this context anticipates aspects of language that came to be strongly

emphasized in the aesthetics and rationale of Viennese modernism. Language is associated and metaphorically connected with certain nonverbal spheres that are meant to represent its negative aspect symbolically. These are music, mime, and magic. What cannot be said— silence—for the first time enters linguistic and poetic theory explicitly.

Hofmannsthal's parenthetic remark on painting in the context of the silent arts is very significant: painting was silent, too, but had also become charged with abstract notions and was thus also compromised.[3] He is clearly referring to academic painting and the allegorical style of late historicism. This kind of painting he considers as having been discredited by delivering itself over to words. There is, however, "silent" painting that speaks directly to the soul. In another fictive letter of Hofmannsthal's a character describes the impression made on him by some paintings that he happens to see in an exhibition. At the end it is revealed that the paintings were by van Gogh.[4] In a similar way Schiele can be seen, from Hofmannsthal's point of view, as one of the painters who restored silence to painting and rescued it from words.

Hofmannsthal's document attempts to resolve and overcome the crisis of communication by attributing aesthetic and sensual qualities to abstract and nonconcrete language. It was the need of new possibilities to express the unsayable and to re-create individuality that led to an alteration and expansion of the concept of language in contemporary Vienna. On the one hand, its salient characteristics, mime, music, magic, can be seen in relation to the traditional preference of Austrian culture for the performing arts;[5] on the other hand, they owe much to the influence of the German philosopher Friedrich Nietzsche. As a whole they aimed at a revitalization of language that allegedly had been deadened by modern civilization.

Nietzsche and Viennese Modernism

Nietzsche may be seen as a precursor, or prophet, of the avant-garde movements at the beginning of the twentieth century. His insights anticipate some of their most important preoccupations.[6] His direct influence on the proponents of Viennese modernism can also be clearly traced. His thought has had an impact on various fields, including psychoanalysis, philosophy, politics, literature, architecture, and music.[7]

This cannot be pursued here in detail, but a few examples may

perhaps suffice: Nietzsche's treatment of the unconscious and of the relationship between dream and reality markedly influenced Sigmund Freud. His impact on the political and aesthetic ideas of a Viennese student movement in the 1880's—the so-called Pernersdorfergruppe, to which not only Gustav Mahler but also Viktor Adler, later the founder of the Social Democratic party, belonged—has also been demonstrated.[8] Nietzsche's thought was particularly important for the theoretical approach to art and language in fin-de-siècle Vienna, which took over many of his insights.

However, Nietzsche neither dedicated any special work to the theory of language nor presented his ideas on it systematically. He developed them within the framework of the critique of reason and a philosophy of art. (The short, posthumously published essay "On Truth and Lie in a Nonmoral Sense"[9] of 1873 may be considered a summary of his thoughts on language.) No matter how problematic it might seem to isolate certain language-critical motifs from their context, two tendencies can be distinguished quite clearly: a demystification of language resulting from his attack on reason and metaphysics on the one hand, and its apotheosis and glorification through aesthetics on the other. The question is posed whether language is the "adequate expression of all reality."[10] Nietzsche's answer is neither yes nor no, but yes *and* no. He reduces and elevates the significance of language at the same time.

Demystification of Language

As far as language is concerned, Nietzsche has reached a critical position from which there is no turning back. He destroys nothing less than the belief in achieving cognition through language. The idea that man attains truth through language turns out to be just as much of an illusion as the supposition that something in reality corresponds to the premises of logic. In Nietzsche's view, "it is only now dawning upon man that he has propagated an enormous error with his belief in language."[11] Language and reality are of a different kind: "We believe we know something about things themselves when we speak of trees, colors, snow, and flowers, while in reality we have nothing but metaphors for things." There is no absolute cognition whatsoever, according to Nietzsche, but only a relative accuracy and regularity of perception. Truth is "anthropomorphic through and through," and language expresses the "relation of things to man"[12] rather than the

substances of things. Even if there were a metaphysical world, we would be denied access to it because we see "everything with the human head" and "we cannot cut this head off."[13]

Nietzsche not only destroys our belief in language, he also denies any possibility of expressing individual and private experience in language. This is due to the nature of language itself. He tries to demonstrate this in terms of the theory of evolution. Language and consciousness are merely instruments to guarantee the survival of the human race. Being "the most endangered animal," man has had to learn to express himself and to make himself understood. Ego, consciousness, thinking, truth, and so on are not essences but fictions and reflections of man's ability and his "need for communication." Because both language and consciousness have developed under this need, human language does not contain individual elements, nor does consciousness belong to the individual. According to this theory, the fact that somebody understands us does not prove that we can express ourselves, but rather the opposite. Only in the "perspective of the herd"[14] do we therefore have access to our personal experience. This is of course not only a reduction of language, but also a downgrading of man himself.

The third motif is the inadequacy of language in relation to the totality of the world. In his famous *Birth of Tragedy in the Spirit of Music* Nietzsche tries to establish a new philosophy of art beyond classical aesthetics. The primacy of music and the distinction between the Apollonian and the Dionysian principles characterize the system of arts and the correlations of literary types: The fine arts and epics belong to the bright and figurative Apollonian sphere, tragedy and poetry to the dark and ecstatic Dionysian. Music is superior to language. By comparison with its universal significance, verbal language is inadequate because it can only signify and define the individual object. Tragedy originates by imitating music, and poetry cannot express anything "that has not previously occurred in music."[15]

The Power of Signs

We have seen that Nietzsche both reduces the importance of verbal language and also celebrates it. As the word loses its authority as the representation of truth, the sign becomes infinitely powerful. Once he has accepted the difference between language and reality, man becomes the absolute ruler of a world of signs.

The artists are the noble ones who can break up the abstract and anonymous character of language. They dispose of the riches that man's need for communication has accumulated. The "aesthetic condition" as the culminating point of communication between living beings derives from an "abundance of the means of communication." [16]

But art is not only a preoccupation of those whose creations arise out of the conventions of the community. Man is—originally and essentially—an artist. In relation to reality he behaves aesthetically as a creative subject by transforming the nervous irritation of the senses into a flowing mass of images. Later these "metaphors of intuition" (*Anschauungsmetaphern*), as Nietzsche calls them, are translated by language and science into phantomlike schemes of words and concepts. It is now that man "subjects his thinking and acting to the power of abstraction." Art is the sphere in which man's fundamental "impulse to form metaphors" expands anew. In art and in myths man remembers the "aboriginal faculty of human imagination." [17] In the same way as primitive man, the artist is guided by intuitions rather than by abstractions, and as he experiences them he either falls silent or speaks through forbidden and shocking metaphors. To create art, according to Nietzsche, means to produce images and thereby translate words and concepts into a "silent" language.

In the Dionysian state, man is stimulated to achieve the "highest point of all his symbolic abilities." Therefore he needs a new "world of symbols" that goes beyond verbal language and includes all the "physical symbolism" of the body, as in the "gesture of dance," and that finally leads to a "total release of all symbolic energies." [18] The essay on tragedy is a speculative justification of the liberation of the artistic forces. As far as language is concerned, it is important to notice that Nietzsche is interested in a new conception of (poetic) language rather than in a critique of language in general; he indicates this by tracing its origin in music and by transforming the act of speaking into gesture and dance.

It is in this sort of context that we have to view not only literature, but every kind of artistic practice in the early twentieth century, including that of Schiele, whose work might appear exactly in this perspective. Indeed, he plays on all the symbolic energies that the image of the human body can be charged with.

Hofmannsthal: Music, Mime, Magic

The above considerations bring us back to Hofmannsthal. He was not only *the* poetic genius in Vienna at the end of the century, but also one of the most sensitive theorists of language, and among "the first experts on Nietzsche to be taken seriously."[19] It seems that his ideas did indeed "crystallize beautifully in Nietzsche's cold clearness,"[20] as he explained to Arthur Schnitzler in a letter in 1891. It is Nietzsche's theory of language that led Hofmannsthal to the problem of magic and of skepticism about language, something that permeated his poetry and his thought from the very beginning.

We have seen that—following Nietzsche—Hofmannsthal discovered and emphasized nonverbal aspects of language: magic, mime, music. The poet is seen as magician who deals with supremely precious words and with the help of metaphor participates in the divine through "a sudden flash of illumination in which we feel the great unity of the world."[21]

In the essay on the actor Mitterwurzer quoted above, Hofmannsthal emphasizes the mimic aspect of language. Expressed by the actor, words become "something completely elemental," the "extreme and most affecting expression of the body."[22] In the mouth of the actor, the word achieves an atavistic power in which something speechless and unsayable expresses itself. Word becomes a part of the body, and language thus shows its material concreteness. It now resembles "pure gesture,"[23] by means of which the individual and the universal express themselves. Speaking has become like mime, making visible the unsayable.

Hofmannsthal's "A Letter"[24] of 1902 is considered the most famous manifestation of the language crisis. It is a fictive letter written by a certain Lord Chandos to the philosopher Francis Bacon in which he explains why he has renounced all poetic activity. The young poet is suffering from a strange mental disease: he has lost the ability to speak or think about any subject coherently. He describes his gradual loss of trust in language, starting with abstract words like spirit, soul, body and proceeding right down to everyday words. He lives in a state of confusion in which all things and actions appear strange. Words turn into abstract signs without any apparent relationship to objects.

This frustrating state, however, is interrupted by ecstatic moments of joy and unbounded delight that cannot be described with words.

Insignificant and humble objects such as, for example, a watering can, produce intimations of a universal significance and a renewed belief in existence through which "everything appears to be something" to him. Chandos has a premonition of total communion beyond the limits of individual existence. His body turns into a medium of cognition: "It is as though my body consisted of nothing but ciphers" that can supply the key to everything. He feels as though he is "thinking with the heart" in a medium that is "more direct, more liquid, more shining than words" [25] and that communicates with the world on a level below that of consciousness, in a mute and unknown language.

In various contexts Hofmannsthal aims at a new qualification of language. As a medium of the unsayable the body is metaphorically present in young Hofmannsthal's poetic and linguistic reflections. It is the place where the individual and the universal join, and thus where real language is born. He actually wrote several *Tanzdichtungen* (scenarios for ballets) and pieces for mime. It seems that the silent language of the body is something poetical that language contrasts and competes with, rather than an alternative to verbal language. To a certain extent, Hofmannsthal's emphasis on the body is representative of Vienna's desire to communicate "what is too big, too general, too close to be expressed in words," [26] as he puts it himself in the essay "On Mime" in 1911. Schiele's works may similarly be considered a manifestation of this desire.

Karl Kraus: The Ethics and Erotism of Language

In opposition to Hofmannsthal's "Nietzschean" position, belief in language is basic to Karl Kraus's critique. In his struggle against the falsifying clichés and phrases of language, Kraus presupposes a possible representation of truth in language. He shows no ambivalence or skepticism toward language whatsoever, and his concept of language implies a prestabilized harmony of language and morality.

The satirical works of Karl Kraus consist of the 36 years of *Die Fackel*, which he edited between 1899 and 1936, and which was written for the most part entirely by himself. The butt of Kraus's satire is the language of journalists and feuilleton writers. The critic's task is to unmask the immorality and lies that occur in the unscrupulous use of language. By the ingenious use of quotation the satirist demonstrates corrup-

tion and abuse of language. For Kraus, therefore, language has a clear ethical function as an instrument of critique.[27]

The ethical function of language implicitly presupposes a positive concept of language. However, only in his famous essay of 1910, "Heine and the Consequences," did Kraus "discover" and analyze the positive aspects of language.[28] According to Kraus, it was the German poet Heinrich Heine who first committed the sin of separating form and content and thus made language susceptible to corruption. It was Heine who destroyed the original unity of language by discovering form as something "that is only a garment for the body and not flesh for the spirit."[29] This discovery has made it possible for form and content to be joined in a superficial and arbitrary relationship.

For the first time, the fields of eroticism and language overlap in "Heine and the Consequences." Kraus allegorizes language as the woman, that is, the mother and the goddess before whom the poet should prostrate himself in "silent ecstasy."[30] From this point on, Kraus formulates his theory of language almost exclusively in sexual metaphors.[31]

The basis for the personalization of language has been the mythologizing of woman.[32] The transposition of the so-called "sexual question" into the cultural and ideological arena is one of the driving powers behind the struggle against bourgeois morality. Erotic motifs characterize Kraus's thought throughout. Like Otto Weininger, Sigmund Freud, Arthur Schnitzler, or Peter Altenberg, Karl Kraus participated in the discussion of the question of sex before World War I. Further, the sexual sphere provided the imagery for Kraus's theory of language. The metaphor of eroticism emerges in Kraus's conception of language with strong moralistic connotations: the human body in its original nakedness and in a state of ecstasy testifies to the unity of language and truth.

Wittgenstein: Philosophy and Literature

Karl Kraus is among those who—according to Ludwig Wittgenstein's own testimony—had some influence on his thought.[33] Apart from the ethical and language-critical impulse in general, it is interesting to note that the metaphorical image of body and raiment occurs in the *Tractatus Logico-Philosophicus* applied to everyday language in opposition to the ideal language analyzed in the work.[34]

As far as the *Tractatus* is concerned, Wittgenstein claims to have "definitely resolved the problems" of language. This work represented his attempt to separate the sayable from the unsayable and to explain how the sayable can be said. But—as has been remarked—the price for this solution was rather high. Questions concerning the "problems of life"[35] can neither be put nor answered within the context of an ideal, objective language. We have to keep silent about them. Wittgenstein thus resolves problems by excluding them. He overcomes skepticism with yet more skepticism and restricts the sayable to scientific propositions, thus introducing a new concept of language and a new theory of meaning and significance. He goes one decisive step beyond the efforts of his contemporaries by resolving their problems in a radically positive way.

The *Tractatus* has been called an "ethical act."[36] Its critique of language and its struggle for clearness have undoubtedly been motivated by an ethical impulse. But Wittgenstein himself has called his work not only "strictly philosophical" but "at the same time literary,"[37] that is, aesthetic. Its conclusion can be seen in the context of Hofmannsthal's "despairing love" for the silent arts. It is in fact a desperate and paradoxical solution because all that really matters has to remain unsaid or be left to a silent language. Wittgenstein's silence is in no way meaningless. The unsayable—be it ethical or aesthetic—simply appears. This can even apply to the *Tractatus* itself. We can suppose that it might appear as a gesture, without the use of signs and symbols. Wittgenstein was very keen on the elegance and beauty of his sentences, and indeed his inspirers, Bertrand Russell and Gottlob Frege, noted this with surprise.[38] The tendency to the literary is to be seen here within a philosophical context: as an attempt to transgress the logical limitation of language by aesthetic means. Philosophy, it seems, has to rely on literature to suggest the unsayable, and style is a manifestation of the unsayable in language. Style is individuality that appears without expressing itself directly: the silent, mimic presence of the speaker in what is said. With its stylistic precision and adroit use of metaphor and imagery, Wittgenstein's *Tractatus* proves itself to be not only an ethical but also an aesthetic act in the context of the intricate and complex discourse on language at the beginning of the century.[39]

Critique and Crisis of Language

The fin-de-siècle language crisis (*Sprachkrise*) is usually regarded as a symptom of the political and cultural crisis that the liberal bourgeoisie experienced from the 1880's and 1890's onward.[40] Generally it means the intellectual's loss of confidence in the ability of language to represent reality and—more specifically—the aesthete's skepticism about his own means of expression. The solution of that syndrome is mostly seen in an ethical position that subjects both aestheticism and the ornaments and phrases of the ideologies and institutions of society to a radical criticism. The works of Karl Kraus or Adolf Loos represent typical examples of this attitude.[41] Within this general complex of questions, however, ethical and aesthetic motifs can neither be separated nor placed in opposition.

The substance of the language crisis lay in the fact that language had lost its aura through its circulation in a society that had become abstract and anonymous, and more specifically, through its vulgarization in the mass media. The crisis can be seen, as well, as a reaction to the incipient technological transformation of information through the invention of new media.[42]

Viennese modernism has produced a series of attempts to confront the inflation of the means of expression from which the individual suffers. Such attempts converge in a tendency to both emphasize and reduce the means. Skepticism was felt with regard to the possibilities of expressing individuality, rather than with regard to individuality itself.[43] The need to renounce false individuality is a prime motif in the discussion of any kind of language. The critique of the pseudo-individual aims at the protection of the true. Viennese modernism, therefore, consists of various attempts to criticize obsolete means of expression on the one hand, and of designs for authentic language on the other, which border on silence or even end in a (rhetorical) renunciation of language per se. As a metaphor for the unsayable, the human body was present in the aesthetics and the language critique of Hofmannsthal, Kraus, and Wittgenstein. Through its use of metaphor, language criticism is connected to the "silent arts" of dance, music, and theater just as is Schiele's painting, with its mimic language of pose and gesture. The emphasis on the body in Viennese modernism was due to an awareness of the inadequacy of language and verbal communication. It can also be seen as a confirmation of the liberation of "physical symbolism" prophesied by Nietzsche.

What is the role of Egon Schiele's painting within this complex of problems? His work can be seen as a creation of a silent language of forms, as well as an implied critique of any kind of painting that leaves anything to words. In this sense, his pictures may be considered as silent: they were not interpretations of abstract notions and conventional ideas, nor could they be described adequately with words, at least not by Schiele's contemporaries. They are works that sought desperately to show the unsayable and to make audible the rhythm of the music that underlies the bodies depicted.

In Schiele's work there was, however, a tendency to mime in an even more radical sense. The photographs Schiele had taken by the photographer Joseph Anton Trcka in 1914 explain this dramatic aspect of his painting.[44] Schiele not only posed in front of his paintings, he also painted on photographic prints and negatives, thus anticipating techniques of the Austrian neo-avant-garde such as *Wiener Aktionismus*, and Arnulf Rainer's *Übermalung*. Schiele is reported to have played with Javanese shadow-play figures for hours on end "without getting tired and without saying a word."[45] His painting is thus closer to acting and music than to words.

It is probable that Schiele was well versed in the aesthetic debates of his time. Certainly he was deeply immersed in his generation's desperate search for new forms of expression. His paintings and drawings were as ecstatic and as mystical as they could be without quite breaking with traditional representation. In Nietzsche's terms, they can be described as "Dionysian" interlopers within the Apollonian sphere of the figurative arts.

Notes

ELSEN: "Drawing and a New Sexual Intimacy"

1. I am grateful to my colleague Patrick Werkner for bringing this statement to my attention. It is published in Christian M. Nebehay, *Egon Schiele, 1890–1918: Leben, Briefe, Gedichte* (Salzburg, 1979), pp. 112–13. At the Academy, Schiele had been studying with Christian Griepenkerl, described by Rudolf Leopold as "notorious for his reactionary outlook in art." Rudolf Leopold, *Egon Schiele: Paintings, Watercolours, Drawings* (London, 1972), p. 12.

2. Serge Sabarsky writes: "The year 1910 was very important for Schiele. At this moment he fully discovered and developed his personal style. The earlier influence of Klimt and of Jugendstil would disappear from his work. He made the acquaintance of architects." *Egon Schiele,* exhibition catalogue, Palais des Beaux-Arts, Charleroi, 1987, p. 21. Sabarsky makes no mention of what influenced Schiele's "discovery" of his new style. Leopold writes in the same catalogue: "In that which concerns Schiele's draughtsmanship one will notice the influence of Toulouse-Lautrec" (p. 30). The influence of Rodin on Klimt, who actually knew the sculptor, must be the subject of another study. Suffice it to say that Rodin's influence on Klimt's drawings appears to come as early as the late 1890's. Klimt seems to have developed his own mode of Rodin's continuous drawing, which helped him to escape from stylization. See Werner Hofmann, *Gustav Klimt* (New York, 1971), especially plates 1, 5, 11, 13, and 14.

3. Albert Elsen and Kirk Varnedoe, *The Drawings of Rodin* (New York, 1971), pp. 69, 76.

4. Elsen and Varnedoe, *Drawings*, p. 85.

5. Albert Elsen, "Rodin's Drawings and the Art of Matisse," *Arts*, March 1987.

6. J. Schmoll, "Rodin's Late Drawings and the Art of Matisse," in Ernst-Gerhard Guse, *Auguste Rodin, Drawings and Watercolors*, trans. John Gabriel and Michael Taylor (New York, 1985), p. 226.

7. Elizabeth Chase Geissbuhler, *Rodin, Later Drawings* (Boston, 1963), p. 20.

8. Amadée Ozenfant, *Foundations of Modern Art* (New York, 1952), p. 53.

9. The information on these drawing exhibitions comes from Claudie Judrin, *Inventaire des dessins*, vol. 1 (Paris, 1984), 46–48. It was Judrin, working from old exhibition photographs and catalogues, who identified many of the works shown.

10. According to my colleague Patrick Werkner, this was a very venturesome institution that was a bookstore, publishing company, and sometimes a gallery. In 1910 it exhibited Schönberg's paintings; in 1914 Kubin's drawings were shown. Lectures were given by Freud and Hofmannsthal in the bookstore. See Patrick Werkner, *Austrian Expressionism: The Formative Years* (Palo Alto, 1993). It is also highly probable that Oscar Kokoschka saw this exhibition. Those early drawings he made that come closest to those of Rodin in terms of proximity to the viewer, contour, and continuous drawing are dated "1907 ?" and three such works can be found in the Solomon R. Guggenheim Museum's 1986 catalogue of its exhibition *Oskar Kokoschka*. See figure 97, *The Acrobat's Daughter*, who is shown running with an exaggerated trailing leg; figure 98, *The Acrobat*, that is a close-up half-length view of a naked man's back in which the contour lines sometimes stop and overlap and the man's left arm has the tell-tale appearance, given by continuous drawing, of appearing to be rumpled; and figure 99, *Nude With Back Turned*, in which we look down on the model whose extremities are roughly drawn and whose contours sometimes overlap. In his book *Egon Schiele* (New York, 1981), Frank Whitford writes: "It was Kokoschka's drawings, rather than his painting, which interested Schiele, and the similarities between the figure studies produced by Kokoschka in 1908 and 1909 and by Schiele in 1910 are unmistakable" (p. 57). I concur with Whitford's view, but he neglects to point out that Rodin's drawings were the crucial connection.

11. Geissbuhler, *Rodin*, p. 77. We are fortunate in having Rilke's talk, which he gave in more cities than Vienna, and which has been published. The relevant part begins, "These drawings of the last ten years are not, as so many take them to be, rapid jottings, preparatory and transitory studies; they contain a final statement of long uninterrupted experience. And this they contain, as by a miracle, in something which is nothing, in a rapid outline, in a contour breathlessly caught from Nature, in the contour of a contour too delicate and precious for Nature to retain. Never have lines, even in the rarest of Japanese drawings, possessed such a power of expression and at the same time been so innocent of purpose. For there is no representation here, no intention, no

trace of a name. And withal what is not here? Is there any attitude of holding or of letting go or of no longer being able to hold, of bending and stretching and contracting, of falling or flying, ever seen or imagined, which is not found here? . . . Now for the first time, seen unexpectedly in these sheets, the meaning becomes clear: the utmost we know of love and suffering, and bliss and woe, breathes from these sheets, we know not why." *Rainer Maria Rilke: Selected Works*, 2 vols., prose trans. by A. Craig Houston (London, 1954), 1: 143–44.

12. Alessandra Comini, *Egon Schiele's Portraits* (Berkeley, 1974), p. 53.

13. Photographs of the installation can be found in Alain Beausire, *Quand Rodin Exposait* (Paris, 1989), pp. 139–40.

14. Ibid., pp. 208–9.

15. Daniele Gutmann, "La Secession et Auguste Rodin (1897–1905), Vienne 1880–1938," in *L'Apocalypse de Vienne*, Centre Pompidou, 1986, p. 567.

16. Ibid., p. 567.

17. Comini, *Schiele's Portraits*, p. 38.

18. Leopold's *Egon Schiele* is very useful because of the number of works it reproduces, its information, and occasional insightful comments. However, Leopold does not distinguish between naked and nude, contour and outline drawing. He seems not to have been aware of continuous drawing and does not question the source of its evidences in Schiele's drawings. Consider, for instance, Leopold's referral to a drawing *Girl With a Blue Shirt*: "Schiele interrupts the outline of the thigh without apparent reason, and then pursues it with a serration which is not justified by the subject" (p. 268). Regarding a brilliant continuous drawing, *The Dancer* (plate 133) he writes: "The pencil, firmly pressed into the sheet, travels over it as in a trance" (p. 298).

19. Leopold writes: "The earliest means elaborated by Schiele, and the one he used first to establish his individual style—indeed, his mastery—was a distinctive treatment of line. As an integral part of this technique, Schiele made a highly developed use of emphasis and omission" (*Egon Schiele*, p. 9).

20. This was already a trend in late nineteenth-century drawing. See Albert Boime's informative essay on the subject of an exhibition of academic drawing in *Strictly Academic: Life Drawing in the Nineteenth Century*, exhibition catalogue, University Art Gallery, State University of New York at Binghamton, 1974, p. 14.

21. The shift from the psychologically shallow early drawn portraits by Schiele to sharper characterizations and the penetration of the individual's privacy comes with this new self-confidence in his power of seeing, his instincts, and their coordination with drawing. If there is an influence from Toulouse-Lautrec, it may be in the portraits in which there are two modes of drawing, one for the face and one for the costume, with the former being deliberated or sharply observed, and the latter undeliberated, a merger of quick outline drawing and scribbling.

22. Boime, *Strictly Academic*, p. 8.

23. Leopold, *Egon Schiele*, p. 318 and plate 143.

24. Ibid. See plate 175, *Seated Model Holding Her Feet in Her Hands*, and plate 225, *Curved Female Nude*.

25. Leopold, for example, sees the *Seated Nude Leaning on Her Arm*, plate 191, as being derived from a Hodler painting, *The Spring*, p. 314, and Schiele's *Squatting Woman Resting on Her Legs*, plate 148, is compared with Rodin's sculpture *Femme Accroupie*. In both cases the Schiele drawings are thinkable without such sources because the differences are significant and consistent with his new studio practice.

26. At least one Schiele scholar seems to have missed this. Leopold writes that Schiele "never shrank from conveying the ugliness of a subject, indeed, he tended to exaggerate it" (*Egon Schiele*, p. 142). The same author, in commenting on the drawing *Seated Woman Leaning on an Arm*, finds the extended hip bone "ugly" (p. 314).

27. Leopold notices the former omissions and gives a plausible explanation. Referring to his plate 36: "The feet, as well as traces of a seat, have been omitted for the sake of the figure's coherence and unity, also its autonomy within the composition" (*Egon Schiele*, p. 96); and with regard to *Leaning Man* (his plate 41), Leopold cites the "omission of the right hand since it would have formed a focal point unrequired by Schiele" (p. 106). In his self-portraits the missing hand(s) of the drawings are restored in the painting.

28. Alessandra Comini, *Egon Schiele* (New York, 1976), plate 11.

29. Leopold cites Otto Benesch as a source for saying that at least in 1910 Schiele was not acquainted with Fauve art (*Egon Schiele*, p. 106).

30. For a good example of Lautrec's tinting, see his naked woman on all fours reproduced in Nora Deslop, *Toulouse-Lautrec, The Baldwin M. Baldwin Collection*, exhibition catalogue, San Diego Museum of Art, p. 67.

31. Klimt shows this same exhibitionist motif of the raised skirt. See Alessandra Comini, *Gustav Klimt* (New York, 1975), plate 79, a drawing of a "virgin." Neither Schiele nor Klimt used the odalisque pose in which the model reclines parallel to the drawing's surface so that she could be seen in the traditional full extension with the "line of action" running continuously from head to toe.

32. According to one of Rodin's oldest artist friends, Paul Desbois, "Pour Rodin la femme c'etait un trou." The source is René Cheruy's unpaginated file of personal notes in the Musée Rodin archives.

33. It is not the purpose of this essay to explore motivations in both artists for their erotic drawings. Schiele's friend Arthur Roessler wrote, "What drove him to depict erotic scenes from time to time was perhaps the mystery of sex . . . and the fear of loneliness, which grew to terrifying proportions." Whitford, *Egon Schiele*, p. 89.

34. Albert Elsen, ed., *Rodin Rediscovered* (Washington, D.C., 1981), p. 180. For one of the best discussions of Rodin's erotic drawings, see Varnedoe's essays in *Rodin Rediscovered*, "Life Drawings and Water Colors"; "Rodin's

Drawings"; "The Continuous Line"; "Modes and Meaning of Rodin's Drafts-manship."

35. Varnedoe sees voyeurism in the case of Rodin's drawings of paired lesbians: "Although there are no known instances of heterosexual activity in these works [by Rodin], lesbian play of varying degrees of intensity . . . is common and the overtones of acknowledged voyeurism are pervasive." Elsen, ed., *Rodin Rediscovered*, p. 180. Frank Whitford is not consistent in his view (and that of Schiele) with respect to the model's facial reactions: writing of some 1914 erotic drawings, Whitford says: "Whether lying or sitting, the model is rigid [*sic*], her face is blank . . . Schiele makes these women look like a collection of dolls" (*Egon Schiele*, p. 144). (On page 156, Whitford states that Schiele's wife Edith "insisted that he gave the erotic drawings, for which even she occasionally posed, the face of another, an imaginary woman.") However, Whitford reproduces in figure 114 a seated, naked model with exposed crotch, who looks right at us. Earlier, on page 97, in describing drawings of Wally, Whitford writes: "In a series of superb drawings she stares out at us, inviting and expectant, her doll-like eyes and full sensual mouth innocent and know-ing at the same time." In figure 141 on page 83, the *Crouching Nude* returns our stare by looking straight at us.

36. Elsen, ed., *Rodin Rediscovered*, p. 156.

37. Comini, *Schiele's Portraits*, p. 62. Unfortunately, Comini does not cite her source for saying that the erotic drawings of Rodin as well as Klimt were much sought. This knowledge might help us to know where else Schiele could have seen Rodin's work of this type.

38. *Antee*, June 1, 1907. "In Schiele's 1912 prison diary he suggested that pornography may be in the mind of the beholder. He wrote, "No erotic work of art is filth if it is artistically significant: it is only turned into filth through the beholder if he is filthy." Quoted in Whitford, *Egon Schiele*, p. 119. For a recent and thorough discussion of the question of the prison diary's authenticity, see Jane Kallir, *Egon Schiele: The Complete Works* (New York, 1990), pp. 127–28.

39. Leopold observed this earlier than I. He explains the purpose of the rough board, to "enrich the broad strokes of the soft graphite lead, a technique frequently used by Schiele during the 1913–1916 period" (*Egon Schiele*, p. 175).

40. See Comini, *Egon Schiele*, p. 63—the drawing of *Aunt and Nephew* (1915), done in black chalk.

KRAPF-WEILER: "The Response to Vincent van Gogh"

Since this was presented at the Stanford symposium on Schiele, papers con-cerning the Viennese response to van Gogh were published in the exhibition catalogue *Vincent van Gogh und die Moderne*, Museum Folkwang (Essen, 1990), pp. 411–34: Almut Krapf-Weiler, "Zur Wirkungsgeschichte Vincent van Goghs in Wien: Oskar Kokoschka, Richard Gerstl" and Marian Bisanz-Prakken, "Gus-tav Klimt, Egon Schiele." I would like to thank Marian Bisanz-Prakken for

sharing and discussing information during our work for this catalogue. I am also grateful to my husband, Dr. Michael Krapf, Österreichische Galerie, for advice and corrections, as well as to Prof. Dr. Otto Graf and Visiting Prof. Dr. Anthony Alofsin, Institut für Kunstgeschichte, Akademie der bildenden Künste in Wien, 1990. I am obliged to Prof. Dr. Dwight C. Miller, Art Department, Stanford University, for looking over the paper during his stay in Vienna in the summer of 1992.

1. Sixteenth exhibition of the Secession, January–February 1903, van Gogh, no. 178–82; Ludwig Hevesi, *Acht Jahre Secession* (Vienna, 1906), p. 419; Ilona Sármány-Parsons, "Der Einfluß der französischen Postimpressionisten in Wien und Budapest," *Mitteilungen der Österreichischen Galerie* (Vienna, 1990–91), p. 70; Walter Feilchenfeldt, *Vincent van Gogh and Paul Cassirer: The Reception of Van Gogh in Germany from 1901 to 1914* (Zwolle, 1988), p. 144.

2. Erwin Mitsch, *The Art of Egon Schiele* (London, 1957), p. 18.

3. *Ver Sacrum* 1. Jg., 1. H. (January 1898).

4. Hermann Bahr, Diary, May 1, 1918: "Wir sahen zusammen Stifterzeichnungen und Goethezeichnungen an (diese bald in ihrer Intensität an van Gogh erinnernd, bald Rembrandt übertreffend)." Bahr-Nachlaß, Theatermuseum, Vienna. I want to thank Dr. Hedi Pistorius for pointing this out.

5. Fritz Novotny, "Über die Popularität van Goghs" (1953), reprinted in Fritz Novotny, *Über das Elementare in der Kunstgeschichte* (Vienna, 1968), p. 46.

6. Hugo von Hofmannsthal, *Die Prosaischen Schriften*, vol. 3, *Die Farben* (Berlin, 1907); also in "Das Erlebnis des Sehens," *Kunst und Künstler*, 6. Jg., 5. H. (Febuary 1908), reprinted in *Erzählungen—erfundene Gespräche und Briefe—Reisen*, ed. Bernd Schöller, *Gesammelte Werke* (Frankfurt am Main, 1979), p. 565.

7. Rainer Maria Rilke, *Briefe über Cézanne* (Wiesbaden, 1952), pp. 10, 14–17; Robert Musil, "Anmerkungen zu einer Metaphysik, April 1914," *Gesammelte Werke*, 9 vols. (Rowohlt, 1978), 8: 1016.

8. Erwin Mitsch, *The Art of Egon Schiele*, p. 20.

9. Christian M. Nebehay, *Egon Schiele, 1890–1918: Leben, Briefe, Gedichte* (Salzburg, 1979), pp. 143, 501.

10. Fritz Novotny and Johannes Dobai, *Gustav Klimt* (Salzburg, 1967), pp. 63, 64; Johannes Dobai, *Gustav Klimt: Die Landschaften* (Salzburg, 1985), p. 29; Bisanz-Prakken, "Gustav Klimt, Egon Schiele," p. 418.

11. Ibid., p. 421.

12. *Internationale Kunstschau*, exhibition catalogue (Vienna, 1909), room 19, no. 4, *Junges Mädchen*; no. 14, *Portrait des Malers Hans Massmann*; no. 17, *Portrait der Malers Anton Peschka*; no. 20, *Jugendströmung*.

13. Alessandra Comini, *Egon Schiele's Portraits* (Berkeley, 1974), figures 51 and 52.

14. Compare Nebehay, *Egon Schiele 1890–1918*, p. 129. Rudolf Leopold, *Egon Schiele: Gemälde, Aquarelle, Zeichnungen* (Salzburg, 1972; English trans., London, 1973).

15. Compare Bisanz-Prakken, "Gustav Klimt, Egon Schiele," p. 424.

16. Julius Meier-Graefe, *A History of the Development of Modern Art*, 2d ed. (Munich, 1927), pp. 662, 665.

17. Compare Almut Krapf-Weiler, "Zur Bedeutung des Österreichischen Barock für Oskar Kokoschka, "*Wiener Jahrbuch für Kunstgeschichte* 55 (1987): 195. Oskar Sandner, *Oskar Kokoschka*, exhibition catalogue, Bregenz, 1976, p. 1.

18. Jaroslaw Leshko, "Oskar Kokoschka: Paintings, 1907–1915," Ph.D. diss., Columbia University, 1977, pp. 75, 256.

19. Compare Jane Kallir, *Austria's Expressionism*, exhibition catalogue, Galerie St. Etienne, New York, 1981, pp. 24–25; Otto Breicha, *Richard Gerstl*, exhibition catalogue, Historisches Museum der Stadt Wien, Vienna, 1983–84, p. 15; Almut Krapf-Weiler, "Richard Gerstl," in *Wien um 1900, Kunst und Kultur* (Vienna, 1985), pp. 73–78; Patrick Werkner, *Physis und Psyche: Der österreichische Frühexpressionismus* (Vienna, 1986), p. 57.

20. *Kunst und Künstler* 3 (1905): 122.

WERKNER: "The Child-Woman and Hysteria"

The title of this paper, as presented at Stanford, was originally "Schiele, Youth, and the Changing Image of the Body." Because of the structure of the symposium, it was also intended as a general introduction to Schiele's art. In preparing this essay for print, I have been able to focus more on the general topic of youth and the cultural context of the image of the female body. Some aspects of the essay's first section are treated in a broader context in Patrick Werkner, *Austrian Expressionism: The Formative Years* (Palo Alto, 1993). I am grateful to Michael Huter for discussions and criticism of this essay. I also thank Nicholas Parsons for his help.

1. Egon Schiele, letter to Leopold Czihaczek, September 1, 1911, in Christian M. Nebehay, *Egon Schiele, 1890–1918: Leben, Briefe, Gedichte* (Salzburg, 1979), p. 182, no. 251.

2. Ibid.

3. The drawings were apparently commissioned by the lecturer, a Dr. Kornfeld. Letter from Erwin Osen to Schiele, August 15, 1913, in Nebehay, *Egon Schiele, 1890–1918*, p. 270, no. 570.

4. Arthur Roessler, "Egon Schiele," *Bildende Künstler* 3 (1911): 114.

5. Schiele, letter to Czihaczek, September 1, 1911, in Nebehay, *Egon Schiele, 1890–1918*.

6. A sculpture by Minne is represented in Karl Moll's painting *Self-Portrait in the Studio* from c. 1906, where it is shown together with van Gogh's portrait of his mother from 1888, which was also in Moll's collection. See Figure 16.

7. Most of the photographs, among them the following examples, are in the collection of the Historisches Museum der Stadt Wien. For a selection of the photographs, see Hans Bisanz, *Peter Altenberg: Mein äußerstes Ideal—Altenbergs Photosammlung von geliebten Frauen, Freunden, und Orten* (Vienna, 1987).

8. "Altenberg's ongoing concern with the act of seeing and the ethics of vision . . . made him an avid collector of photographs and picture postcards. These objects, which Altenberg usually signed and inscribed with aphoristic and lyrical commentaries, constitute a second oeuvre, one that is arguably just as significant as the sketches and prose poems upon which his literary reputation currently rests." Leo A. Lensing, "Peter Altenberg's Fabricated Photographs: Literature and Photography in Fin-de-Siècle Vienna," in *Vienna 1900: From Altenberg to Wittgenstein*, ed. Edward Timms and Ritchie Robertson; Austrian Studies 1 (Edinburgh, 1990), p. 47.

9. Reproduced in *Traum und Wirklichkeit: Wien 1870–1930*, exhibition catalogue, Vienna, Künstlerhaus, 1985, p. 325. Emphasis here and in the following quotations is Altenberg's.

10. Ibid., p. 325.

11. Reproduced in Bisanz, *Peter Altenberg*, p. 105.

12. Ibid., p. 51.

13. Peter Haiko and Mara Reissberger, "Ornamentlosigkeit als neuer Zwang," in *Ornament und Askese im Zeitgeist des Wien der Jahrhundertwende*, ed. Alfred Pfabigan (Vienna, 1985), pp. 110–19.

14. Adolf Loos, "Damenmode" (1898), in Adolf Loos, *Sämtliche Schriften*, Bd. 1 (Vienna, 1962), pp. 157–64. English translation quoted from Adolf Loos, "Ladies' Fashion," in *Spoken into the Void* (Cambridge, Mass., 1982), p. 103.

15. Haiko and Reissberger, "Ornamentlosigkeit," p. 117.

16. Ibid.

17. Ibid.

18. One could also think of a different symbolism that has not yet been discussed in the literature on the house. "Clean-shaven" could also have overtones related to the "beardedness" of the Orthodox Jew. By shaving his beard, he assimilated to modern culture. Loos's friend Karl Kraus mocked the Viennese Zionists who, like Theodor Herzl, defiantly grew beards to accentuate their Jewish solidarity. Kraus had formally renounced his allegiance to Judaism in 1899 (and converted to Catholicism in 1911, with Loos acting as godfather— until he left the church again in 1923). The unornamented, "unbearded" house thus could also be read as a statement against Jewish particularism. Kraus extrapolated from Loos when he wrote: "I am not taken in by the facade! . . . I can make tabula rasa. I sweep the street, I loosen the beards, I shave the ornaments!" On this quote from *Die Fackel* and on Kraus's attitude toward beards, see Edward Timms, *Karl Kraus, Apocalyptic Satirist: Culture and Catastrophe in Habsburg Vienna* (New Haven, 1984), pp. 132–35.

19. See Timms, *Karl Kraus*, pp. 72–75, and Nike Wagner, *Geist und Geschlecht: Karl Kraus und die Erotik der Wiener Moderne* (Frankfurt am Main, 1981), pp. 95–105. Besides focusing on Kraus, Wagner's book is an excellent study of the role of gender and sexuality in Viennese modernism. For a photograph of Annie Kalmar from Altenberg's collection—with an epigram by the poet— see Bisanz, *Peter Altenberg*, p. 43.

20. Edward Timms, "The 'Child-Woman': Kraus, Freud, Wittels, and Irma

Karczewska," in *Vienna 1900*, ed. Timms and Robertson, p. 91. Wittels's article was published in *Die Fackel* no. 230–31, July 15, 1907, pp. 14–33.

21. Leo A. Lensing, " 'Geistige Väter' und 'Das Kindweib': Sigmund Freud, Karl Kraus, und Irma Karczewska in der Autobiographie von Fritz Wittels," *Forum* 36, no. 431–32 (October–November 1989): 62–71; Timms, "The 'Child-Woman.' "

22. Werkner, *Austrian Expressionism*, pp. 228–35; Patrick Werkner, "Kokoschkas frühe Gebärdensprache und ihre Verwurzelung im Tanz," in *Oskar-Kokoschka-Symposion der Hochschule für angewandte Kunst in Wien* (Salzburg, 1986), pp. 82–99.

23. Kraus commented on the trial in two articles in *Die Fackel* in November 1905: "Die Kinderfreunde" and "Nachträgliches zum Prozeß Beer." They are reprinted in Karl Kraus, *Sittlichkeit und Kriminalität* (Frankfurt am Main, 1966), pp. 131–51 and 152–60.

24. Kraus, *Sittlichkeit und Kriminalität*, p. 131 (editor's comment).

25. Vera J. Behalova, *Adolf Loos: Villa Karma*, Ph.D. diss., Vienna, 1974, p. 31. See also Vera J. Behal, "Die Villa Karma und ihre Architekten Lavanchy/Loos/Ehrlich," in *Adolf Loos*, exhibition catalogue, Vienna, Albertina and Historisches Museum der Stadt Wien, 1989–90, pp. 135–58. A vivid study of Theodor Beer as the wooer—and later the lover—of Bertha Eckstein-Diener (who was to become known as the poet Sir Galahad) is presented by Sibylle Mulot Déri, *Sir Galahad: Porträt einer Verschollenen* (Frankfurt am Main, 1987), pp. 123–56.

26. Werner J. Schweiger, *Der junge Kokoschka* (Vienna, 1983), p. 117.

27. For a detailed account of the circumstances of Schiele's imprisonment, see Jane Kallir, *Egon Schiele: The Complete Works* (New York, 1990), pp. 127–47. On recent analogous cases concerning the conflict between art and censorship in the United States, see Lawrence A. Stanley, "Art and 'Perversion': Censoring Images of Nude Children," *Art Journal* 50, no. 4 (Winter 1991): 20–27.

28. For the topic of youth in Viennese art, see Helen O. Borowitz, "Youth as Metaphor and Image in Wedekind, Kokoschka, and Schiele," *Art Journal* 33, no. 3 (Spring 1974): 219–25. Literary history has a longer tradition than art history in dealing with fin-de-siècle gender roles. On the *femme fragile* see Ariane Thomalla, *Die "femme fragile": Ein literarischer Frauentypus der Jahrhundertwende* (Düsseldorf, 1972), and Jens Malte Fischer, *Fin-de-siècle: Kommentar zu einer Epoche* (Munich, 1978), pp. 62–65. The various roles in which painters of the late nineteenth century represented the *femme fatale* and her sisters are treated in Bram Dijkstra, *Idols of Perversity: Fantasies of Feminine Evil in Fin-de-Siècle Culture* (Oxford, 1986).

29. See Patrick Werkner, "Hermann Bahr und seine Rezeption Gustav Klimts: Österreichertum, 'sinnliches Chaos' und Monismus," in *Hermann-Bahr-Symposion in Linz 1984*, ed. Margaret Dietrich (Linz, 1987), pp. 65–76.

30. The sexual interest in the child-woman was not limited to the intellectual and artistic circles of Vienna. This interest takes various different forms depending on individual socialization. Sander Gilman has shown that the

classic work of pornography in German, the novel *Josefine Mutzenbacher, or the History of a Viennese Whore As Told by Herself,* which appeared in Vienna in 1906, stands out among that era's numerous other fictional accounts of the lives of prostitutes: the novel presents itself as the sexual history of a female child between the ages of five and fourteen. "The accessibility of the child as sexual object is emphasized. But it is not any child. It is specifically, at least in the world of Vienna, the female proletarian child. The sexuality attributed to the proletarian is the sexuality of the other." In Vienna, "the sexual object par excellence . . . is the lower-class female, the proletariat as the source of all debauchery." Sander L. Gilman, "Freud and the Prostitute: Male Stereotypes of Female Sexuality in fin-de-siècle Vienna," *Journal of the American Academy of Psychoanalysis* 9, no. 3 (1981): 349. Gilman could also have called his article a study in Viennese misogyny of that time.

31. Quoted in Michael Worbs, *Nervenkunst: Literatur und Psychoanalyse im Wien der Jahrhundertwende* (Frankfurt am Main, 1983), pp. 270–71. Worbs extensively discusses the impact of psychoanalytical publications on Hofmannsthal and on the contemporaneous reception of the play.

32. For a reproduction, see Werkner, *Austrian Expressionism*, figure 159.

33. *Erdgeist* 4, no. 10 (1909).

34. Georges Didi-Huberman, *Invention de l'hystérie: Charcot et l'iconographie photographique de la Salpêtrière* (Paris, 1982); Manfred Schneider, "Hysterie als Gesamtkunstwerk," in *Ornament und Askese,* ed. Pfabigan, pp. 212–29; Debora Silverman, "Sigmund Freud—Jean-Martin Charcot, in *Vienne 1880–1938: L'Apocalypse Joyeuse,* exhibition catalogue, Paris, Centre Pompidou, 1986, pp. 576–85; *Wunderblock: Eine Geschichte der modernen Seele,* exhibition catalogue, Vienna, Messepalast, 1989 (see in particular Georges Didi-Huberman, "Ästhetik und Experiment bei Charcot," pp. 281–96); Peter Gorsen, "Der Dialog zwischen Kunst und Psychiatrie heute," in *Von Chaos und Ordnung der Seele: Ein interdisziplinärer Dialog über Psychiatrie und moderne Kunst,* ed. Otto Benkert and Peter Gorsen (Berlin, 1990).

35. D. M. Bourneville and P. Régnard, *Iconographie photographique de la Salpêtrière,* 3 vols. (Paris, 1876–80).

36. Paul Richer, *Études cliniques sur l'hystéro-épilepsie ou grande hystérie* (Paris, 1881).

37. Jean-Martin Charcot and Paul Richer, *Les demoniaques dans l'art* (Paris, 1887). Recent interest in the connection between hysteria and aesthetics has prompted new editions of this work. The German translation of the book, to which additional reproductions were added, was edited with a commentary by Manfred Schneider, *Die Besessenen in der Kunst* (Göttingen, 1988).

38. Jean-Martin Charcot and Paul Richer, *Les difformes et les malades dans l'art* (Paris, 1889).

39. All quotations from Schneider, "Hysterie als Gesamtkunstwerk," pp. 216–17.

40. See Worbs, *Nervenkunst.*

41. See Hermann Bahr, *Expressionismus* (Munich, 1916).

42. Hermann Bahr, *Dialog vom Tragischen* (Berlin, 1904), p. 9.

43. Erwin Rohde, *Psyche. Seelenkult und Unsterblichkeitsglaube der Griechen* (Freiburg, 1894); American edition, *The Cult of Souls and Belief in Immortality Among the Greeks*, 2 vols. (New York, 1966).

44. Quoted from the American edition, p. 285. On the topic of "Greek hysteria" and its recent impact on Austrian art, see Ekkehard Stärk, *Hermann Nitschs "Orgien Mysterien Theater" und die "Hysterie der Griechen": Quellen und Traditionen im Wiener Antikebild seit 1900* (Munich, 1987).

45. Silverman, "Sigmund Freud—Jean-Martin Charcot," p. 583: "Dans la Médecine de Klimt, la femme nue prend l'attitude exacte du deuxième stade de l'hystérie selon Charcot (la catalepsie), entre l'hypnose et les actes provoqués par la suggestion." Schneider, "Hysterie als Gesamtkunstwerk," p. 221, argues in an analogous way, pointing to correspondences between the directions for Elektra in Hofmannsthal's play and hysteric symptoms: "Und wie heißt es in Hofmannsthals Tragödie? 'Elektra hat sich erhoben. . . . Sie hat den Kopf zurückgeworfen wie eine Mänade. Sie wirft die Knie, sie reckt die Arme aus, es ist ein namenloser Tanz.' Das manädische Zeichen par excellence—der in den Nacken geworfene Kopf—und der 'namenlose' Tanz, der als hysterischer oder epileptischer Anfall erfolgen kann, das ist der völlige Zusammenschluß von Kunst und Pathologie." At this point in particular, the connection between Greek philology, art, and psychoanalysis becomes evident.

46. See Werkner, "Kokoschkas Gebärdensprache."

47. Ibid., p. 94.

48. Peter Altenberg, "Die Tänzerin," in *Internationale Schwarz-Weiß-Ausstellung*, exhibition catalogue, Vienna, 1913, p. 19.

49. On Klimt's present popularity, see Gottfried Fliedl, *Gustav Klimt: Die Welt in weiblicher Gestalt* (Köln, 1989), pp. 7–10; English edition, *Gustav Klimt* (Cologne, 1990).

50. On the far-reaching cultural and political implications of the general rediscovery of "Vienna 1900," see Leon Botstein, "The Viennese Connection," *Partisan Review* no. 2 (1982): 262–73; Manfred Wagner, "Wien und sein Fin-de-siècle in der Gegenwart," in *Ornament und Askese*, ed. Pfabigan, pp. 297–312; Russell A. Berman, *Modern Culture and Critical Theory: Art, Politics, and the Legacy of the Frankfurt School* (Madison, Wisc., 1989). See in particular "The Vienna Fascination," pp. 204–41.

51. In view of the cultural context of contemporary eating disorders, a striking affinity between Viennese modernism and today is apparent. The Jugendstil motif of the reconciliation of the genders in the state of preadolescence and the myth of the androgynous resulted in body images around 1900 that are now once again topical: "For some anorexics, the slenderness and loss of curves that result from dieting represent a triumphant transformation of the female figure into that of a preadolescent boy." Richard A. Gordon, *Anorexia and Bulimia: Anatomy of a Social Epidemic* (Cambridge, Mass., 1990), p. 56. The symptoms of anorexia are representative of the contradictions between reality and a culturally imposed imagery of the female body. The contemporary popu-

larity of Art Nouveau and of Viennese Jugendstil in particular, insofar as their images correspond to the body ideals of today, thus reveals also the present crisis of gender roles. Around 1900, hysterical women expressed powerlessness and repressed sexuality through dramatic symptoms. By this means, they gained attention and thus exerted power. Like hysteria around the turn of the century, today's anorexia nervosa is a "modern" disease. It secures attention for those who are afflicted with it. Anorexia is "socially patterned, the fashionable style of achieving specialness through deviance" (ibid., p. 11). Will the anorexic be a kind of hysteric/*femme fragile* for the 1990s?

52. Carol Duncan, "Virility and Domination in Early Twentieth-Century Vanguard Painting," *Artforum*, December 1973, pp. 30–39; reprinted in *Feminism and Art History: Questioning the Litany*, ed. Norma Broude and Mary D. Garrard (New York, 1982), pp. 293–313.

53. Ibid., pp. 305, 294. I agree with Duncan's argument for a certain section of the art she discusses. Her statements, though, seem undifferentiated in their generalized interpretation, and misrepresent, I believe, both the artists' individualities and differences in an artist's oeuvre. I do not see the "purely physical approach" of the artists toward their female models (p. 312) as sole motive of their images. The notion that "the artist, despite his unconventional means, looked at them with the same eyes and the same class prejudices as other bourgeois men" (p. 310) can hardly be upheld as a generalized statement applicable to all early twentieth-century vanguard paintings.

54. Linda Ganjian, "The Sexual Politics in a Selection of Gustav Klimt's Works," unpublished typescript, Bard College, N.Y. 1990, p. 11. (Quoted with author's permission.)

55. See Kathrin Hoffmann-Curtius, "Frauenbilder Oskar Kokoschkas," in *Frauen—Bilder—Männer—Mythen: Kunsthistorische Beiträge*, ed. Ilsebill Barta et al. (Berlin, 1987), pp. 148–78.

56. On Schiele's self-portraits, see Alessandra Comini, *Egon Schiele's Portraits* (Berkeley, 1974).

WAGNER: "Egon Schiele"

1. Manfred Wagner, "Zwischen Aufbruch und Schatten: Musikgeschichte Österreichs zwischen 1918 und 1938," in *Aufbruch und Untergang*, ed. Franz Kadrnoska (Vienna, 1981), pp. 383–92.

2. Kurt Blaukopf, *Gustav Mahler oder der Zeitgenosse der Zukunft* (Vienna, 1969).

3. Allan Janik and Stephen Toulmin, *Wittgensteins Wien* (Munich, 1984); American edition, *Wittgenstein's Vienna* (New York, 1973).

4. See Peter Berner, Emil Brix, and Wolfgang Mantl, eds., *Wien um 1900* (Vienna, 1986); Hubert Christian Ehalt, Gernot Heiss, and Hannes Stekel, eds., *Glücklich ist, wer vergisst . . . ? Das andere Wien um 1900* (Vienna, 1986);

Robert Fleck, ed., *Weltpunkt Wien: Un Regard sur Vienne: 1985* (Vienna, 1985); Alfred Pfabigan, ed., *Ornament und Askese im Zeitgeist des Wien der Jahrhundertwende* (Vienna, 1985); and Gotthart Wunberg, ed., *Die Wiener Moderne: Literatur, Kunst, und Musik zwischen 1890 und 1910* (Stuttgart, 1981).

5. Manfred Wagner, "Wien um 1900 oder die Lehre vom Januskopf der Liberalität," *Wiener Journal* 74 (1986): 17–19.

6. Manfried Welan, "Wien—eine Welthauptstadt des Geistes," in *Wien um 1900*, ed. Berner, Brix, and Mantl, p. 39.

7. Manfred Wagner, "Schönbergs Krise um 1911 als Symptom der österreichischen Kulturgeschichte," in *Die Wiener Schule in der Musikgeschichte des 20. Jahrhunderts*, ed. Rudolf Stephan and Sigrid Wiesmann, 2 vols. (Vienna, 1986), 2: 155–60.

8. Peter Gorsen, *Sexualästhetik: Zur bürgerlichen Rezeption von Obszönität und Pornographie* (Reinbek, 1972), p. 11.

9. Patrick Werkner, *Physis und Psyche: Der österreichische Frühexpressionismus* (Vienna, 1986), p. 14.

10. *Schönberg-Gespräch, Symposionsbericht*, ed. Hochschule für angewandte Kunst in Wien (Vienna, 1984).

11. Hans Weigel, Walter Lukan, and Max D. Peyfuss, *Jeder Schuss ein Russ', jeder Stoss ein Franzos'* (Vienna, 1983).

12. Letter to Leopold Czihaczek, September 1, 1911, in Christian M. Nebehay, *Egon Schiele, 1890–1918: Leben, Briefe, Gedichte* (Salzburg, 1979), p. 182.

13. Gottfried Fliedl, "Das Weib macht keine Kunst, aber den Künstler," in *Der Garten der Lüste* (Cologne, 1985), pp. 92–93.

14. Manfred Wagner, "Österreichs bildende Künstler als Bühnenbildner: Versuch einer kritischen Deutung seit 1945," in *Ausstellungskatalog*, ed. Österreichischer Bundestheaterverband (Vienna, 1984), p. 22.

15. Werkner, *Physis und Psyche*, p. 173.

16. Arnim Friedemann, "Ausstellungskritik," *Wiener Abendpost*, March 21, 1918.

17. Rudolf Leopold, *Egon Schiele—Gemälde, Aquarelle und Zeichnungen* (Salzburg, 1972), p. 212.

18. Manfred Wagner, "Der Jugendstil als Zukunftsvision," in *Wien um 1900*, ed. Berner, Brix, and Mantl, pp. 152–56.

19. Wolfgang Mantl, "Wien um 1900—ein goldener Stachel," ibid., pp. 256–57.

20. Carl Schorske, *Fin-de-Siècle Vienna: Politics and Culture* (New York, 1980).

21. Egon Schiele, Manifesto on the occasion of the "New Artists" exhibition, Vienna, 1909, quoted in Nebehay, *Schiele, 1890–1918*, p. 97.

22. Manfred Wagner, "Schubert—ein Österreicher, oder Identität in Höhen und Tiefen," in *Wiener Festwochen*, exhibition catalogue, Vienna, 1988, p. 34.

23. Werkner, *Physis und Psyche*, p. 175.

24. From Nebehay, *Schiele, 1890–1918*, p. 143.

25. Manfred Wagner, "Kriegshetze in Wien—eine Herausforderung für

Gustav Mahler?" in Manfred Wagner, *Kultur und Politik, Politik und Kunst* (Vienna, 1991), pp. 87–97.

26. Walter Falk, *Der kollektive Traum vom Krieg* (Heidelberg, 1977), pp. 166–67.

HAIKO: "The 'Obscene'"

1. Letter from Egon Schiele to Leopold Czihaczek, September 1, 1911, in Christian M. Nebehay, *Egon Schiele, 1890–1918: Leben, Briefe, Gedichte* (Salzburg, 1979), p. 181.

2. Ibid., p. 191.

3. Wilhelm Schölermann, "Café Museum"; reprinted in *Kontroversen: Adolf Loos im Spiegel der Zeitgenossen*, ed. Adolf Opel (Vienna, 1985), p. 9.

4. Adolf Loos, "Architektur," in *Trotzdem—1900–1930*, ed. Adolf Opel (Vienna, 1982), p. 92.

5. Adolf Loos, "Ornament und Verbrechen," in *Trotzdem*, pp. 78–79.

6. Ibid., p. 79.

7. Sigmund Freud, "Die 'kulturelle' Sexualmoral und die moderne Nervosität" (1908), in *Sigmund Freud-Studienausgabe*, vol. 9 (Frankfurt, 1974), p. 18.

8. Loos, "Ornament und Verbrechen," p. 79.

9. Adolf Loos, "Ornament und Erziehung," in *Trotzdem*, pp. 174, 177.

10. Adolf Loos, "Damenmode," in *Ins Leere gesprochen* (Vienna, 1981), pp. 127, 128, 130, 133.

11. Ibid., p. 126.

12. Loos, "Ornament und Verbrechen," pp. 87, 88.

13. *Neue Freie Presse*, May 18, 1911. See Hermann Czech and Wolfgang Mistelbauer, *Das Looshaus* (Vienna, 1976), p. 79.

14. *Kritik und Revue*, July 24, 1911. See Czech and Mistelbauer, *Das Looshaus*, p. 86.

15. *Die Fackel*, no. 317–18, March 3, 1911, p. 18. See Czech and Mistelbauer, *Das Looshaus*, p. 86.

16. Loos, "Damenmode," p. 128.

17. See Czech and Mistelbauer, *Das Looshaus*, pp. 63, 79.

18. *Berliner Lokal-Anzeiger*, October 9, 1910. See Czech and Mistelbauer, *Das Looshaus*, p. 79.

19. Adolf Loos, "Architektur," in *Trotzdem*, p. 100; *Neues Wiener Journal*, December 8, 1910. See Czech and Mistelbauer, *Das Looshaus*, p. 75.

20. Otto Wagner, *Moderne Architektur* (Vienna, 1896), pp. 62–63.

21. See Peter Haiko, *Otto Wagner und das Kaiser-Franz-Josef-Stadtmuseum: Das Scheitern der Moderne in Wien* (Tübingen, 1988), p. 42.

22. "Der Museumskrieg," *Neue Freie Presse*, May 17, 1903, p. 2.

23. Ibid.

24. Ibid.

BOTSTEIN: "Egon Schiele and Arnold Schönberg"

This paper is a modified version of a talk given at the Schiele conference at Stanford University in 1990. Since the author is at best an outsider in the field of art history and criticism, he would like to acknowledge the affectionate tolerance and forebearance of his colleagues Patrick Werkner and Peter Haiko.

1. The sources for much of this argument are Christian M. Nebehay, *Egon Schiele: Leben und Werk* (Salzburg, 1980) and *Egon Schiele: Sketch Books* (New York, 1989); Klaus Albrecht Schröder and Harald Szeeman, eds., *Egon Schiele und seine Zeit* (Munich, 1988); Frank Whitford, *Egon Schiele* (New York, 1981); Alessandra Comini, *Egon Schiele's Portraits* (Berkeley, 1974); Hans Bisanz, *Egon Schiele: Frühe Reife, Ewige Kindheit* (Vienna, 1990); Patrick Werkner, *Physis und Psyche: Der österreichische Frühexpressionismus* (Vienna, 1986); Ernst Hilmar, *Arnold Schönberg: Gedenkaustellung 1974* (Vienna, 1974); Hans Heinz Stuckenschmidt, *Schönberg: His Life, World, and Work* (New York, 1977); Reinhard Gerlach, *Musik und Jugendstil der Wiener Schule 1900–1908* (Laaber, 1985); Jane Kallir, *Arnold Schoenberg's Vienna* (New York, 1984); and Leon Botstein, *Judentum und Modernität: Essays zur Rolle der Juden in der deutschen und österreichischen Kultur 1848 bis 1938* (Vienna, 1991).

2. See for example the positive but limited entry in a popular short textbook in the history of music, B. Kothe's *Abriss der allgemeinen Musikgeschichte*, 9th edition, ed. R. Prochazka (Leipzig, 1915), p. 347.

3. See for example the reviews by Robert Hirschfeld, "Die 'Schaffenden'" and "Konzerte" in *Wiener Abendpost*, February 1, 1905, and March 5, 1907.

4. See Carl Schorske, "Gustav Klimt: Painting and the Crisis of the Liberal Ego," in *Fin-de-siècle Vienna: Politics and Culture* (New York, 1980), pp. 208–9.

5. Willi Reich, *Schoenberg: A Critical Biography*, trans. Leo Black (New York, 1981), p. 49.

6. Jan Maegaard, "Schönberg's Incomplete Works and Fragments," paper presented November 16, 1991, at the Arnold Schoenberg Institute.

7. See the Schönberg-Kraus correspondence in the Wiener Stadtbibliothek, as well as *Die Fackel*, February 1909, pp. 44–45; see also Adolf Loos, *Die Schriften von Adolf Loos* (Innsbruck, 1931–32), pp. 233–35, 455.

8. Reprinted in Adolf Loos, *Trotzdem—1900–1930*, ed. Adolf Opel (Vienna, 1982), pp. 78–79.

9. See Ulich Thieme, *Studien zum Jugendwerk Arnold Schönbergs* (Regensburg, 1979), pp. 48–53.

10. See Arnold Schönberg, "Mahler," in *Style and Idea*, ed. Leonard Stein (London, 1975), pp. 449–50.

11. See Otto Weininger, *Über die letzten Dinge* (Vienna, 1907).

12. Arnold Schönberg, "The Relationship to the Text," in *Style and Idea*, pp. 141–42.

13. See Siegfried Mauser, *Das expressionistische Musiktheater der Wiener Schule* (Regensburg, 1982), pp. 11–12.

14. See "Ein Interview" and "Über Musikkritik," both from 1909, in Arnold Schönberg, *Stil und Gedanke: Aufsätze zur Musik* (Reutlingen, 1976), pp. 157–58.

H U T E R : "Body as Metaphor"

All translations are the author's.

1. Hugo von Hofmannsthal, "Eine Monographie: 'Friedrich Mitterwurzer' von Eugen Guglia," in *Reden und Aufsätze I: 1891–1913*, ed. Bernd Schöller (Frankfurt am Main, 1979), pp. 479–80.

2. Ibid., p. 479.

3. Ibid., p. 479.

4. Hugo von Hofmannsthal, "Die Briefe des Zurückgekehrten," in *Erzählungen—Erfundene Gespräche und Briefe—Reisen*, ed. Bernd Schöller, *Gesammelte Werke* (Frankfurt am Main, 1979), pp. 564–67.

5. Carl E. Schorske, *Fin-de-Siècle Vienna: Politics and Culture* (Cambridge, 1985), pp. 7–8.

6. See Gert Mattenklott, "Die dionysische Seele: Nietzsches Kunstpsychologie in der Tragödienschrift," *Merkur* 42 (1988): 741–50.

7. In a series of interdisciplinary studies, the Italian philosopher Massimo Cacciari strongly emphasized Nietzsche's "presence" in "Wittgenstein's Vienna." See his *Krisis* (Milan, 1976), and *Dallo Steinhof* (Milan, 1980).

8. See William J. McGrath, *Dionysian Art and Populist Politics* (New Haven, 1974).

9. Friedrich Nietzsche, "Über Wahrheit und Lüge im außermoralischen Sinn," in *Werke*, 3 vols., ed. Karl Schlechta (Munich, 1973), 3: 309–22. On Nietzsche's philosophy on language see Brigitte Scheer, "Die Bedeutung der Sprache im Verhältnis von Kunst und Wissenschaft bei Nietzsche," in *Kunst und Wissenschaft bei Nietzsche*, ed. Mihailo Djuric and Josef Simon (Würzburg, 1986), pp. 108–11.

10. Nietzsche, "Über Wahrheit und Lüge," 3: 311.

11. Friedrich Nietzsche, "Menschliches, Allzumenschliches," in Nietzsche, *Werke*, 1: 453.

12. Nietzsche, "Über Wahrheit und Lüge," 3: 312–13, 316.

13. Nietzsche, "Menschliches, Allzumenschliches," 1: 452.

14. Friedrich Nietzsche, "Die fröhliche Wissenschaft," in *Werke*, 2: 220–21.

15. Friedrich Nietzsche, "Die Geburt der Tragödie aus dem Geist der Musik," in *Werke*, 1: 43.

16. Friedrich Nietzsche, "Aus dem Nachlaß der Achziger Jahre," in *Werke*, 3: 753.

17. Nietzsche, "Über Wahrheit und Lüge," 3: 314, 319, 316.

18. Nietzsche, "Die Geburt der Tragödie," 1: 28.

19. See Hans Steffen, "Hofmannsthal und Nietzsche," in *Nietzsche und die deutsche Literatur*, ed. Bruno Hillebrand, 2 vols. (Munich, 1978), 2: 7–8.

20. Hugo von Hofmannsthal, letter to Arthur Schnitzler July 7, 1891, cited in ibid., 1: 77.

21. Hugo von Hofmannsthal, "Philosophie des Metaphorischen," in *Reden und Aufsätze I*, p. 192.

22. Hofmannsthal, "Eine Monographie," p. 480.

23. Hugo von Hofmannsthal, "Über die Pantomime," in *Reden und Aufsätze I*, p. 504.

24. Hugo von Hofmannsthal, "Ein Brief," in *Erzählungen—Erfundene Gespräche und Briefe—Reisen*, pp. 460–72.

25. Ibid., pp. 469, 471.

26. Hofmannsthal, "Über die Pantomime," p. 502.

27. The language of war and the lies of the propaganda confirmed Kraus's prophecy. Language had become independent of facts; "clichés proceed autonomously." See Karl Kraus, "Aphorismen," in *Schriften*, ed. Christian Wagenknecht, 12 vols. (Frankfurt am Main, 1986–88), 8: 229. Kraus's public speeches in Vienna at the beginning of World War I reveal the horror of a language that not only governs man but even starts to act on its own, promoting violence and death. For a short while the only possible reaction in the face of this terrible new word is silence. Kraus postulates that "he who has something to say now step forward and be silent." See Karl Kraus, "In dieser großen Zeit," in *Weltgericht I, Schriften*, 5: 9. Morality has retreated into silence.

28. See Werner Kraft, *Das Ja des Neinsagers: Karl Kraus und seine geistige Welt* (Munich, 1974), p. 8.

29. Karl Kraus, "Heine und die Folgen," in *Untergang der Welt durch schwarze Magie, Schriften*, 4: 188.

30. Kraus, "Heine und die Folgen," p. 210.

31. See Josef Quack, *Bemerkungen zum Sprachverständnis von Karl Kraus* (Bonn, 1976), p. 52.

32. See Nike Wagner, *Geist und Geschlecht: Karl Kraus und die Erotik der Wiener Moderne* (Frankfurt am Main, 1982), pp. 195–97.

33. Ludwig Wittgenstein, *Vermischte Bemerkungen: Eine Auswahl aus dem Nachlaß*, ed. Georg Henrik von Wright (Frankfurt am Main, 1977), p. 43.

34. Ludwig Wittgenstein, *Tractatus Logico-Philosophicus*, 4.002, in *Werkausgabe*, 8 vols. (Frankfurt am Main, 1984), 1: 25–26.

35. Ibid., preface and 6.5.2.

36. Allan Janik and Stephen Toulmin, *Wittgenstein's Vienna* (New York, 1973), p. 167.

37. Ludwig Wittgenstein, *Briefwechsel mit B. Russell, G. E. Moore, J. M. Keynes, F. P. Ramsey, W. Eccles, P. Engelmann und L. Ficker*, ed. B. F. McGuinness and G. H. von Wright (Frankfurt am Main, 1980), p. 95.

38. See Manfred Frank, "Wittgensteins Gang in die Dichtung," in Manfred Frank and Gianfranco Soldati, *Wittgenstein: Literat und Philosoph* (Pfullingen, 1989), pp. 42–43.

39. There is no doubt about the affinity of Wittgenstein's questions with

those of Nietzsche. Not only was he a reader of Nietzsche (see Brian McGuinness, *Wittgensteins frühe Jahre* [Frankfurt am Main, 1988], p. 349–50), he certainly adopted various Nitzschean motifs. There is a remark of Wittgenstein's to demonstrate this. He says that music is the "most artful of all arts" because it contains the "whole of infinite complexity" without expressing it explicitly. Music "maintains" perfect "silence" about its content. See Wittgenstein, *Vermischte Bemerkungen*, p. 25.

40. See Schorske, *Fin-de-Siècle Vienna*, pp. xxvi–xxvii, 16.

41. See Janik and Toulmin, *Wittgenstein's Vienna*, p. 99, and the revised German edition, *Wittgensteins Wien* (Munich, 1984), p. 129.

42. See Friedrich Kittler, *Grammophon Film Typewriter* (Berlin, 1986).

43. Adolf Loos said that modern man's individuality is so strong "as not to be expressed by clothes." See Adolf Loos, "Ornament und Verbrechen," in Adolf Loos, *Trotzdem—1900–1930*, ed. Adolf Opel (Vienna, 1982), p. 88. Compare Karl Kraus: "The artist is different. But just because of this, he should side with the others in his external appearance." See Kraus, "Aphorismen," in *Schriften*, 8: 66.

44. See Christian M. Nebehay, *Egon Schiele: Leben und Werk* (Salzburg, 1980), pp. 137, 139, 142.

45. Arthur Roessler, *Erinnerungen an Egon Schiele* (Vienna, 1948), p. 36. The quotation is from Nebehay, *Schiele: Leben und Werk*, p. 78.

Egon Schiele: Short Biography

1890 June 12, Egon Schiele was born in Tulln, Lower Austria, the son of Adolf Eugen Schiele, an employee of the Austrian Railways, and Marie, neé Soukup. He had three sisters, of whom one died as a child.

1901 Attended the Realgymnasium (high school) Krems.

1902–1905 Attended the Realgymnasium Klosterneuburg.

1904 Death of Schiele's father.

After 1906, Schiele lived in Vienna.

1906–1909 Studied at the Academy of Fine Arts, Vienna, under Christian Griepenkerl, professor of portrait and history painting.

1907 Meeting with Gustav Klimt.

1909 Schiele exhibited at the important "Internationale Kunstschau 1909" in Vienna. In this year he left the Academy and exhibited, together with some friends, as a member of the "Neukunstgruppe," in the gallery of Gustav Pisko, Vienna. For this show he wrote a manifesto, "Neukünstler." He met the influential art

critic Arthur Roessler, who reviewed the show favorably. Roessler introduced him to several collectors, became a friend of the artist, and often served as a kind of protector.

1911–1915 Schiele lived together with his model Wally Neuzil, formerly a model for Gustav Klimt. He rented a garden studio in Krumau, in southern Bohemia, and later one in Neulengbach, Lower Austria.

1912 Exhibited with the "Neukunstgruppe" in Budapest, took part in the "Sonderbund" exhibition, Cologne, and in other exhibitions in Munich and Vienna. He was arrested in Neulengbach, initially charged with abduction and seduction of a minor, later with "offenses against morality." On the latter charges he was convicted and sentenced to 24 days in prison.

From 1913 onward, Schiele took part in several exhibitions in Vienna, Budapest, Germany, Rome, Brussels, Paris, Zurich, Amsterdam, Stockholm, Copenhagen. The Berlin vanguard magazine *Die Aktion* published drawings and poems by Schiele.

1914 Outbreak of the First World War.

1915 Schiele married Edith Harms.

1916 *Die Aktion* devoted an issue to Schiele's art. He was drafted into the Austro-Hungarian army, but not transferred to the front.

1918 Death of Gustav Klimt. Schiele's participation in the Vienna Secession exhibition was very successful. He rented a special studio for painting in large formats. Edith Schiele, who was pregnant, died in an influenza epidemic. Three days later, on October 31, Schiele died of the same disease. On November 11, Emperor Charles resigned, followed by the collapse of the Austro-Hungarian empire. End of World War I.

Select Bibliography

Exhibition catalogues are preceded by an asterisk.

1. Publications on Schiele

Comini, Alessandra. *Egon Schiele*. New York, 1976.
———. *Egon Schiele's Portraits*. Berkeley, 1974.
Denkler, Horst. "Malerei mit Wörtern: Zu Egon Schieles poetischen Schriften." In *Wissenschaft als Dialog: Studien zur Literatur und Kunst seit der Jahrhundertwende*, ed. Renate von Heydebrand and Klaus Gunther Just. Stuttgart, 1969, pp. 271–88.
Hofmann, Werner. *Egon Schiele: "Die Familie."* Stuttgart, 1968.
Gustav Klimt and Egon Schiele. New York, The Solomon R. Guggenheim Museum, 1965.
Gustav Klimt, Egon Schiele. New York, Galerie St. Etienne, 1980.
Gustav Klimt, Egon Schiele: Zum Gedächtnis ihres Todes vor 50 Jahren. Zeichnungen und Aquarelle. Vienna, Albertina, 1968.
Kallir, Jane. *Egon Schiele: The Complete Works*. New York, 1990.
Kallir, Otto. *Egon Schiele: Oeuvre Catalogue of the Paintings*. New York, 1966.
———. *Egon Schiele: The Graphic Work*. New York, 1970.
Leopold, Rudolf. *Egon Schiele: Paintings, Watercolours, Drawings*. London, 1973.
Malafarina, Gianfranco. *L'Opera di Egon Schiele*. Milan, 1982.

Mitsch, Erwin. *Egon Schiele, 1890–1918.* Salzburg, 1974.

Nebehay, Christian M. *Gustav Klimt, Egon Schiele und die Familie Lederer.* Bern, 1987.

———. *Egon Schiele, 1890–1918: Leben, Briefe, Gedichte.* Salzburg, 1979.

———. *Egon Schiele: Leben und Werk.* Salzburg, 1980.

———. *Egon Schiele: Sketchbooks.* New York, 1989.

Novotny, Fritz. *Egon Schiele: Gedenkshrift zur 50. Wiederkehr des Todestages.* Vienna, 1968.

Roessler, Arthur. *Briefe und Prosa von Egon Schiele.* Vienna, 1921.

———. *Erinnerungen an Egon Schiele.* Vienna, 1922. Expanded edition, Vienna, 1948.

———, ed. *Egon Schiele im Gefängnis: Aufzeichnungen und Zeichnungen.* Vienna, 1922.

Sabarsky, Serge. *Egon Schiele.* New York, 1985.

———. *Egon Schiele: Disegni Erotici.* Milan, 1981.

Salter, Ronald. "Georg Trakl und Egon Schiele: Aspekte des österreichischen Expressionismus in Wort und Bild." In *Österreichische Gegenwart: Die moderne Literatur und ihr Verhältnis zur Tradition,* ed. Wolfgang Paulsen. Bern, 1980, pp. 59–79.

Schiele, Egon. *Egon Schiele—Die Gedichte.* Vienna, 1977.

———. *Egon Schiele—Ich ewiges Kind: Gedichte.* Vienna, 1985. American edition: *Egon Schiele—I, Eternal Child: Paintings and Poems.* New York, 1988.

———. *Egon Schiele—Schriften und Zeichnungen.* Innsbruck, 1968.

Egon Schiele. Munich, Haus der Kunst, 1975.

Egon Schiele. Rome, Pinacoteca Capitolina, 1984.

Egon Schiele and His Circle. New York, Galerie La Boëtie, 1971.

Egon Schiele and the Human Form: Drawings and Watercolors. Des Moines Art Center, 1971–72.

Egon Schiele: Ausstellung zur 50. Wiederkehr seines Todestages. Vienna, Österreichische Galerie, 1968.

Egon Schiele: Leben und Werk. Vienna, Historisches Museum der Stadt Wien, 1968.

Egon Schiele und seine Zeit: Österreichische Malerei und Zeichnung von 1900 bis 1930 aus der Sammlung Leopold. Zurich, Kunsthaus; Vienna, Kunstforum Länderbank, et al., 1988–90. English edition: *Egon Schiele and His Contemporaries: From the Leopold Collection, Vienna.* Munich, 1989.

Egon Schiele: Zeichnungen und Aquarelle, 1906–1918. Vienna, Akademie der bildenden Künste, 1984.

Egon Schiele. Zum 100. Geburtstag: Die Aquarelle und Zeichnungen aus eigenem Besitz. Vienna, Albertina, 1990.

Schwarz, Heinrich. "Schiele, Dürer, and the Mirror." *The Art Quarterly* 30, no. 3–4 (1967): 210–23.

Steiner, Reinhard. *Egon Schiele.* Cologne, 1991.

Tietze, Hans. "Egon Schiele." *Die bildenden Künste* 2 (1919): 99–110.

Webb, Karl E. "Trakl/Schiele and the Rimbaud Connection: Psychological Alienation in Austria at the Turn of the Century." In *Internationales Georg-Trakl-Symposion, Albany, N.Y. 1983*, ed. Joseph P. Strelka. Bern, 1984, pp. 12–21.

Whitford, Frank. *Egon Schiele*. New York, 1981.

Wilson, Simon. *Egon Schiele*. Ithaca, N.Y., 1980.

2. Publications on Viennese Modernism and/or pertaining to Schiele

Austria's Expressionism. New York, Galerie St. Etienne, 1984.

Botstein, Leon. *Judentum und Modernität: Essays zur Rolle der Juden in der deutschen und österreichischen Kultur 1848 bis 1938*. Vienna, 1991.

Brix, Emil, and Patrick Werkner, eds. *Die Wiener Moderne: Ergebnisse eines Arbeitsgesprächs der Arbeitsgemeinschaft Wien um 1900*. Vienna, 1990.

Comini, Alessandra. *The Fantastic Art of Vienna*. New York, 1978.

Experiment Weltuntergang: Wien um 1900. Hamburg, Kunsthalle, 1981.

Janik, Allan, and Stephen Toulmin. *Wittgenstein's Vienna*. New York, 1973.

Johnston, William M. *The Austrian Mind: An Intellectual and Social History, 1848–1938*. Berkeley, 1972.

Kallir, Jane. *Arnold Schoenberg's Vienna*. New York, 1984.

Körperzeichen: Österreich. Winterthur, Kunstmuseum, 1982.

Le Arti a Vienna, dalla secessione alla caduta dell'impero asburgico. Venice, Palazzo Grassi, 1984.

Nielsen, Erika, ed. *Focus on Vienna 1900: Change and Continuity in Literature, Music, Art, and Intellectual History*. Munich, 1982.

Pfabigan, Alfred, ed. *Ornament und Askese im Zeitgeist des Wien der Jahrhundertwende*. Vienna, 1985.

Powell, Nicolas. *The Sacred Spring: The Arts in Vienna, 1898–1918*. Greenwich, Conn., 1974.

Schorske, Carl E. *Fin-de-Siècle Vienna: Politics and Culture*. New York, 1980.

Selz, Peter. *German Expressionist Painting*. Berkeley, 1957.

Shedel, James S. *Art and Society: The New Art Movement in Vienna, 1897–1918*. Palo Alto, 1981.

Timms, Edward. *Karl Kraus, Apocalyptic Satirist: Culture and Catastrophe in Habsburg Vienna*. New Haven, 1984.

Timms, Edward, and Ritchie Robertson, eds. *Vienna 1900: From Altenberg to Wittgenstein*. Austrian Studies, vol. 1. Edinburgh, 1990.

Traum und Wirklichkeit: Wien 1870–1930. Vienna, Künstlerhaus, 1985.

Vienna 1900: Art, Architecture, and Design. New York, The Museum of Modern Art, 1986.

Vienne 1880–1938: L'Apocalypse joyeuse. Paris, Centre Pompidou, 1986.

Vergo, Peter. *Art in Vienna, 1898–1918: Klimt, Kokoschka, Schiele, and Their Contemporaries*. Ithaca, N.Y., 1981.

Wagner, Manfred. *Kultur und Politik. Politik und Kunst.* Vienna, 1991.

Wagner, Nike. *Geist und Geschlecht: Karl Kraus und die Erotik der Wiener Moderne.* Frankfurt am Main, 1982.

Waissenberger, Robert, ed. *Vienna, 1890–1920.* New York, 1985.

Waissenberger, Robert, ed. *Wien, 1870–1930: Traum und Wirklichkeit.* Salzburg, 1984.

Werkner, Patrick. *Physis und Psyche: Der österreichische Frühexpressionismus.* Vienna, 1986. American edition: *Austrian Expressionism: The Formative Years.* Palo Alto, 1993.

Wien um 1900: Kunst und Kultur. Vienna, 1985.

Wien um 1900: Klimt, Schiele, und ihre Zeit. (Text in Japanese and German.) Tokyo, Sezon Museum of Art, 1989.

Worbs, Michael. *Nervenkunst: Literatur und Psychoanalyse im Wien der Jahrhundertwende.* Frankfurt am Main, 1983.

Wunberg, Gotthard, ed. *Die Wiener Moderne: Literatur, Kunst, und Musik zwischen 1890 und 1910.* Stuttgart, 1981.

List of Illustrations

Figure 1. Anton Joseph Trcka, portrait photograph of Egon Schiele, 1914.

Figure 2. Egon Schiele, *Reclining Nude Leaning on Right Elbow*, 1908.

Figure 3. Egon Schiele, *Crouching Male Nude (Self-Portrait)*, 1918.

Figure 4. Auguste Rodin, *Two Nudes*, ca. 1898.

Figure 5. Egon Schiele, *Kneeling Semi-Nude*, 1917.

Figure 6. Egon Schiele, *Wally in Red Blouse with Raised Knees*, 1913.

Figure 7. Auguste Rodin, *Reclining (or Kneeling) Nude*, ca. 1898.

Figure 8. Egon Schiele, *Semi-Nude Girl with Red Hair*, 1917.

Figure 9. Auguste Rodin, *Crouching Woman*, ca. 1900.

Figure 10. Egon Schiele, *Seated Pregnant Nude*, 1910.

Figure 11. Auguste Rodin, *Naked Woman Reclining with Legs Apart, Hands on Her Sex*, ca. 1900.

Figure 12. Egon Schiele, *Seated Female Nude*, 1911.

Figure 13. Auguste Rodin, *Naked Woman with Her Legs Apart*, ca. 1900.

Figure 14. Auguste Rodin, *Sapphic Couple*, 1898.

Figure 15. Egon Schiele, *Girlfriends*, 1913.

Figure 16. Karl Moll, *Self-Portrait in the Studio*, ca. 1906.

Figure 17. Gustav Klimt, *Avenue in the Park, Schloss Kammer*, 1912.

Figure 18. Vincent van Gogh, *L'Arlésienne* (*Madame Ginoux*), 1888.

Figure 19. Egon Schiele, *Portrait of Gertrude Schiele*, 1909.

Figure 20. Giovanni Segantini, *The Evil Mothers*, 1894.

Figure 21. Egon Schiele, *Autumn Tree in Turbulent Air* or *Winter Tree*, 1912.

Figure 22. Oskar Kokoschka, *Child with the Hands of Its Parents*, 1909.

Figure 23. Vincent van Gogh, *Madame Roulin with Her Daughter Marcelle*, 1888.

Figure 24. Vincent van Gogh, *The Potato Eaters*, 1885.

Figure 25. Oskar Kokoschka, *The Friends*, 1917–18.

Figure 26. Richard Gerstl, *Self-Portrait Semi-Nude, Against a Blue Background*, undated.

Figure 27. Egon Schiele, *Schiele, Drawing a Nude Model Before a Mirror*, 1910.

Figure 28. Egon Schiele, *Nude Girl*, 1911.

Figure 29. Egon Schiele, *Black-Haired Girl with Raised Skirt*, 1911.

Figure 30. Egon Schiele, *Two Girls on a Fringed Blanket*, 1911.

Figure 31. Egon Schiele, *Female Nude*, 1910.

Figure 32. Egon Schiele, *Seated Male Nude* (*Self-Portrait*), 1910.

Figure 33. Egon Schiele, *Nude Self-Portrait, Grimacing*, 1910.

Figure 34. Egon Schiele, *Two Little Girls*, 1911.

Figure 35. Oskar Kokoschka, *Study in Movement*, ca. 1908.

Figure 36. Photograph from Peter Altenberg's collection, with epigram by the poet.

Figure 37. Phases in an attack of hysteria, from Jean-Martin Charcot and Paul Richer, *Les démoniaques dans l'art* (Paris, 1887).

Figure 38. Gustav Klimt, *Judith* (*I*), 1901.

Figure 39. Window decoration of a perfume shop, Vienna, 1991.

Figure 40. Adolf Loos, house on the Michaelerplatz, Vienna, 1909–11.

Figure 41. Caricature from *Illustrirtes Wiener Extrablatt*, January 1, 1911.

Figure 42. Otto Wagner, design for Kaiser-Franz-Josef-Stadtmuseum, 1903.

Figure 43. Otto Wagner, design for Kaiser-Franz-Josef-Stadtmuseum, 1902.

Figure 44. Egon Schiele, *Embrace* (*Lovers II*), 1917.

Figure 45. Egon Schiele, *The Family* (*Squatting Couple*), 1918.

Copyright and Photographic Acknowledgments

Index

Adler, Viktor, 121
Aesthetics: influence of hysteria on, 69–73 *passim*; German nationalist vs. alternative, 79f; Schiele's alternative to, 86ff; cultural politics of Viennese, 101–17 *passim*
After Millet (Kokoschka), 46
Age of Bronze (Rodin), 12
Altenberg, Peter: *Fabricated Photographs*, 62; photography of young women, 64f; on the dance body, 72; fascination with child-woman, 93; eroticism of, 111
Altmann, Elsie, 64, 66
Apollonian principles, 122
Arbeiter Zeitung (socialist daily), 37, 107
Art: body images as expression of, 14, 51; Viennese Expressionism, 31, 42, 69–73 *passim*; Viennese Secessionists, 32, 51, 59, 62; Austrian Expressionists, 50; Viennese Jugendstil, 62, 74–78 *passim*; use of Dionysian/Apollonian principles, 122f; Nietzsche on expression through, 123. *See also* Expressionism; Fin-de-siècle culture; Viennese modernism

Artists' models: academically acceptable position of, 5f; Schiele's use of, 6f, 14–18 *passim*, 51–61 *passim*; continuous drawing of, 8–11 *passim*; capturing line of action of, 14, 51; Rodin's use of, 16; erotic drawings of, 22–27 *passim*. *See also* Body
Art Nouveau, 74
Austrian Expressionists, 50
Autumn Tree in Turbulent Air or *Winter Tree* (1912, Schiele), 39, 112
Avenue in the Park, Schloss Kammer (1912, Klimt), 37f

Bach, David Josef, 107
Bahr, Hermann: on van Gogh's impact on Expressionism, 31f; on hysteric image, 69; "Dialogue of the Tragic" (1904), 71; attacks against, 107
Bedroom at Neulengbach (Schiele), 39
The Bedroom at Arles (van Gogh), 39
Beer, Theodor, 67f
Beethoven frieze (1902, Klimt), 12, 62, 105
Beethoven monument (Klinger), 12
Bernatzik, Wilhelm, 33

Birth of Tragedy in the Spirit of Music
 (Nietzche), 122
Black-Haired Girl with Raised Skirt (1911,
 Schiele), 53
Blaue Reiter group, 109
Blind Mother (1914, Schiele), 112
Body, the: erotic drawings of, 22–27
 passim; Viennese Secessionists' ideals
 regarding, 51; Schiele's fascination
 with, 56–61 *passim*; artistic fascination
 with, 61f; Viennese modernism signifi-
 cance of, 61, 128; physical ideal of, 72f;
 modern image of, 73f; silent language
 of, 83, 125; Dionysian state and sym-
 bolism of, 123. *See also* Child-woman
 image; Female image; Gesture
Born, Wolfgang, 47
Boulez, Pierre, 116
Bourdelle, 11
Breuer, Josef, 71
The Bridge (1913, Schiele), 112
Bruce, Bessie, 64, 66
The Burghers of Calais (Rodin), 12

Cage, John, 116
Carter, Elliot, 116
Cézanne, Paul, 33
Charcot, Jean Martin, 69ff
Child with the Hands of Its Parents (1909,
 Kokoschka), 44, 46
Child image, 59
Child-woman image: Schiele's use of, 61–
 69 *passim*; Freud's concept of infantile
 autoeroticism of, 67; Viennese ideal
 of, 72f; fin-de-siècle society fascina-
 tion with, 93. *See also* Body; Female
 image
"The Child-Woman" (Wittels), 67
Cogwheel Railway on the Kahlenberg
 (Gerstl), 47
Color: Schiele's use of, 20, 22, 56, 113; van
 Gogh's use of, 31; Schönberg's interest
 in, 109. *See also* Paintings
Comini, Alessandra, 23, 27
Continuous drawing: Rodin's invention
 of, 8–11 *passim*; Schiele develops his
 version of, 13f
Corinth, Lovis, 69

The Corridor of the Hospital (van Gogh), 37
Crouching Male Nude (Self-Portrait) (1918,
 Schiele), 7
Crouching Woman (1900, Rodin), 19
*The Cult of Souls and Belief in Immortality
 Among the Greeks* (Rohde), 72

Das Theater (magazine), 69
Dead Mother I and II (Schiele), 88
Death: Schiele's fascination with, 59, 87;
 Mahler's apostrophization of, 87
Death and the Maiden (1915, Schiele), 113
Degas, Edgar, 18f, 23
"Dialogue of the Tragic" (1904, Bahr), 71
Die Amme (van Gogh), 46
Die Fackel (magazine), 67, 93, 125
Die Glückliche Hand, Op. 18 (Schönberg),
 104, 109
Dionysian principles, 122f
Drawings: academically acceptable
 method of, 5f; continuous, 8–11 *passim*;
 Schiele's version of continuous, 13f;
 Schiele's post-academic, 14–18 *passim*;
 Degas,' 18f, 23; of Gerti Schiele, 22;
 Rodin's and Schiele's erotic, 22–27
 passim; Schiele's deliberate coarsening
 of his, 27, 30; Schiele's representa-
 tion of children in, 59. *See also* Erotic
 drawings; Paintings
The Dreaming Youths (Kokoschka), 62
Dr. Gachet (van Gogh), 39
Duncan, Carol, 76f

The Earth (Rodin), 12
*Egon Schiele: Paintings, Watercolours, Draw-
 ings* (Leopold), 13
Egon Schiele's Portraits (Comini), 23
Elektra (1903, von Hofmannsthal), 69
El Greco, 33
Embrace (1915, Schiele), 112f
Engelmann, Paul, 93
Erotic drawings: Rodin's and Schiele's,
 22–27 *passim*; Schiele's use of color
 in, 56; obscenity charges and, 68, 89f;
 Schiele's expression through, 82–86
 passim, 110f. *See also* Drawings; Sexu-
 ality
Erotic language, 126

Erwartung (1909, Schönberg), 109
Evening in Autumn (1893, Hodler), 39
The Evil Mothers (1894, Segantini), 39, 42
Expressionism: mood of early, 29f;
 Viennese, 31, 42, 69–73 *passim*; con-
 tributions to development of, 33;
 van Gogh's influence on Austrian,
 50; atavistic sexuality of German, 83;
 Schönberg's form of, 109f; Schönberg's
 abandonment of, 110. *See also* Art
Eysoldt, Gertrud, 69

Fabricated Photographs (Altenberg), 62
Facade with Windows (1914, Schiele), 112
The Family (1918, Schiele), 114f
The Farmer's Gardens (Klimt), 36
Female image: Viennese Secessionists' vs.
 Schiele's, 59ff; *Femme fatale* vs. *femme*
 fragile, 68–69; hysteria and, 69–72
 passim; modern, 73f; Viennese Jugend-
 stil, 74–78 *passim*. *See also* Body; Child-
 woman image
Female Nude (1910, Schiele), 55
Fin-de-siècle culture: Schiele's leap from,
 73, 116; male voyeurism in, 77; de-
 scribed, 80f; feeling of longing within,
 82; fascination with child-woman
 image, 93; reactionaries vs. progres-
 sives conflict, 106f; modernist intel-
 lectual movements of, 116f; language
 crisis of, 119f, 127f
Fischl, Eric, 117
Five Piano Pieces Op. 23 (Schönberg),
 104, 109
Four Trees (Schiele), 39
Frege, Gottlob, 127
Freud, Sigmund: case of Irma Karczew-
 ska and, 67; study of hysteria by, 71; on
 development of ego, 91; influenced by
 Nietzsche, 120
Freundschaftsbild painting, 46
The Friends (1917–18, Kokoschka), 46, 49
The Friends (Rodin), 12
The Fruit Garden (Gerstl), 47

Gauguin, Paul, 33
German Expressionism, 83
Gerstl, Richard: *Cogwheel Railway on the*
 Kahlenberg, 47; *The Fruit Garden*, 47;
 Grinzing, 47; influenced by van Gogh,
 47–50 *passim*; *Nussdorf*, 47; *Self-Portrait*
 Semi-Nude, Against a Blue Background,
 47; *Tree at Traunsee*, 47; influence on
 Schönberg's paintings, 102
Gesamtkunstwerk, 86, 106
Gesture: Schiele's use of, 83ff, 110; death
 as the obverse of, 87; Mahler's focus
 on, 106. *See also* Body
Girlfriends (1913, Schiele), 29
Golden Apple Tree (Klimt), 36
Graff, Erwin von, 59
Griepenkerl, Christian, 82
Grizning (Gerstl), 47
Gurrelieder (Schönberg), 105

Haiko, Peter, 64, 66
Hammer, Victor, 47
Hanslick, Eduard, 79f
Harms, Edith, 112
Heine, Heinrich, 126
Hermits (1912, Schiele), 85, 88
Hevesi, Ludwig, 12
Hirschfeld, Robert, 105
History of the Development of Modern Art
 (Meier-Graefe), 39, 42
Hodler, Ferdinand, *Evening in Autumn*
 (1893), 39
Hoffmann, Josef, 103
Hofmannsthal, Hugo von: on impact of
 van Gogh's work, 31, 35; *Elektra* (1903),
 69; on fin de siècle's language crisis,
 119f; influenced by Nietzsche's lan-
 guage theory, 124f; love for the silent
 arts, 127
Holder, Ferdinand, 61
The Hospital in Arles (van Gogh), 37
Hysteria: aesthetic influence of, 69–73
 passim; Vienna therapists' fascination
 with, 69, 71

Iconographie photographique de la Salpêtrière,
 69
Illustriertes Wiener Extrablatt, 96
Imdahl, Max, 88
Impressionisten (1907, Meier-Graefe), 40,
 46

Impressionist Show (Viennese Secession, 1903), 32f
Instantaneous drawing, *see* Continuous drawing
International Art Exhibition (1909), 37

Jacob's Ladder (Schönberg), 104f
Janin, Clement, 8
Judith (I) (1901, Klimt), 74ff
Judrin, Claudie, 12
Jugendstil: described, 62; female imagery of Viennese, 74–78 *passim*; rediscovery of, 74
Jung, C. G., 71

Kaiser-Franz-Josef-Stadtmuseum (designed by Wagner), 95–100 *passim*
Kallir-Nirenstein, Otto, 47
Kalmar, Annie, 66f
Kandinsky, Vassily, 101, 109
Karczewska, Irma, 66f
Kiefer, Anselm, 117
Klee, Paul, 10
Klimt, Gustav: early advocate for van Gogh, 33; *The Farmer's Gardens*, 36; *Golden Apple Tree*, 36; *Avenue in the Park, Schloss Kammer* (1912), 37f; influence on Schiele, 37, 103–10 *passim*; German Expressionists on, 42; symbolism and historicism of his work, 61; Beethoven frieze (1902), 62, 105; imagery adopted by modern consumer, 73, 78; *Judith (I)* (1901), 74ff; paintings as male fantasy, 83; interest in music, 101
Klinger, Max, 12, 105
Kneeling Semi-Nude (1917, Schiele), 15
Kokoschka, Oskar: influence of van Gogh on, 42, 46; on Viennese Expressionism, 42; *Child with the Hands of Its Parents* (1909), 44, 46; *After Millet*, 46; *The Friends* (1917–18), 46; *Portrait of Father Hirsch*, 46; *Still Life with Pineapple and Bananas*, 46; *The Tempest*, 46; *The Dreaming Youths*, 62; *Study in Movement* (1908), 63; expression of gender struggle by, 77
Koons, Jeff, 117
Kraus, Karl: on genius, 32; love affairs

of, 66; editor of *Die Fackel*, 93; attacks on aestheticism by, 106ff; supporter of Mahler, 106; concept of language, 125ff; language crisis and work of, 128
Kubin, Alfred, 77
Kunstschau exhibition (1908), 107
Kunst und Künstler (periodical), 36, 47

Landing, Evelyn, 64
Landscape at Arles (van Gogh), 39
Lang, Erwin, 72
Lang, Lilith, 64
Language: Hoffmannsthal on crisis of, 119f; Nietzsche's position on, 121f; nonverbal aspects of, 124f; ethics and erotism of, 125f; philosophy and, 126ff
La Plume (art magazine), 8
La Revue Banche (art magazine), 8
L'Arlésienne (1888, van Gogh), 37, 40
Le Jardin des supplices (Mirbeau), 10, 17, 28
Lensing, Leo A., 62
Leopold, Rudolf, 13
Lesbian drawings: Schiele's, 23; Rodin's, 27
Les démoniaques dans l'art (Charcot and Richer), 70f
"A Letter" (1902, Hofmannsthal), 124
Liebermann, Max, 47
Longo, Robert, 117
Loos, Adolf: as Kokoschka's patron, 37, 62; views on ornamentation of women, 64, 66, 90–95 *passim*, 107; obscenity accusations against, 67f, 90; attacks on aestheticism by, 106ff; language crisis and work of, 128. *See also* Michaelerplatz house

Madame Roulin with Her Daughter Marcelle (De Amme) (1888, van Gogh), 45
Maegaard, Jan, 105
Mahler, Alma, 47
Mahler, Gustav: controversial music of, 80, 105f; view of death, 87; death of, 112; member of the Pernersdorfergruppe, 121
Matisse, Henri, 10, 101
Meier-Graefe, Julius: promoter of von Gogh's work, 32f; *History of the Devel-*

opment of Modern Art author, 39, 42; *Impressionisten* (1907), 40, 46
Mendelssohn, Felix, 102
Mercure de France (periodical), 47
The Metamorphosis of Ovid (Rodin), 12
Michaelerplatz house: symbolism of Loos's, 93, 95; pictured, 94. *See also* Adolf Loos
Miethke show (1906), 36f, 46
Mildenburg, Anna, 69
Minne, George, 39, 61
Mirbeau, Octave, 10, 17, 28
Mitsch, Erwin, 31
Model, *see* Artists' models
Moll, Carl: early advocate for van Gogh, 33, 36; *Self-Portrait in the Studio* (1906), 34
Moser, Kolo, 32
Moses und Aron (Schönberg), 110
Musil, Robert, 35, 81
Muther, Richard, 33

Naked Woman with Her Legs Apart (1900, Rodin), 26
Naked Woman Reclining with Legs Apart, Hands on Her Sex (1900, Rodin), 24
Nestroy, Johann, 108
Neue Freie Presse, 93
New Artists: views of, 5; founding of, 82; Schiele's credo for, 86
Nietzsche: influence on Viennese modernism, 120; on expression through language, 121ff
Nouvelle Iconographie de la Salpêtrière (ed. Charcot and Richer), 69
Novotny, Fritz, 33f
Nude Girl (1911, Schiele), 52
Nude Self-Portrait, Grimacing (1910, Schiele), 58
Nussdorf (Gerstl), 47

Obertimpfler, Lina, 66
Obscenity: accusations against Loos/Schiele, 68, 89f; architecture of, 100. *See also* Erotic drawings
Ode to Napoleon Op. 41 (Schönberg), 104
"On Mime" (1911, Hofmannsthal), 125

"On Truth and Lie in a Nonmoral Sense" (Nietzsche), 121
Op. 9 Chamber Symphony (Schönberg), 104
Oppenheimer, Max, 101
"Ornament and Crime" (Loos), 66, 90f, 107
Osen, Erwin, 56, 59
Ozenfant, Amadée, 11

Paintings: *Freundschaftsbild*, 46; Schiele's representation of children, 59; Klimt's work as male fantasy, 83; Schönberg's, 108ff; rescued from words, 120; Schiele's "silent," 128f. *See also* Color; Drawings
Pelleas and Melisande (1903, Schönberg), 112
Pernersdorfergruppe, 121
Pierrot Lunaire (1912) Op. 21 (Schönberg), 109
Pisko, Gustav, 82
The Plain of Auvers sur Oise (van Gogh), 33, 47
"The Popularity of Vincent van Gogh" (Novotny), 33
Portrait of Father Hirsch (Kokoschka), 46
Portrait of Gerti Schiele (1909, Schiele), 41
Portrait of His Mother (van Gogh), 33
The Potato Eaters (1885, van Gogh), 46

Rainer, Arnulf, 129
Reclining Nude Leaning on Right Elbow (1908, Schiele), 6
Reclining (or Kneeling) Nude (1898, Rodin), 17
Reichel, Oskar, 37
Reininghaus, Carl, 37, 85
Reissberger, Mara, 64, 66
Richer, Paul, 69ff
Rilke, Raier Maria, 11, 35
Rodin, Auguste: influence on Schiele's drawing, 6–30 *passim*; invention of continuous drawing by, 8–11 *passim*; *Two Nudes* (1898), 9; European drawing exhibitions of, 11ff; *Age of Bronze*, 12; *The Burgers of Calais*, 12; *The Earth*, 12; *The Metamorphosis of Ovid* (*The Friends*),

12; *She Who Was the Helmet Maker's Old Wife*, 12; *The Walking Man*, 12, 20; use of models by, 16; *Reclining (or Kneeling) Nude* (1898), 17; *Crouching Woman* (1900), 19; erotic drawings of, 22–27 *passim*; *Naked Woman Reclining with Legs Apart, Hands on Her Sex* (1900), 24; *Naked Woman with Her Legs Apart* (1900), 26; *Sapphic Couple* (1898), 28

Roessler, Arthur: patron of Schiele's art, 36f; describes Gerstl's work, 47; describes Schiele's work, 59; on fascination with sexuality, 84

Rohde, Erwin, 72

Roller, Alfred, 105

Romako, Anton, 46

Russell, Bertrand, 127

Salle, David, 117

Sapphic Couple (1898, Rodin), 28

Schenker, Heinrich, 105f

Schiele, Drawing a Nude Model Before a Mirror (1910, Schiele), 52

Schiele, Egon: emotional impact of paintings, 1–4 *passim*; early work of, 5ff; *Reclining Nude Leaning on Right Elbow* (1908), 6; Rodin's influence on, 6–30 *passim*; use of models by, 6f, 14–18 *passim*, 51–61 *passim*; *Crouching Male Nude (Self-Portrait)* (1918, Schiele), 7; *Kneeling Semi-Nude* (1917), 15; *Wally in Red Blouse with Raised Knees* (1913), 16; *Semi-Nude Girl with Red Hair* (1917), 18; use of color by, 20, 22, 56; *Seated Pregnant Nude* (1910), 21; erotic drawings of, 22–27 *passim*, 82–86 *passim*; *Seated Female Nude* (1911), 25; deliberate coarsening of drawings by, 27, 30; *Girlfriends* (1913), 29; friendship between Klimt and, 37; influence of van Gogh on, 37–50 *passim*; *Autumn Tree in Turbulent Air* or *Winter Tree* (1912), 39, 43, 112; *Bedroom at Neulengbach*, 39; *Four Trees*, 39; *Portrait of Gerti Schiele* (1909), 41; early figurative work of, 51–61 *passim*; *Nude Girl* (1911), 52; *Schiele, Drawing a Nude Model Before a Mirror* (1910), 52; *Black-Haired Girl with Raised Skirt* (1911), 53; *Two Girls on a Fringed Blanket* (1911),

54; *Female Nude* (1910), 55; *Seated Male Nude (Self-Portrait)* (1910), 57; *Nude Self-Portrait, Grimacing* (1910), 58; *Two Little Girls* (1911), 60; child-woman image used by, 61–69 *passim*; imprisonment of, 68, 89f; voyeurism of, 77f, 111; aesthetic goals of, 82–88 *passim*; use of gesture by, 83ff, 110; *Hermits* (1912), 85, 88; *Dead Mother I and II*, 88; *Self-Portrait in a Black Robe* (1910), 88; compared to Schönberg, 101–17 *passim*; influence of Klimt on, 105–10 *passim*; *Blind Mother* (1914), 112; *The Bridge* (1913), 112; *Embrace* (1915), 112f; *Facade with Windows* (1914), 112; later work of, 112–17 *passim*; *Death and the Maiden* (1915), 113; *The Family* (1918), 114f; *Two Squatting Women* (1918), 114f; "silent" paintings of, 128f

Schiele, Gerti, 22

Schnitzler, Arthur, 107, 124

Schönberg, Arnold: compared to Schiele, 101–17 *passim*; stages of musical works, 105; evolution of painting/musical composition, 108ff; public outcry against, 111

Schorske, Carl, 86

Schubert, Franz, 86

Seated Female Nude (1911, Schiele), 25

Seated Male Nude (Self-Portrait) (1910, Schiele), 57

Seated Pregnant Nude (1910, Schiele), 21

Segantini, Giovanni, *The Evil Mothers* (1894), 39, 42

Self-Portrait in a Black Robe (1910, Schiele), 88

Self-Portrait Semi-Nude, Against a Blue Background (Gerstl), 47

Self-portraits: Schiele's, 56; Schönberg's, 108f. *See also* Paintings

Self-Portrait in the Studio (1906, Moll), 34

Semi-Nude Girl with Red Hair (1917, Schiele), 18

Serenade Op. 24 (Schönberg), 104

Sessions, Roger, 116

Sexuality: expressed through art, 82–86 *passim*; of German Expressionism, 83; sensuality vs. female, 92f; Schiele's growing focus on, 110f; of language, 126. *See also* Erotic drawings

Sex (Weininger), 77
She Who Was the Helmet Maker's Old Wife (Rodin), 12
Sprechstimme (Schönberg), 109
Starry Night (van Gogh), 46
Still Life with Pineapple and Bananas (Kokoschka), 46
Strauss, Richard, 102
The Streetworkers in Arles (van Gogh), 37
Studies on Hysteria (Freud and Breuer), 71
Study in Movement (1908, Kokoschka), 63
Suite for Piano Op. 25 (Schönberg), 104
Sunflower motif, 36, 39
The Survivor from Warsaw Op. 46 (Schönberg), 104

The Tempest (Kokoschka), 46
The Thinker (Rodin), 12
Tietze, Hans, 32
Tintoretto, 33
Toulouse-Lautrec, 22, 39
Tractatus Logico-Philosophicus (Wittgenstein), 126f
Trcka, Joseph Anton, 129
Tree at Traunsee (Gerstl), 47
Trio Op. 45 (Schönberg), 104
Two Ballades Op. 12 (Schönberg), 104
Two Girls on a Fringed Blanket (1911, Schiele), 54
Two Little Girls (1911, Schiele), 60
Two Nudes (1898, Rodin), 9

Übermalung (Rainer), 129

Van Gogh, Theo, 47, 50
Van Gogh, Vincent: muted influence of, 31; early appreciation for, 32–36 *passim*; *The Plain of Auvers sur Oise*, 33, 47; *Portrait of His Mother*, 33; reproduces series of low-cost lithographs, 33, 35; *The Corridor of the Hospital*, 37; *The Hospital in Arles*, 37; influence on Schiele, 37–50 *passim*; *L'Arlésienne* (1888), 37, 40; *The Streetworkers in Arles*, 37; *The Bedroom at Arles*, 39; *Dr. Gachet*, 39; *Landscape at Arles*, 39; *Zouave*, 39; *Madame Roulin with Her Daughter Marcelle (De Amme)* (1888), 45; *Die Amme*, 46; influence on Kokoschka, 46f; *The Potato Eaters* (1885),

46; *Starry Night*, 46; influence on Gerstl by, 47–50 *passim*; letters to brother, 47, 50
Varnedoe, Kirk, 23
Verklärte Nacht (Schönberg), 112
Ver Sacrum (periodical), 32, 62, 107
Viennese Expressionism: response to van Gogh, 31; Meier-Graefe on, 42; hysteria and, 69–73 *passim*
Viennese Jugendstil, 62, 74–78 *passim*
Viennese modernism: significance of young/adolescent body in, 61, 128; Kokoschka's involvement with, 62ff; the case of Irma Karczewska in, 67; influence of Nietzsche on, 120ff
Viennese Secessionists: Bahr on, 32; *Ver Sacrum* periodical of, 32, 62; ethereal bodily ideals of, 51; female portraiture of, 59
Violin Piano Fantasy Op. 47 (Schönberg), 104
"Virility and Domination in Early Twentieth-Century Vanguard Painting" (Duncan), 78f
Vollard, Ambroise, 10
Voyeurism: Viennese *femme fatale/femme fragile* ideal, 72f; Schiele's, 77f, 111; within fin-de-siècle culture, 77

Wagner, Otto, 90, 95–100 *passim*
Wagner, Richard, 102, 107
Walden, Herwarth, 42
The Walking Man (Rodin), 12, 20
Wally in Red Blouse with Raised Knees (1913, Schiele), 16
Webern, Anton von, 101
Weininger, Otto, 77, 108
Werkner, Patrick, 83
Westhoff, Clara, 35
Wiener Aktionismus, 129
Wiener Werkstätte, 62, 105
Wiesenthal, Grete, 66, 69
Wildgans, Anton, 81
Wittels, Fritz, 67
Wittgenstein, Ludwig, 107f, 126f

Zemlinksy, Alexander von, 105
Zouave (van Gogh), 39